Lucy R. Lippard,
the editor of this volume,
is an art historian and critic of contemporary art.
In 1968 she received a John Simon Guggenheim grant
to write a forthcoming book on Ad Reinhardt.
Among her other publications are *Pop Art,*
Changes (a collection of essays), and
numerous articles and museum catalogs
on Dada and Surrealism.

To Max Ernst,
My fine point of departure

Surrealists on Art

Edited by

Lucy R. Lippard

A SPECTRUM BOOK

Prentice-Hall, Inc. *Englewood Cliffs, N.J.*

Current Printing (last number):
10 9 8 7 6 5 4 3 2 1

C–13-878090-0
P–13-878082-x

Library of Congress Catalog Card Number: 78–104858

Printed in the United States of America

PRENTICE-HALL INTERNATIONAL, INC. (*London*)
PRENTICE-HALL OF AUSTRALIA, PTY. LTD. (*Sydney*)
PRENTICE-HALL OF CANADA, LTD. (*Toronto*)
PRENTICE-HALL OF INDIA PRIVATE LIMITED (*New Delhi*)
PRENTICE-HALL OF JAPAN, INC. (*Tokyo*)

Acknowledgment

My thanks go first to the artists, their wives, relatives, editors, and translators, who permitted me to reprint the texts included here. Others whose cooperation was invaluable were Bernard Karpel, Librarian of the Museum of Modern Art, and his staff; William Camfield, William Rubin, Pierre Matisse, George Wittenborn, Mimi Wheeler, the publications Department at the Museum of Modern Art, and translators Margaret I. Lippard and Gabriel Bennett.

Note on the Translations

Since most anthologies of Surrealism have included very few artists' writings, most of the texts in this book have not been previously translated. In some cases the intention to revise previous translations was abandoned when, for reasons of style rather than fundamental inadequacy of existing work, I undertook entirely new versions. In two cases (Kiesler and Bellmer), regrettably, translations were made from a second language because the originals were inaccessible.

Contents

Introduction

*I admit that two-and-two-makes-four is an excellent thing,
but if all things are to be praised, I should say that two-and-
two-makes-five is also a delightful thing.*

—Fyodor Dostoevski

Since there was virtually no Surrealist art criticism, and since what
art history there is of the movement has been written either by
eulogists or observers after the fact, the artists' writings in this
anthology have a unique significance. They are almost the sole con-
temporary documents on the development, intentions, and preoccupa-
tions of Surrealist visual art. As such, they will prove confusing,
unreasonable, and often bewilderingly "poetic"—qualities that plague
many artists' attempts at verbalization but were particularly rampant
in the self-consciously liberated atmosphere of Surrealism. In any
case, given the nature of the art, subjective interpretation is un-
avoidable.

I have included here several minor artists, because their literary
talents were often more developed than those of their more im-
portant colleagues, or because of additional light their writings can
throw on the far-ranging goals of Surrealism. Others, who might
equally well have been included on a qualitative basis have been
omitted because they wrote little or nothing. A small amount of
prose and poetry not directly related to art has been offered because
the artist-writers have created potent verbal analogues to their plastic
achievements. Moreover, images, autobiographical fragments, and de-
scriptions of events and moods can provide the assiduous reader with
significant hints at artistic and personal development.

I have not attempted to augment the growing bibliography of
conjecture on Surrealism itself. A brief preface cannot do justice to
the complexity of a movement that set out to change the world. Aside
from the fascinating body of Surrealist literature (often inseparable in
motivation from the art), the polemics, and the labyrinthine record
of internecine struggles; and aside from the major general history
of the movement, Maurice Nadeau's *The History of Surrealism* (New
York: Collier Books, 1967 [rev. ed.]), there are only two studies of the
plastic arts that can be highly recommended: Marcel Jean's *The
History of Surrealist Painting* (New York: Grove Press, 1960) and
William Rubin's *Dada and Surrealism* (New York: Abrams, 1969). On
film there is Ado Kyrou's *Le Surréalisme au Cinéma* (Paris: Terrain
vague, 1963). A special issue of the magazine *Artforum* (September,
1966) bears witness to the continuing attraction of Surrealism, for it
was only in the mid-1960s that some attempt was made, by a younger

generation of American critics and historians, to construct what Rubin calls a valid "critical framework" within which to examine Surrealist art.

* * *

The Surrealists had nightmares because they couldn't paint too well.

—Sidney Tillim (1966)

Do you still remember that time when painting was considered an end in itself? We have passed the period of individual exercises.

—Paul Eluard (1933)

Surrealism was officially baptized in 1924, though its birth cries were audible by 1922, when Dada, "the Virgin Microbe," disintegrated into influential particles. The official Surrealist movement continued into its senility until the death, in 1964, of André Breton, but most visual artists of any note had left the fold by 1945, when Surrealism's last direct influence (on the New York School) was absorbed, and the last international Surrealist exhibition that can be called important in any sense at all took place in Paris in 1947. In most opinions, the truly heroic years lasted only until 1929; certainly they were over by 1935.

Underlying all Surrealist art is the collage esthetic, or the "reconciliation of two distant realities" on a new and unexpected plane. Its prime literary source was Isidore Ducasse (alias Comte de Lautréamont), a 19th-century poet virtually unknown until Breton exhumed him, whose famous image—"the fortuitous encounter of an umbrella and a sewing machine on a dissecting table"—triggered endless Surrealist variations in all media. Its pictorial inventor (aside from such historical figures as Hieronymus Bosch and Odilon Redon) was Giorgio de Chirico, and its immediate animator was the Dada-Surrealist Max Ernst, in 1919. In Ernst's collages of 1921 it is possible to see an illustration of the gradually diverging strains of Dada and Surrealism. His Dada work, founded on the harsh conjunction of opposing realities, was essentially destructive and dissective in its approach to accepted meanings, styles, and pictorial references. By 1921, however, the artist began to connect dissimilar objects by association; the result was no longer a single new image but a new *situation,* narrative, or drama comprised of recognizable images integrated into a novel context that was closer to the now standard idea of Surrealist "dream pictures." The unity of this carefully constructed oneiric realism was assured by such smooth passage between images. Many of these collages seem like individual frames from films or comic strips, dislocated parts of strange tales. The Surrealists hoped eventually to

draw from the juxtaposition of thus dislocated fragments a new, super-reality, rather than mere destruction of the old.

> *One thing is certain, that I hate simplicity in all its forms.*
> —Salvador Dali

The basis of this collage esthetic is the pun, a word originating in the Italian *puntiglio* and implying a "fine point." In modern literature, the pun is inextricably bound to the "stream of consciousness" technique of James Joyce (who was not adopted by the Surrealists, but must have been aware of them in Paris in the 1930s). Joyce's magnificent and often outrageous use of puns transcended specific translation when the multiple meanings of a phrase were expanded into innuendoes based on several ancient and modern languages. He used them in such a way that their rhythms and general allusions were available, and tantalizing, even to the less-than-erudite reader, for no linguistic (and now pictorial) form has deeper roots in the play between conscious and unconscious response to life than the pun.

Similarly, the Surrealist image of a hybrid reality wrenched from its accustomed context is recognizable on several levels, the lowest of which is mere grotesquerie or whimsical fantasy and the highest, the sheer density of associations that can be accumulated in a nearly abstract image. A psychologist's definition of adult fantasy is illusion, a mental image taken as reality by a disturbed mind. It was this aspect of the fantastic that most interested the Surrealists. The intermingling of writing and drawing that is typical of schizophrenic art, explored only formally by the Cubists, was one source of the Dadas' efforts to fathom the contents of the alienated or extraordinary mind, efforts that were further systematized by the Surrealists. By 1919, both Ernst and Breton had worked with or studied the insane. From their experiences came the seeds of automatism, the technique of allowing a passive hand to record the "dictations" of the subconscious.

* * *

> *Everybody knows there is no such thing as Surrealist painting: neither pencil lines made as a result of accidental gesturing, nor images tracing dream figures, nor imaginative fantasies can qualify as such.*
> —Pierre Naville (1925)

> *Surrealism is within the compass of every consciousness.*
> —Surrealist tract

The artists and the poets who wrote the texts collected here were more or less, at one time or another, adherents of the constantly

revolving platforms upon which André Breton—the "Pope of Surrealism"—took his stand (the exceptions are Giorgio de Chirico, Pablo Picasso, and Joseph Cornell). While most of the men were excommunicated at one time or another, their work was generally untouched by Breton's theoretical vicissitudes. In fact, the visual arts had no place in the original blueprint for the movement, which was conceived not in order to achieve esthetic "progress," but to revolutionize society at every level. Surrealist writers, such as Breton, Louis Aragon, or Paul Eluard, justified the inclusion of visual art by proclaiming that what they liked was not painting but "beyond painting" or a "challenge to painting." Surrealism intended to initiate a new humanism, in which "talent" did not exist, in which there were no artists and non-artists, but a broad new consciousness that would sweep the old concept of art along with it.

These two ideas—everyman an artist and the artist as medium—developed and changed from Marcel Duchamp to Max Ernst to Jean Dubuffet to Andy Warhol. An early Surrealist tract announced that "every true adept of the Surrealist revolution is obliged to believe that the Surrealist movement is not a movement in the abstract, and particularly in a certain poetic abstract that is utterly detestable, but is really capable of changing something in the minds of men." Through the 1940s, second-generation Surrealists could say, as did Matta: "I always defended Breton's definition of Surrealism, which has to do with the total emancipation of man. Surrealism is 'more reality.' There is always the need for man to grasp 'more reality'; for only in this way can we create a truly *human* condition." It is indicative of Surrealism's failure to effect this change that its art is now its best-known product. Even Breton eventually fell back on art when his disillusionment with revolution became complete; Nadeau dates the failure of Surrealism from the moment in 1935 when Breton "classifies himself, whether willingly or not, in the category of the *artists*."

By the mid 30s, most of the artists, having exhausted the superficial benefits of automatic techniques, found their pictorial vocabularies impoverished and their styles becoming increasingly illusionistic. In the wake of Salvador Dali's introduction of the "dream photograph" and "paranoic criticism" (see below pp. 86–107) came a resurgence of interest in the object, the illusionist phase of the collage esthetic. The Surrealist objects of the 1930s differed from Duchamp's Dada "ready-mades" and other Dada and early Surrealist objects in their complexity and self-consciousness. Where the earlier works had seemed either spontaneous or basically restricted to a single shape, pun, or idea, the later stage brought forth the most esoteric and visually elaborate images, some of which were perishable or impermanent in form, others of which differed from sculpture only in that they were assembled entirely from non-art materials. Dummies and manne-

quins played an important part (the influence of de Chirico was stronger than it had been since Dada). In the International Surrealist Exhibition of 1938, full-sized mannequins played leading roles in the theatrical installation. An interest in primitive art, important to Surrealism since its inception, but now particularly valued for its fetishistic qualities and occult implications, also increased.

> The Surrealist dimension of film is . . . most strikingly communicated in the first sequence of [Feuillade's 1915] Vampires. On a bedroom wall hangs a painted landscape; in the landscape is a Sphinx, painted against a deep, receding (painted) space. The picture is shifted to one side, revealing a deep, dark recess in the screened wall. Musidora, pale and dark-eyed, emerges, and the game begins, War— and it is Surrealism's war—is declared on a world of surfaces.
> —Annette Michelson

> Perfection
> is laziness.
> —André Breton and Paul Eluard

> Criticism can only exist as a form of love.
> —André Breton

In the film, the Surrealists found the ideal medium in which to combine verbal and visual collage, and it is in the contemporary film that the Surrealist contribution is most conspicuous, despite Dali's contention in 1932 that "contrary to current opinion, the cinema is infinitely poorer and more limited for the expression of the real function of thought than writing, painting, sculpture and architecture. There is hardly anything below it except music, whose spiritual value is, as everyone knows, just about nil." Not only was the film, like the dream, experienced in the dark by an audience detached from itself, but its photographic realism offered the possibility of a still more credible (and physically enveloping) disruption of ordinary events, behavior, and time sequence. It also reached more people, and was therefore a more potent revolutionary and evangelical weapon. Around 1930 the Surrealist film was considered a real threat to public decency (as in the L'Age d'or affair). Its effectiveness can be judged by comparison with any of the saccharine "dream sequences" found in Hollywood musicals. Today, the sight gag (or visual pun) is found as frequently in TV commercials as it is in over- or underground movies.

The Surrealist antipathy to logical and reasoned explanation is partially responsible for the absence of what we call criticism. Poetry was considered an appropriate and complementary analogue for paint-

ing, while scholarly or "intellectual" criticism was bypassed because as Eluard put it, "poetry is the opposite of literature . . . a poem must be a debacle of the intellect." The Surrealists' interest in science, scientific techniques, and scientific metaphor might be seen as a contradiction of this attitude, but in fact the Surrealists saw science as an indicator of the unknown similar to their own art. There were "laws of the unconscious." Modern science's incorporation of flux and disorder was understood by Breton and the others as a confirmation of Surrealism's "will to objectification." "Objective chance" was the "geometric locus" of coincidences, the expression of a hidden order. The collective procedures used by the Surrealists to "force inspiration" —the collaborative drawing (Exquisite Corpse), the collaborative novel or poem (see p. 87 and p. 135)—simulated the product of a scientific "team" and reflected scorn for *mere* art, opium of the individualist. The "enquiry" was one of their favorite methods of systematizing the products of the subconscious, and a Bureau of Surrealist Enquiries, engaged in collecting from the public "communications relative to diverse forms which the unconscious activity of the mind is likely to take," actually existed on the rue de Grenelle in Paris for a few months in 1924–25. Automatic writing was presented as research, experiment; and the review *La Révolution Surréaliste* had an austere format modeled after the scientific journal *La Nature*. In the 1930s, scientific jargon and lengthy pseudoscientific speculations crept into Surrealist theory (see below, the texts of Dali, Dominguez, Breton, and Onslow-Ford). An Hegelian orientation was compatible with these perorations, and Roger Shattuck has noted that Breton's three favorite Surrealist metaphors all derive from physics: "*interference,* the reinforcement and canceling out that results from crossing different wave lengths; the *short circuit,* the dangerous and dramatic breaching of a current of energy; and *communicating vessels,* that register barely visible or magnified responses among tenuously connected containers." [1] The cosmic references of later Surrealism were the basis of another attempt at a new humanism. All along, the scientific principle of discovering a suspected but unknown order, of exposing and embodying the invisible, was obviously attractive to visual artists who were by nature accustomed to making visible the invisible.

* * *

The Poet of the future will surmount the depressing notion of the irreparable divorce of action and dream.

—André Breton

Surrealism is not concerned with what is produced around

[1] Roger Shattuck, "Love and Laughter: Surrealism Reappraised," in Maurice Nadeau, *The History of Surrealism* (New York: Collier Books, 1967), p. 23.

it on the pretext of art, or even anti-art or philosophy, in a word all that does not have as its purpose the annihilation of being in a blind and inward splendor, is no more the soul of ice than fire . . .

—André Breton

. . . the radical denial of the Establishment and the communication of the new consciousness depend more and more fatefully on a language of their own, as all communication is monopolized and validated by the one-dimensional society.

—Herbert Marcuse

By 1929 Breton was disgusted with the artists' and poets' use of automatism for personal and esthetic ends alone; *The Second Surrealist Manifesto* (see below, pp. 27–35) marks the beginning of the movement's political phase, during which most of the artists went their own ways. The above quotation from Marcuse is not necessary to point up the similarities between at least the goals of Surrealism's revolution and that cultural and social revolution projected by young people in 1970. Forty years has emphasized, rather than dimmed, the pertinence and urgency of many Surrealist programs, though their methods may now seem hopelessly impractical. Parallels are found under the blanket of revolution—in proposals for free love, destruction of capitalism, equality of all men including the "normal" and the "abnormal," and a Utopian reconciliation between the "masses" and the "elite," to be accomplished, according to the Surrealists, through total freedom from social repression and destruction of barriers between conscious and unconscious, admissible and inadmissible behavior.

* * *

The materiality, the presence of the work of sculpture in the world, essentially independent of any single individual, but rather a residue of the experience of many individuals, and the dream, the experience of the sea, the trees, and the stones—I'm interested in that kind of essential thing.

—Carl Andre (1969)

In view of the similarity between the broad goals of the Surrealists and those of today's youth, it is not surprising that interest in the multilateral Surrealist enigma has proved stronger than ever in recent years, and that of all the twentieth-century movements in art, Surrealism, along with Dada, has more vibrant connections with contemporary art than any other. These influences, appropriately enough, have been exerted largely unconsciously, in the various ways new art has plugged into the network of ideas evolved by the Surrealists. If much Surrealist

painting now appears dated and retrograde, its successors have found new ways to utilize its main tenets: the collage esthetic, concreteness or "materialism," automatic techniques, chance or random order, black humor, and biomorphic morphology—though Surrealist art *per se* holds little attraction for most advanced artists today. Traces of these tenets have filtered into the most unexpected areas, among them modernist abstraction—which the Surrealists abhorred as "unreal" and "escapist" art for art's sake—and, to mention only a few, pop art, funk art, "anti-form," happenings, even areas of "primary structure," "conceptual art," technological art (particularly in its collaborative, anonymous aspect), and intermedia environment. Reconciling such stylistically diverse sensibilities is the Surrealist emphasis on direct experience: physiological (unconscious as well as intellectual) identification, direct confrontation and communion between artist and viewer, with the work as the "communicating vessel."

Georgetown, Maine,
August 1969

Poet-Critics

André Breton

André Breton (1896–1966) was a founder of the Paris Dada movement, and, after breaking with Tristan Tzara in 1921, the founder and "Pope" of Surrealism. Primarily a poet, novelist and critic, occasionally maker of visual objects, Breton was the basic formulator of the Surrealist esthetic. His first manifesto provided a point of departure and argument for poets and painters alike. Its publication in the first issue of *La Révolution Surréaliste* officially announced the movement, though during the "époque flou" between the foundering of Dada and the founding of its more sophisticated replacement, much proto-Surrealist work had been produced in all media. Breton himself had experimented with automatic writing during that period, having become interested in the unconscious as early as 1916, when he worked as an orderly in a mental hospital. In 1918 he discovered Lautréamont and found many of his nascent ideas confirmed in the poet's *Les Chants de Maldoror*.

The word Surrealism was coined by Guillaume Apollinaire in the preface to Satie's ballet, *Parade,* in 1917, and when Breton adopted it for his movement, he had to prevail over the slightly different context in which it was being used by Ivan Goll and Paul Dermée. *The First Surrealist Manifesto* is an exhilarating (if loquacious) call to action, stating Surrealism's basic premises: return to childhood; idealization of madness, non-conformism, the "abnormal" rejected by a repressed society; Freudian free association and "stream of consciousness," anti-clericalism, free love, eroticism, and occultism. The first five years of the movement, fraught though they were with lively quarrels, were the heroic years, and in 1929, when the first manifesto was republished, Breton restated his faith in its tenets: "I will only affirm my unshakable confidence in the principle of an activity which has never disappointed me, which seems more generously, more absolutely, more madly than ever worthy of my devotion, and that because it alone bestows, still only at long intervals, the transfiguring rays of

a grace that on all points I persist in opposing to divine grace."
 Brief excerpts from the two manifestoes have been translated
over the years, but it was not until 1969 that the first full-
length translation appeared: *André Breton: Manifestoes of
Surrealism*, translated by Richard Seaver and Helen R. Lane
(Ann Arbor: University of Michigan Press, 1969).

Excerpts from *The First Surrealist Manifesto* (1924)

So strong is the belief in life, in what is most fragile in life—
real life, I mean—that in the end this belief is lost. Man, that inveterate
dreamer, daily more discontent with his destiny, has trouble assessing
the objects he has been led to use, objects that his nonchalance has
brought his way, or that he has earned through his own efforts, almost
always through his own efforts, for he has agreed to work, at least he
has not refused to try his luck (or what he calls his luck!). At this point
he feels extremely modest: he knows what women he has had, what
silly affairs he has been involved in; he is unimpressed by his wealth
or poverty, in this respect he is still a newborn babe and, as for the
approval of his conscience, I confess that he does very nicely without
it. If he still retains a certain lucidity, all he can do is turn back toward
his childhood which, however his guides and mentors may have botched
it, still strikes him as somehow charming. There, the absence of any
known restrictions allows him the perspective of several lives lived
at once; this illusion becomes firmly rooted within him; now he is only
interested in the fleeting, the extreme facility of everything. Children
set off each day without a worry in the world. Everything is near at
hand, the worst material conditions are fine. The woods are white or
black, one will never sleep.
 But it is true that we would not dare venture so far, it is not merely
a question of distance. Threat is piled upon threat, one yields, aban-
dons a portion of the terrain to be conquered. This imagination which
knows no bounds is henceforth allowed to be exercised only in strict
accordance with the laws of an arbitrary utility; it is incapable of
assuming this inferior role for very long and, in the vicinity of the
twentieth year, generally prefers to abandon man to his lusterless fate.
 Though he may later try to pull himself together upon occasion,
having felt that he is losing by slow degrees all reason for living,
incapable as he has become of being able to rise to some exceptional

situation such as love, he will hardly succeed. This is because he henceforth belongs body and soul to an imperative practical necessity which demands his constant attention. None of his gestures will be expansive, none of his ideas generous or far-reaching. In his mind's eye, events real or imagined will be seen only as they relate to a welter of similar events, events in which he has not participated, *abortive* events. What am I saying: he will judge them in relationship to one of these events whose consequences are more reassuring than the others. On no account will he view them as his salvation.

Beloved imagination, what I most like in you is your unsparing quality.

The mere word "freedom" is the only one that still excites me. I deem it capable of indefinitely sustaining the old human fanaticism. It doubtless satisfies my only legitimate aspiration. Among all the many misfortunes to which we are heir, it is only fair to admit that we are allowed the greatest degree of freedom of thought. It is up to us not to misuse it. To reduce the imagination to a state of slavery —even though it would mean the elimination of what is commonly called happiness—is to betray all sense of absolute justice within oneself. Imagination alone offers me some intimation of what *can be,* and this is enough to remove to some slight degree the terrible injunction; enough, too, to allow me to devote myself to it without fear of making a mistake (as though it were possible to make a bigger mistake). Where does it begin to turn bad, and where does the mind's stability cease? For the mind, is the possibility of erring not rather the contingency of good?

There remains madness, "the madness that one locks up," as it has aptly been described. That madness or another. . . . We all know, in fact, that the insane owe their incarceration to a tiny number of legally reprehensible acts and that, were it not for these acts their freedom (or what we see as their freedom) would not be threatened. I am willing to admit that they are, to some degree, victims of their imagination, in that it induces them not to pay attention to certain rules—outside of which the species feels itself threatened— which we are all supposed to know and respect. But their profound indifference to the way in which we judge them, and even to the various punishments meted out to them, allows us to suppose that they derive a great deal of comfort and consolation from their imagination, that they enjoy their madness sufficiently to endure the thought that its validity does not extend beyond themselves. And, indeed, hallucinations, illusions, etc., are not a source of trifling pleasure. The best controlled sensuality partakes of it, and I know that there are many evenings when I would gladly tame that pretty hand which, during the last pages of Taine's *L'Intelligence,* indulges in some curious misdeeds. I could spend my whole life prying loose the secrets of the

insane. These people are honest to a fault, and their naiveté has no
peer but my own. Christopher Columbus should have set out to
discover America with a boatload of madmen. And note how this
madness has taken shape, and endured. . . .

We are still living under the reign of logic: this, of course, is what
I have been driving at. But in this day and age logical methods are
applicable only to solving problems of secondary interest. The ab-
solute rationalism that is still in vogue allows us to consider only
facts relating directly to our experience. Logical ends, on the con-
trary, escape us. It is pointless to add that experience itself has found
itself increasingly circumscribed. It paces back and forth in a cage
from which it is more and more difficult to make it emerge. It too
leans for support on what is most immediately expedient, and it is
protected by the sentinels of common sense. Under the pretense of
civilization and progress, we have managed to banish from the mind
everything that may rightly or wrongly be termed superstition, or
fancy; forbidden is any kind of search for truth which is not in con-
formance with accepted practices. It was, apparently, by pure chance
that a part of our mental world which we pretended not to be con-
cerned with any longer—and, in my opinion by far the most im-
portant part—has been brought back to light. For this we must give
thanks to the discoveries of Sigmund Freud. On the basis of these
discoveries a current of opinion is finally forming by means of which
the human explorer will be able to carry his investigations much
further, authorized as he will henceforth be not to confine himself
solely to the most summary realities. The imagination is perhaps
on the point of reasserting itself, of reclaiming its rights. If the depths
of our mind contain within it strange forces capable of augmenting
those on the surface, or of waging a victorious battle against them,
there is every reason to seize them—first to seize them, then, if need
be, to submit them to the control of our reason. The analysts them-
selves have everything to gain by it. But it is worth noting that no
means has been designated a priori for carrying out this undertaking,
that until further notice it can be construed to be the province of
poets as well as scholars, and that its success is not dependent upon
the more or less capricious paths that will be followed.

Freud very rightly brought his critical faculties to bear upon the
dream. It is, in fact, inadmissible that this considerable portion of
psychic activity (since, at least from man's birth until his death, thought
offers no solution of continuity, the sum of the moments of dream,
from the point of view of time, and taking into consideration only
the time of pure dreaming, that is the dreams of sleep, is not inferior
to the sum of the moments of reality, or, to be more precisely limiting,

the moments of waking) has still today been so grossly neglected. I have always been amazed at the way an ordinary observer lends so much more credence and attaches so much more importance to waking events than to those occurring in dreams. It is because man, when he ceases to sleep, is above all the plaything of his memory, and in its normal state memory takes pleasure in weakly retracing for him the circumstances of the dream, in stripping it of any real importance, and in dismissing the only *determinant* from the point where he thinks he has left it a few hours before: this firm hope, this concern. He is under the impression of continuing something that is worthwhile. Thus the dream finds itself reduced to a mere parenthesis, as is the night. And, like the night, dreams generally contribute little to furthering our understanding. This curious state of affairs seems to me to call for certain reflections:

1) Within the limits where they operate (or are thought to operate) dreams give every evidence of being continuous and show signs of organization. Memory alone arrogates to itself the right to excerpt from dreams, to ignore the transitions, and to depict for us rather a series of dreams than the *dream itself*. By the same token, at any given moment we have only a distinct notion of realities, the co-ordination of which is a question of will.[1] What is worth noting is that nothing allows us to presuppose a greater dissipation of the elements of which the dream is constituted. I am sorry to have to speak about it according to a formula which in principle excludes the dream. When will we have sleeping logicians, sleeping philosophers? I would like to sleep, in order to surrender myself to the dreamers, the way I surrender myself to those who read me with eyes wide open; in order to stop imposing, in this realm, the conscious rhythm of my thought. Perhaps my dream last night follows that of the night before, and will be continued the next night, with an exemplary strictness. *It's quite possible*, as the saying goes. And since it has not been proved in the slightest that, in doing so, the "reality" with which I am kept busy continues to exist in the state of dream, that it does not sink back down into the immemorial, why should I not grant to dreams what I occasionally refuse reality, that is, this value of certainty in itself which, in its own time, is not open to my repudiation? Why should I not expect from the sign of the dream more than I expect from a degree of consciousness which is daily more acute? Can't the dream also be used in solving the fundamental questions of life? Are these questions the same in one case as in the other and, in the dream,

[1] Account must be taken of the *depth* of the dream. For the most part I retain only what I can glean from its most superficial layers. What I most enjoy contemplating about a dream is everything that sinks back below the surface in a waking state, everything I have forgotten about my activities in the course of the preceding day, dark foliage, stupid branches. In "reality," likewise, I prefer to *fall*.

do these questions already exist? Is the dream any less restrictive or punitive than the rest? I am growing old and, more than that reality to which I believe I subject myself, it is perhaps the dream, the difference with which I treat the dream, which makes me grow old.

2) Let me come back again to the waking state. I have no choice but to consider it a phenomenon of interference. Not only does the mind display, in this state, a strange tendency to lose its bearings (as evidenced by the slips and mistakes the secrets of which are just beginning to be revealed to us), but, what is more, it does not appear that, when the mind is functioning normally, it really responds to anything but the suggestions which come to it from the depths of that dark night to which I commend it. However conditioned it may be, its balance is relative. It scarcely dares express itself and, if it does, it confines itself to verifying that such and such an idea, or such and such a woman, has made an impression on it. What impression it would be hard pressed to say, by which it reveals the degree of its subjectivity, and nothing more. This idea, this woman, disturb it, they tend to make it less severe. What they do is isolate the mind for a second from its solvent and spirit it to heaven, as the beautiful precipitate it can be, that it is. When all else fails, it then calls upon chance, a divinity even more obscure than the others to whom it ascribes all its aberrations. Who can say to me that the angle by which that idea which affects it is offered, that what it likes in the eye of that woman is not precisely what links it to its dream, binds it to those fundamental facts which, through its own fault, it has lost? And if things were different, what might it be capable of? I would like to provide it with the key to this corridor.

3) The mind of the man who dreams is fully satisfied by what happens to him. The agonizing question of possibility is no longer pertinent. Kill, fly faster, love to your heart's content. And if you should die, are you not certain of reawaking among the dead? Let yourself be carried along, events will not tolerate your interference. You are nameless. The ease of everything is priceless.

What reason, I ask, a reason so much vaster than the other, makes dreams seem so natural and allows me to welcome unreservedly a welter of episodes so strange that they would confound me now as I write? And yet I can believe my eyes, my ears; this great day has arrived, this beast has spoken.

If man's awaking is harder, if it breaks the spell too abruptly, it is because he has been led to make for himself too impoverished a notion of atonement.

4) From the moment when it is subjected to a methodical examination, when, by means yet to be determined, we succeed in recording the contents of dreams in their entirety (and that presupposes a

discipline of memory spanning generations; but let us nonetheless begin by noting the most salient facts), when its graph will expand with unparalleled volume and regularity, we may hope that the mysteries which really are not will give way to the great Mystery. I believe in the future resolution of these two states, dream and reality, which are seemingly so contradictory, into a kind of absolute reality, a *surreality,* if one may so speak. It is in quest of this surreality that I am going, certain not to find it but too unmindful of my death not to calculate to some slight degree the joys of its possession.

A story is told according to which Saint-Pol-Roux, in times gone by, used to have a notice posted on the door of his manor house in Camaret, every evening before he went to sleep, which read: THE POET IS WORKING.

A great deal more could be said, but in passing I merely wanted to touch upon a subject which in itself would require a very long and much more detailed discussion; I shall come back to it. At this juncture, my intention was merely to mark a point by noting the *hate of the marvelous* which rages in certain men, this absurdity beneath which they try to bury it. Let us not mince words: the marvelous is always beautiful, anything marvelous is beautiful, in fact only the marvelous is beautiful. . . .

We are all more or less aware of the road traveled. I was careful to relate, in the course of a study of the case of Robert Desnos entitled ENTRÉE DES MÉDIUMS,[2] that I had been led to "concentrate my attention on the more or less partial sentences which, when one is quite alone and on the verge of falling asleep, become perceptible for the mind without its being possible to discover what provoked them." I had then just attempted the poetic adventure with the minimum of risks, that is, my aspirations were the same as they are today but I trusted in the slowness of formulation to keep me from useless contacts, contacts of which I completely disapproved. This attitude involved a modesty of thought certain vestiges of which I still retain. At the end of my life, I shall doubtless manage to speak with great effort the way people speak, to apologize for my voice and my few remaining gestures. The virtue of the spoken word (and the written word all the more so) seemed to me to derive from the faculty of foreshortening in a striking manner the exposition (since there was exposition) of a small number of facts, poetic or other, of which I made myself the substance. I had come to the conclusion that Rimbaud had not proceeded any differently. I was composing, with a concern for variety that deserved better, the final poems of *Mont de piété,* that is, I managed to extract from the blank lines of this book an incredible

[2] See *Les Pas perdus,* published by N. R. F. [*Nouvelle Revue Française.*]

advantage. These lines were the closed eye to the operations of thought that I believed I was obliged to keep hidden from the reader. It was not deceit on my part, but my love of shocking the reader. I had the illusion of a possible complicity, which I had more and more difficulty giving up. I had begun to cherish words excessively for the space they allow around them, for their tangencies with countless other words that I did not utter. The poem BLACK FOREST derives precisely from this state of mind. It took me six months to write it, and you may take my word for it that I did not rest a single day. But this stemmed from the opinion I had of myself in those days, which was high, please don't judge me too harshly. I enjoy these stupid confessions. At that point cubist pseudo-poetry was trying to get a foothold, but it had emerged defenseless from Picasso's brain, and I was thought to be as dull as dishwater (and still am). I had a sneaking suspicion, moreover, that from the viewpoint of poetry I was off on the wrong road, but I hedged my bet as best I could, defying lyricism with salvos of definitions and formulas (the Dada phenomena were waiting in the wings, ready to come on stage) and pretending to search for an application of poetry to advertising (I went so far as to claim that the world would end, not with a good book but with a beautiful advertisement for heaven or for hell).

In those days, a man at least as boring as I, Pierre Reverdy, was writing:

> The image is a pure creation of the mind.
> It cannot be born from a comparison but from a juxtaposition of two more or less distant realities.
> The more the relationship between the two juxtaposed realities is distant and true, the stronger the image will be—the greater its emotional power and poetic reality . . .[3]

These words, however sibylline for the uninitiated, were extremely revealing, and I pondered them for a long time. But the image eluded me. Reverdy's aesthetic, a completely a posteriori aesthetic, led me to mistake the effects for the causes. It was in the midst of all this that I renounced irrevocably my point of view.

One evening, therefore, before I fell asleep, I perceived, so clearly articulated that it was impossible to change a word, but nonetheless removed from the sound of any voice, a rather strange phrase which came to me without any apparent relationship to the events in which, my consciousness agrees, I was then involved, a phrase which seemed to me insistent, a phrase, if I may be so bold, *which was knocking at the window*. I took cursory note of it and prepared to move on when its organic character caught my attention. Actually, this phrase as-

[3] *Nord-Sud* [Paris], March 1918.

tonished me: unfortunately I cannot remember it exactly, but it was something like: "There is a man cut in two by the window," but there could be no question of ambiguity, accompanied as it was by the faint visual image[4] of a man walking cut half way up by a window perpendicular to the axis of his body. Beyond the slightest shadow of a doubt, what I saw was the simple reconstruction in space of a man leaning out a window. But this window having shifted with the man, I realized that I was dealing with an image of a fairly rare sort, and all I could think of was to incorporate it into my material for poetic construction. No sooner had I granted it this capacity than it was in fact succeeded by a whole series of phrases, with only brief pauses between them, which surprised me only slightly less and left me with the impression of their being so gratuitous that the control I had then exercised upon myself seemed to me illusory and all I could think of was putting an end to the interminable quarrel raging within me.[5]

[4] Were I a painter, this visual depiction would doubtless have become more important for me than the other. It was most certainly my previous predispositions which decided the matter. Since that day, I have had occasion to concentrate my attention voluntarily on similar apparitions, and I know that they are fully as clear as auditory phenomena. With a pencil and white sheet of paper to hand, I could easily trace their outlines. Here again it is not a matter of drawing, *but simply of tracing*. I could thus depict a tree, a wave, a musical instrument, all manner of things of which I am presently incapable of providing even the roughest sketch. I would plunge into it, convinced that I would find my way again, in a maze of lines which at first glance would seem to be going nowhere. And, upon opening my eyes, I would get the very strong impression of something "never seen." The proof of what I am saying has been provided many times by Robert Desnos: to be convinced, one has only to leaf through the pages of issue number 36 of *Feuilles libres* which contains several of his drawings (*Romeo and Juliet, A Man Died This Morning*, etc.) which were taken by this magazine as the drawings of a madman and published as such.

[5] Knut Hamsum ascribes this sort of revelation to which I had been subjected as deriving from *hunger*, and he may not be wrong. (The fact is I did not eat every day during that period of my life). Most certainly the manifestations that he describes in these terms are clearly the same:

The following day I awoke at an early hour. It was still dark. My eyes had been open for a long time when I heard the clock in the apartment above strike five. I wanted to go back to sleep, but I couldn't; I was wide awake and a thousand thoughts were crowding through my mind.

Suddenly a few good fragments came to mind, quite suitable to be used in a rough draft, or serialized; all of a sudden I found, quite by chance, beautiful phrases, phrases such as I had never written. I repeated them to myself slowly, word by word; they were excellent. And there were still more coming. I got up and picked up a pencil and some paper that were on a table behind my bed. It was as though some vein had burst within me, one word followed another, found its proper place, adapted itself to the situation, scene piled upon scene, the action unfolded, one retort after another welled up in my mind, I was enjoying myself immensely. Thoughts came to me so rapidly and continued to flow so abundantly that I lost a whole host of

Completely occupied as I still was with Freud at that time, and familiar as I was with his methods of examination which I had had some slight occasion to use on some patients during the war, I resolved to obtain from myself what we were trying to obtain from them, namely, a monologue spoken as rapidly as possible without any intervention on the part of the critical faculties, a monologue consequently unencumbered by the slightest inhibition and which was, as closely as possible, akin to *spoken thought*. It had seemed to me, and still does—the way in which the phrase about the man cut in two had come to me is an indication of it—that the speed of thought is no greater than the speed of speech, and that thought does not necessarily defy language, nor even the fast-moving pen. It was in this frame of mind that Philippe Soupault—to whom I had confided these initial conclusions—and I decided to blacken some paper, with a praiseworthy disdain for what might result from a literary point of view. The ease of execution did the rest. By the end of the first day we were able to read to ourselves some fifty or so pages obtained in this manner, and begin to compare our results. All in all, Soupault's pages and mine proved to be remarkably similar: the same overconstruction, short-comings of a similar nature, but also, on both our parts, the illusion of an extraordinary verve, a great deal of emotion, a considerable choice of images of a quality such that we would not have been capable of preparing a single one in longhand, a very special picturesque quality and, here and there, a strong comical effect. The only difference between our two texts seemed to me to derive essentially from our respective tempers, Soupault's being less static than mine, and, if he does not mind my offering this one slight criticism, from the fact that he had made the error of putting a few words by way of titles at the top of certain pages, I suppose in a spirit of mystification. On the other hand, I must give credit where credit is due and say that he constantly and vigorously opposed any effort to retouch or correct, however slightly, any passage of this kind which seemed to me unfortunate. In this he was, to be sure, absolutely right.[6] It is, in fact, difficult to appreciate fairly the various elements

delicate details, because my pencil could not keep up with them, and yet I went as fast as I could, my hand in constant motion, I did not lose a minute. The sentences continued to well up within me, I was pregnant with my subject.

Apollinaire asserted that Chirico's first paintings were done under the influence of cenesthesic disorders (migraines, colics, etc.).

[6] I believe more and more in the infallibility of my thought with respect to myself, and this is too fair. Nonetheless, with this *thought-writing*, where one is at the mercy of the first outside distraction, "ebullutions" can occur. It would be inexcusable for us to pretend otherwise. By definition, thought is strong, and incapable of catching itself in error. The blame for these obvious weaknesses must be placed on suggestions that come to it from without.

present; one may even go so far as to say that it is impossible to appreciate them at a first reading. To you who write, these elements are, on the surface, *as strange to you as they are to anyone else,* and naturally you are wary of them. Poetically speaking, what strikes you about them above all is their *extreme degree of immediate absurdity,* the quality of this absurdity, upon closer scrutiny, being to give way to everything admissible, everything legitimate in the world: the disclosure of a certain number of properties and of facts no less objective, in the final analysis, than the others.

In homage to Guillaume Apollinaire, who had just died and who, on several occasions, seemed to us to have followed a discipline of this kind, without however having sacrificed to it any mediocre literary means, Soupault and I baptized the new mode of pure expression which we had at our disposal and which we wished to pass on to our friends, by the name of SURREALISM. I believe that there is no point today in dwelling any further on this word and that the meaning we gave it initially has generally prevailed over its Apollinarian sense. To be even fairer, we could probably have taken over the word SUPERNATURALISM employed by Gérard de Nerval in his dedication to the *Filles de feu.*[7] It appears, in fact, that Nerval possessed to a tee the spirit with which we claim a kinship, Apollinaire having possessed, on the contrary, naught but *the letter,* still imperfect, of Surrealism, having shown himself powerless to give a valid theoretical idea of it. Here are two passages by Nerval which seem to me to be extremely significant in this respect:

> I am going to explain to you, my dear Dumas, the phenomenon of which you have spoken a short while ago. There are, as you know, certain storytellers who cannot invent without identifying with the characters their imagination has dreamt up. You may recall how convincingly our old friend Nodier used to tell how it had been his misfortune during the Revolution to be guillotined; one became so completely convinced of what he was saying that one began to wonder how he had managed to have his head glued back on.
>
> . . . And since you have been indiscreet enough to quote one of the sonnets composed in this SUPERNATURALISTIC dream-state, as the Germans would call it, you will have to hear them all. You will find them at the end of the volume. They are hardly any more obscure than Hegel's metaphysics or Swedenborg's MEMORABILIA, and would lose their charm if they were explained, if such were possible; at least admit the worth of the expression. . . .[8]

Those who might dispute our right to employ the term SURREALISM

[7] And also by Thomas Carlyle in *Sartor Resartus* ([Book III] Chapter VIII, "Natural Supernaturalism"), 1833–34.
[8] See also *L'Idéoréalisme* by Saint-Pol-Roux.

in the very special sense that we understand it are being extremely dishonest, for there can be no doubt that this word had no currency before we came along. Therefore, I am defining it once and for all:

SURREALISM, *n.* Psychic automatism in its pure state, by which one proposes to express—verbally, by means of the written word, or in any other manner—the actual functioning of thought. Dictated by thought, in the absence of any control exercised by reason, exempt from any aesthetic or moral concern.

ENCYCLOPEDIA. *Philosophy.* Surrealism is based on the belief in the superior reality of certain forms of previously neglected associations, in the omnipotence of dream, in the disinterested play of thought. It tends to ruin once and for all all other psychic mechanisms and to substitute itself for them in solving all the principal problems of life. The following have performed acts of ABSOLUTE SURREALISM: Messrs. Aragon, Baron, Boiffard, Breton, Carrive, Crevel, Delteil, Desnos, Eluard, Gérard, Limbour, Malkine, Morise, Naville, Noll, Péret, Picon, Soupault, Vitrac.

They seem to be, up to the present time, the only ones, and there would be no ambiguity about it were it not for the case of Isidore Ducasse, about whom I lack information. And, of course, if one is to judge them only superficially by their results, a good number of poets could pass for Surrealists, beginning with Dante and, in his finer moments, Shakespeare. *In the course of the various attempts I have made to reduce what is, by breach of trust, called genius, I have found nothing which in the final analysis can be attributed to any other method than that.*

Young's *Nights* are Surrealist from one end to the other; unfortunately it is a priest who is speaking, a bad priest no doubt, but a priest nonetheless.

Swift is Surrealist in malice,
Sade is Surrealist in sadism.
Chateaubriand is Surrealist in exoticism.
Constant is Surrealist in politics.
Hugo is Surrealist when he isn't stupid.
Desbordes-Valmore is Surrealist in love.
Bertrand is Surrealist in the past.
Rabbe is Surrealist in death.
Poe is Surrealist in adventure.
Baudelaire is Surrealist in morality.
Rimbaud is Surrealist in the way he lived, and elsewhere.
Mallarmé is Surrealist when he is confiding.
Jarry is Surrealist in absinthe.

Nouveau is Surrealist in the kiss.
Saint-Pol-Roux is Surrealist in his use of symbols.
Fargue is Surrealist in the atmosphere.
Vaché is Surrealist in me.
Reverdy is Surrealist at home.
Saint-Jean-Perse is Surrealist at a distance.
Roussel is Surrealist as a storyteller.
Etc.

I would like to stress this point: they are not always Surrealists, in that I discern in each of them a certain number of preconceived ideas to which—very naively!—they hold. They hold to them because they had not *heard the Surrealist voice,* the one that continues to preach on the eve of death and above the storms, because they did not want to serve simply to orchestrate the marvelous score. They were instruments too full of pride, and this is why they have not always produced a harmonious sound.[9]

Secrets of the Magical Surrealist Art

WRITTEN SURREALIST COMPOSITION
OR
FIRST AND LAST DRAFT

After you have settled yourself in a place as favorable as possible to the concentration of your mind upon itself, have writing materials brought to you. Put yourself in as passive, or receptive, a state of mind as you can. Forget about your genius, your talents, and the talents of everyone else. Keep reminding yourself that literature is one of the saddest roads that leads to everything. Write quickly, without any preconceived subject, fast enough so that you will not remember what you're writing and be tempted to reread what you have written. The first sentence will come spontaneously, so compelling is the truth that with every passing second there is a sentence unknown to our consciousness which is only crying out to be heard. It is somewhat of a problem to form an opinion about the next sentence; it doubtless partakes both of our conscious activity and of the other, if one agrees that the fact of having written the first entails a minimum of perception. This should be of no importance to you, however; to a large

[9] I could say the same of a number of philosophers and painters, including, among these latter, Uccello, from painters of the past, and, in the modern era, Seurat, Gustave Moreau, Matisse (in "La Musique," for example), Derain, Picasso (by far the most pure), Braque, Duchamp, Picabia, Chirico (so admirable for so long), Klee, Man Ray, Max Ernst, and, one so close to us, André Masson.

extent, this is what is most interesting and intriguing about the Surrealist game. The fact still remains that punctuation no doubt resists the absolute continuity of the flow with which we are concerned, although it may seem as necessary as the arrangement of knots in a vibrating cord. Go on as long as you like. Put your trust in the inexhaustible nature of the murmur. If silence threatens to settle in if you should ever happen to make a mistake—a mistake, perhaps due to carelessness—break off without hesitation with an overly clear line. Following a word the origin of which seems suspicious to you, place any letter whatsoever, the letter "l" for example, always the letter "l," and bring the arbitrary back by making this letter the first of the following word.

HOW NOT TO BE BORED
ANY LONGER WHEN WITH OTHERS

This is very difficult. Don't be at home for anyone, and occasionally, when no one has forced his way in, interrupting you in the midst of your Surrealist activity, and you, crossing your arms, say: "It doesn't matter, there are doubtless better things to do or not do. Interest in life is indefensible. Simplicity, what is going on inside me, is still tiresome to me!" or any other revolting banality.

TO MAKE SPEECHES

Just prior to the elections, in the first country which deems it worthwhile to proceed in this kind of public expression of opinion, have yourself put on the ballot. Each of us has within himself the potential of an orator: multicolored loin cloths, glass trinkets of words. Through Surrealism he will take despair unawares in its poverty. One night, on a stage, he will, by himself, carve up the eternal heaven, that *Peau de l'ours.* He will promise so much that any promises he keeps will be a source of wonder and dismay. In answer to the claims of an entire people he will give a partial and ludicrous vote. He will make the bitterest enemies partake of a secret desire which will blow up the countries. And in this he will succeed simply by allowing himself to be moved by the immense word which dissolves into pity and revolves in hate. Incapable of failure, he will play on the velvet of all failures. He will be truly elected, and women will love him with an all-consuming passion.

TO WRITE FALSE NOVELS

Whoever you may be, if the spirit moves you, burn a few laurel leaves and, without wishing to tend this meager fire, you will begin

to write a novel. Surrealism will allow you to: all you have to do is set the needle marked "fair" at "action," and the rest will follow naturally. Here are some characters rather different in appearance; their names in your handwriting are a question of capital letters, and they will conduct themselves with the same ease with respect to active verbs as does the impersonal pronoun "it" with respect to words such as "is raining," "is," "must," etc. They will command them, so to speak, and wherever observation, reflection, and the faculty of generalization prove to be of no help to you, you may rest assured that they will credit you with a thousand intentions you never had. Thus endowed with a tiny number of physical and moral characteristics, these beings who in truth owe you so little will thereafter deviate not one iota from a certain line of conduct about which you need not concern yourself any further. Out of this will result a plot more or less clever in appearance, justifying point by point this moving or comforting denouement about which you couldn't care less. Your false novel will simulate to a marvelous degree a real novel; you will be rich, and everyone will agree that "you've really got a lot of guts," since it's also in this region that this something is located.

Of course, by an analogous method, and provided you ignore what you are reviewing, you can successfully devote yourself to false literary criticism.

HOW TO CATCH THE EYE OF A WOMAN
YOU PASS IN THE STREET

. .
. .
. .
. .
. .

AGAINST DEATH

Surrealism will usher you into death, which is a secret society. It will glove your hand, burying therein the profound M with which the word Memory begins. Do not forget to make proper arrangements for your last will and testament: speaking personally, I ask that I be taken to the cemetery in a moving van. May my friends destroy every last copy of the printing of the *Speech Concerning the Modicum of Reality*.

Surrealism does not allow those who devote themselves to it to forsake it whenever they like. There is every reason to believe that

it acts on the mind very much as drugs do; like drugs, it creates a certain state of need and can push man to frightful revolts. It also is, if you like, an artificial paradise, and the taste one has for it derives from Baudelaire's criticism for the same reason as the others. Thus the analysis of the mysterious effects and special pleasures it can produce—in many respects Surrealism occurs as a *new vice* which does not necessarily seem to be restricted to the happy few; like hashish, it has the ability to satisfy all manner of tastes—such an analysis has to be included in the present study.

1. It is true of Surrealist images as it is of opium images that man does not evoke them; rather they "come to him spontaneously, despotically. He cannot chase them away; for the will is powerless now and no longer controls the faculties." [10] It remains to be seen whether images have ever been "evoked." If one accepts, as I do, Reverdy's definition, it does not seem possible to bring together, voluntarily, what he calls "two distant realities." The juxtaposition is made or not made, and that is the long and the short of it. Personally, I absolutely refuse to believe that, in Reverdy's work, images such as

In the brook, there is a song that flows

or:

Day unfolded like a white tablecloth

or:

The world goes back into a sack

reveal the slightest degree of premeditation. In my opinion, it is erroneous to claim that "the mind has grasped the relationship" of two realities in the presence of each other. First of all, it has seized nothing consciously. It is, as it were, from the fortuitous juxtaposition of the two terms that a particular light has sprung, *the light of the image,* to which we are infinitely sensitive. The value of the image depends upon the beauty of the spark obtained; it is, consequently, a function of the difference of potential between the two conductors. When the difference exists only slightly, as in a comparison,[11] the spark is lacking. Now, it is not within man's power, so far as I can tell, to effect the juxtaposition of two realities so far apart. The principle of the association of ideas, such as we conceive of it, militates against it. Or else we would have to revert to an elliptical art, which Reverdy deplores as much as I. We are therefore obliged to admit that the two terms of the image are not deduced one from

[10] Baudelaire.
[11] Compare the image in the work of Jules Renard.

the other by the mind for the specific purpose of producing the spark, that they are the simultaneous products of the activity I call Surrealist, reason's role being limited to taking note of, and appreciating, the luminous phenomenon.

And just as the length of the spark increases to the extent that it occurs in rarefied gases, the Surrealist atmosphere created by automatic writing, which I have wanted to put within the reach of everyone, is especially conducive to the production of the most beautiful images. One can even go so far as to say that in this dizzying race the images appear like the only guideposts of the mind. By slow degrees the mind becomes convinced of the supreme reality of these images. At first limiting itself to submitting to them, it soon realizes that they flatter its reason, and increase its knowledge accordingly. The mind becomes aware of the limitless expanses wherein its desires are made manifest, where the pros and cons are constantly consumed, where its obscurity does not betray it. It goes forward, borne by these images which enrapture it, which scarcely leave it any time to blow upon the fire in its fingers. This is the most beautiful night of all, the *lightning-filled night:* day, compared to it, is night. . . .

2nd. The mind which plunges into Surrealism relives with glowing excitement the best part of its childhood. For such a mind, it is similar to the certainty with which a person who is drowning reviews once more, in the space of less than a second, all the insurmountable moments of his life. Some may say to me that the parallel is not very encouraging. But I have no intention of encouraging those who tell me that. From childhood memories, and from a few others, there emanates a sentiment of being unintegrated, and then later of *having gone astray,* which I hold to be the most fertile that exists. It is perhaps childhood that comes closest to one's "real life"; childhood beyond which man has at his disposal, aside from his laissez-passer, only a few complimentary tickets; childhood where everything nevertheless conspires to bring about the effective, risk-free possession of oneself. Thanks to Surrealism, it seems that opportunity knocks a second time. It is as though we were still running toward our salvation, or our perdition. In the shadow we again see a precious terror. Thank God, it's still only Purgatory. With a shudder, we cross what the occultists call *dangerous territory.* In my wake I raise up monsters that are lying in wait; they are not yet too ill-disposed toward me, and I am not lost, since I fear them. Here are "the elephants with the heads of women and the flying lions" which used to make Soupault and me tremble in our boots to meet, here is the "soluble fish" which still frightens me slightly. SOLUBLE FISH, am I not the soluble fish, I was born under the sign of Pisces, and man is soluble in his thought! The flora and fauna of Surrealism are inadmissible.

And ever since I have had a great desire to show forbearance to scientific musing, however unbecoming, in the final analysis, from every point of view. Radios? Fine. Syphilis? If you like. Photography? I don't see any reason why not. The cinema? Three cheers for darkened rooms. War? Gave us a good laugh. The telephone? Hello. Youth? Charming white hair. Try to make me say thank you: "Thank you." Thank you. If the common man has a high opinion of things which properly speaking belong to the realm of the laboratory, it is because such research has resulted in the manufacture of a machine or the discovery of some serum which the man in the street views as affecting him directly. He is quite sure that they have been trying to improve his lot. I am not quite sure to what extent scholars are motivated by humanitarian aims, but it does not seem to me that this factor constitutes a very marked degree of goodness. I am, of course, referring to true scholars and not to the vulgarizers and popularizers of all sorts who take out patents. In this realm as in any other, I believe in the pure Surrealist joy of the man who, forewarned that all others before him have failed, refuses to admit defeat, sets off from whatever point he chooses, along any other path save a reasonable one, and arrives wherever he can. Such and such an image, by which he deems it opportune to indicate his progress and which may result, perhaps, in his receiving public acclaim, is to me, I must confess, a matter of complete indifference. Nor is the material with which he must perforce encumber himself; his glass tubes or my metallic feathers . . . As for his method, I am willing to give it as much credit as I do mine. I have seen the inventor of the cutaneous plantar reflex at work; he manipulated his subjects without respite, it was much more than an "examination" he was employing; *it was obvious that he was following no set plan.* Here and there he formulated a remark, distantly, without nonetheless setting down his needle, while his hammer was never still. He left to others the futile task of curing patients. He was wholly consumed by and devoted to that sacred fever.

Surrealism, such as I conceive of it, asserts our complete *nonconformism* clearly enough so that there can be no question of translating it, at the trial of the real world, as evidence for the defense. It could, on the contrary, only serve to justify the complete state of distraction which we hope to achieve here below. Kant's absentmindedness regarding women, Pasteur's absentmindedness about "grapes," Curie's absentmindedness with respect to vehicles, are in this regard profoundly symptomatic. This world is only very relatively in tune with thought, and incidents of this kind are only the most obvious episodes of a war in which I am proud to be participating. Surrealism is the "invisible ray" which will one day enable us to win

out over our opponents. "You are no longer trembling, carcass." This summer the roses are blue; the wood is of glass. The earth, draped in its verdant cloak, makes as little impression upon me as a ghost. It is living and ceasing to live that are imaginary solutions. Existence is elsewhere.

The Second Surrealist Manifesto was a kind of purge. The poetic and artistic pedigrees so lovingly forged by Breton at an earlier period gave way to a doctrine of "absolute revolt," "total insubordination," and "regulated sabotage." It displays the inevitable undermining of the movement's freshness by internecine struggles compounded by an increasingly political bias. Immediately after its publication, the title of the review *Surrealist Revolution* was changed to *Surrealism at the Service of the Revolution,* but the Communist party was far from welcoming to these impractical idealists; further splits in the original group resulted from attempts to be both Surrealist and party-line Communist—a virtual impossibility implied but never admitted by Breton himself. For politics was only part of the Surrealist "Revolution." Surrealism was intended to be a way of life, a "state of mind," and a total change of attitude, civilization, art, literature, and even economics; its ideals were not accomplished, and they have reappeared, often in similar forms, during the 1960s. The painters involved were for the most part apolitical, and by the end of the 1930s friendships such as Max Ernst's and Paul Eluard's had been greatly strained by literary-political goals that seemed incompatible with the visual arts. The artists tended to be emotional revolutionaries rather than theoreticians or activists, although in times of grave international crisis they were often drawn to make general political statements (see Magritte, pp. 154–61, and Miró, pp. 172–76).

Excerpts from *The Second Surrealist Manifesto* (1929)

In spite of the various efforts peculiar to each of those who used to claim kinship with Surrealism, or who still do, one must ultimately

Excerpts from The Second Surrealist Manifesto *(1929) by André Breton. From* André Breton: Manifestoes of Surrealism, *trans. Richard Seaver and Helen R. Lane (Ann Arbor: University of Michigan Press, 1969), pp. 123–27, 140–43, 153–57. Copyright © 1969 by University of Michigan Press. Courtesy of University of Michigan Press.*

admit that, more than anything else, Surrealism attempted to pro-
voke, from the intellectual and moral point of view, *an attack of
conscience,* of the most general and serious kind, and that the extent
to which this was or was not accomplished alone can determine its
historical success or failure.

From the intellectual point of view, it was then, and still is today,
a question of testing by any and all means, and of demonstrating at
any price, the meretricious nature of the old antinomies hypocritically
intended to prevent any unusual ferment on the part of man, were
it only by giving him a vague idea of the means at his disposal, by
challenging him to escape to some meaningful degree from the
universal fetters. The bugaboo of death, the simplistic theatrical por-
trayal of the beyond, the shipwreck of the most beautiful reason in
sleep, the overwhelming curtain of the future, the tower of Babel, the
mirrors of inconstancy, the impassable silver wall bespattered with
brains—these all too gripping images of the human catastrophe are,
perhaps, no more than images. Everything tends to make us believe
that there exists a certain point of the mind at which life and death,
the real and the imagined, past and future, the communicable and the
incommunicable, high and low, cease to be perceived as contradictions.
Now, search as one may one will never find any other motivating
force in the activities of the Surrealists than the hope of finding and
fixing this point. From this it becomes obvious how absurd it would
be to define Surrealism solely as constructive or destructive: the point
to which we are referring is a fortiori that point where construction
and destruction can no longer be brandished one against the other.
It is also clear that Surrealism is not interested in giving very serious
consideration to anything that happens outside of itself, under the
guise of art, or even anti-art, of philosophy or anti-philosophy—in
short, of anything not aimed at the annihilation of the being into a
diamond, all blind and interior, which is no more the soul of ice than
that of fire. What could those people who are still concerned about
the position they occupy *in the world* expect from the Surrealist ex-
periment? In this mental site, from which one can no longer set forth
except for oneself on a dangerous but, we think, supreme feat of
reconnaissance, it is likewise out of the question that the slightest
heed be paid to the footsteps of those who arrive or to the footsteps
of those who leave, since these footsteps occur in a region where by
definition Surrealism has no ear to hear. We would not want Surreal-
ism to be at the mercy of the whims of this or that group of persons;
if it declares that it is able, by its own means, to uproot thought from
an increasingly cruel state of thralldom, to steer it back onto the
path of total comprehension, return it to its original purity—that is
enough for it to be judged only on what it has done and what it still
has to do in order to keep its promises.

Before proceeding, however, to verify the balance sheet, it is worthwhile to know just what kind of moral virtues Surrealism lays claim to, since, moreover, it plunges its roots into life and, no doubt not by chance, into *the life of this period*, seeing that I laden this life with anecdotes like the sky, the sound of a watch, the cold, a malaise, that is, I begin to speak about it in a vulgar manner. To think these things, to hold any rung whatever of this weather-beaten ladder—none of us is beyond such things until he has passed through the last stage of asceticism. It is in fact from the disgusting cauldron of these meaningless mental images that the desire to proceed beyond the insufficient, the absurd, distinction between the beautiful and the ugly, true and false, good and evil, is born and sustained. And, as it is the degree of resistance that this choice idea meets with which determines the more or less certain flight of the mind toward a world at last inhabitable, one can understand why Surrealism was not afraid to make for itself a tenet of total revolt, complete insubordination, of sabotage according to rule, and why it still expects nothing save from violence. The simplest Surrealist act consists of dashing down into the street, pistol in hand, and firing blindly, as fast as you can pull the trigger, into the crowd. Anyone who, at least once in his life, has not dreamed of thus putting an end to the petty system of debasement and cretinization in effect has a well-defined place in that crowd, with his belly at barrel level.[1] The justification of such an act is, to my mind, in no way incompatible with the belief in that gleam of light

[1] I know that these last two sentences are going to delight a certain number of simpletons who have been trying for a long time to catch me up in a contradiction with myself. Thus, am I really saying that "the simplest Surrealist act . . . ?" So what if I am! And while some, with an obvious axe to grind, seize the opportunity to ask me "what I'm waiting for," others raise a hue and cry about anarchy and try to pretend that they have caught me in *flagrante delicto* committing an act of revolutionary indiscipline. Nothing is easier for me than to deprive these people of the cheap effect they might have. Yes, I am concerned to learn whether a person is blessed with violence before asking myself whether, in that person, violence *compromises* or *does not compromise*. I believe in the absolute virtue of anything that takes place, spontaneously or not, in the sense of non-acceptance, and no reasons of general efficacity, from which long, pre-revolutionary patience draws its inspiration—reasons to which I defer—will make me deaf to the cry which can be wrenched from us at every moment by the frightful disproportion between what is gained and what is lost, between what is granted and what is suffered. As for that act that I term the simplest: it is clear that my intention is not to recommend it above every other because it is simple, and to try and pick a quarrel with me on this point is tantamount to asking, in bourgeois fashion, any nonconformist why he doesn't commit suicide, or any revolutionary why he doesn't pack up and go live in the u.s.s.r. Don't come to me with such stories! The haste with which certain people would be only too happy to see me disappear, coupled with my own natural tendency to agitation, are in themselves sufficient reason for me not to clear out of here for no good reason.

that Surrealism seeks to detect deep within us. I simply wanted to
bring in here the element of human despair, on this side of which
nothing would be able to justify that belief. It is impossible to give
one's assent to one and not to the other. Anyone who should pretend
to embrace this belief without truly sharing this despair would soon
be revealed as an enemy. This frame of mind which we call Surrealist
and which we see thus occupied with itself, seems less and less to
require any historical antecedents and, so far as I am personally con-
cerned, I have no objection if reporters, judicial experts, and others
hold it to be specifically modern. I have more confidence in this
moment, this present moment, of my thought than in the sum total
of everything people may try to read into a finished work, into a
human life that has reached the end of its road. There is nothing
more sterile, in the final analysis, than that perpetual interrogation of
the dead: Did Rimbaud become converted on the eve of his death?
Can one find in Lenin's last will and testament sufficient evidence to
condemn the present policy of the Third International? Was an un-
bearable, and completely personal, disgrace the mainspring of Al-
phonse Rabbe's pessimism? Did Sade, in plenary session of the Na-
tional Convention, commit a counterrevolutionary act? It is enough
to allow these questions to be asked to appreciate the fragility of
the evidence of those who are no longer among us. Too many rogues
and rascals are interested in the success of this undertaking of
spiritual highway robbery for me to follow them over this terrain.
When it comes to revolt, none of us must have any need of an-
cestors. . . .

Surrealism, although a special part of its function is to examine
with a critical eye the notions of reality and unreality, reason and
irrationality, reflection and impulse, knowledge and "fatal" ignorance,
usefulness and uselessness, is analogous at least in one respect with
historical materialism in that it too tends to take as its point of de-
parture the "colossal abortion" of the Hegelian system. It seems im-
possible to me to assign any limitations—economic limitations, for
instance—to the exercise of a thought finally made tractable to nega-
tion, and to the negation of negation. How can one accept the fact
that the dialectical method can only be validly applied to the solu-
tion of social problems? The entire aim of Surrealism is to supply it
with practical possibilities in no way competitive in the most immedi-
ate realm of consciousness. I really fail to see—some narrow-minded
revolutionaries notwithstanding—why we should refrain from sup-
porting the Revolution, provided we view the problems of love,
dreams, madness, art, and religion from the same angle they do.[2] Now,

[2] Quoting me incorrectly is one of the recent means most frequently employed
against me. As an example, let me cite the way in which *Monde* tried to make

I have no hesitation in saying that, prior to Surrealism, nothing systematic has been done in this direction, and at the point where we found it *the dialectical method, in its Hegelian form, was inapplicable for us too.* There was, for us too, the necessity to put an end to idealism properly speaking, the creation of the word "Surrealism" would testify to this, and, to quote Engels' classic example once again, the necessity not to limit ourselves to the childish: "The rose is a rose. The rose is not a rose. And yet the rose is a rose," but, if one will forgive me the parenthesis, to lure "the rose" into a movement pregnant with less benign contradictions, where it is, successively, the rose that comes from the garden, the one that has an unusual place in a dream, the one impossible to remove from the "optical bouquet," the one that can completely change its properties by passing into automatic writing, the one that retains only those qualities that the painter has deigned to keep in a Surrealist painting, and, finally, the one, completely different from itself, which returns to the garden. That is a far cry from an idealistic view of any kind, and we would not even bother to refute the allegation if we could cease to be the object of attacks of simplistic materialism, attacks which stem both from those who by base conservatism have no desire to clarify the relations between thought and matter and from those who, because of a revolutionary sectarianism only partly understood, confuse, in defiance of what is required, this materialism with the materialism that Engels basically distinguishes from it and which he defines above all as an "intuition of the world" called upon to prove itself and assume concrete form:

"In the course of the evolution of philosophy, idealism became untenable and was repudiated by modern materialism. The latter, which is the negation of negation, is not the simple restoration of the former materialism: to the durable substructure of the latter it adds all the thought that philosophy and science has amassed in the course of two thousand years, and the product of that long history itself."

We also intend to place ourselves at a point of departure such that for us philosophy is "outclassed." It is, I think, the fate of all those for whom reality is not only important theoretically but for whom it is also a matter of life or death to make an impassioned

use of this sentence: "Claiming to consider the problems of love, dreams, madness, art, and religion from the same viewpoint as that of the revolutionaries, Breton has the gall to write . . ." etc. It is true that, as anyone can read in the next issue of the same paper: "*La Révolution surréaliste* takes us to task in its last issue. It is common knowledge that the stupidity of these people knows absolutely no bounds." (Especially since they have refused your offer, without so much as taking the trouble to answer it, to contribute to *Monde*, right? But so be it.) In the same vein, a contributor to *Cadavre* sharply reprimands me for purportedly having written: "I swear that I'll never wear the French uniform again." *I'm sorry, but it isn't me.*

appeal, as Feuerbach desired, to that reality: our fate to give as we do, *completely,* without any reservations, our allegiance to the principle of historical materialism, his to thrust into the face of the shocked and astounded intellectual world the idea that "man is what he eats" and that a future revolution would have a better chance of success if the people were better nourished, in this specific case with peas instead of potatoes.

Our allegiance to the principle of historical materialism . . . there is no way to play on these words. So long as that depends solely on us—I mean provided that communism does not look upon us merely as so many strange animals intended to be exhibited strolling about and gaping suspiciously in its ranks—we shall prove ourselves fully capable of doing our duty as revolutionaries. This, unfortunately, is a commitment that is of no interest to anyone but ourselves: two years ago, for instance, I was personally unable to cross the threshold of the French Communist Party headquarters, freely and unnoticed as I desired, that same threshold where so many undesirable characters, policemen and others, have the right to gambol and frolic at will. In the course of three interrogations, each of which lasted for several hours, I had to defend Surrealism from the puerile accusation that it was essentially a political movement with a strong anti-communist and counterrevolutionary orientation. It goes without saying that I hardly expected from those who had set themselves up as my judges that the basic premises of my thought would be gone through with a fine tooth comb. "If you're a Marxist," Michel Marty bawled at one of us at about that same time, "you have no need to be a Surrealist." And needless to say it was not we who were making a point of being Surrealists in such a circumstance: this epithet had gone before us in spite of ourselves just as the title of "relativists" might have preceded the followers of Einstein or "psychoanalysts" those of Freud. How is it possible not to be extremely concerned about such a noticeable decline in the ideological level of a party which not long ago had sprung so brilliantly armed from two of the greatest minds of the nineteenth century! It is an all too familiar story: the little that I can glean on this point from my own personal experience is similar to the rest. I was asked to make a report on the Italian situation to this special committee of the "gas cell," which made it clear to me that I was to stick strictly to the statistical facts (steel production, etc.) *and above all not get involved with ideology.* I couldn't do it. . . .

Whatever the evolution of Surrealism may have been in the realm of politics, however urgently the order may have been passed on to us to count only upon the proletarian Revolution for the liberation

of mankind—*the primary condition of the mind*—I can say in all honesty that we did not find any valid reason to change our minds about the means of expression which are characteristically ours and which, we have been able to verify through usage, served us well. Let anyone who cares to condemn this or that specifically Surrealist image that I may have used at random in the course of a preface, it will not release him from further obligations as far as images are concerned. "This family is a litter of dogs." [3] When, by quoting such a sentence out of context, anyone provokes a good deal of gloating, all he will actually have done is assemble a great many ignoramuses. One will not have succeeded in sanctioning neo-naturalistic procedures at the expense of ours, that is, in deprecating everything which, since naturalism, has contributed to the most important conquests the mind has made. I am here reminded of the answers I gave, in September 1928, to these two questions that were asked me:

1) Do you believe that literary and artistic output is a purely individual phenomenon? Don't you think that it can or must be the reflection of the main currents which determine the economic and social evolution of humanity?

2) Do you believe in a literature and an art which express the aspirations of the working class? Who, in your opinion, are the principal representatives of this literature and this art?

My answers were as follows:

1) Most certainly, the same goes for literary or artistic output as for any intellectual phenomenon, in that the only question one can rightly raise concerning it is that of the *sovereignty of thought*. That is, it is impossible to answer your question affirmatively or negatively, and all one can say is that the only observable philosophical attitude in such a case consists in playing up "the contradiction (which does exist) between the nature of human thought which we take to be absolute and the reality of that thought in a crowd of individuals of limited thought: this is a problem that can be resolved only through infinite progress, through the series, at least virtually infinite, of successive generations of mankind. In this sense human thought is sovereign and is not; and its capacity to know is both limitless and limited. Sovereign and limitless by its nature, its vocation, potentially, and with respect to its ultimate goal in history; but lacking sovereignty and limited in each of its applications and in any of its several states." [4] This thought, in the area where you ask me to consider such and such a specific expression in relation to it, can only oscillate between the awareness of its inviolate autonomy and that of its

[3] Rimbaud.
[4] Friedrich Engels, *La Morale et le droit. Vérités éternelles.*

utter dependence. In our own time, artistic and literary production appears to me to be wholly sacrificed to the needs that this drama after a century of truly harrowing poetry and philosophy (Hegel, Feuerbach, Marx, Lautréamont, Rimbaud, Jarry, Freud, Chaplin, Trotsky) has to work itself out. Under these circumstances, to say that this output can or must reflect the main currents which determine the economic and social evolution of humanity would be offering a rather unrefined judgment, implying the purely circumstantial awareness of thought and giving little credit to its fundamental nature: both unconditioned and conditioned, utopian and realistic, finding its end in itself and aspiring only to serve, etc.

2) I do not believe in the present possibility of an art or literature which expresses the aspirations of the working class. If I refuse to believe in such a possibility, it is because, in any prerevolutionary period the writer or artist, who of necessity is a product of the bourgeoisie, is by definition incapable of translating these aspirations. I do not deny that he can get some idea of these aspirations and that, in rather exceptional moral circumstances, he may be capable of conceiving of the relativity of any cause in terms of the proletarian cause. I consider it to be a matter of sensitivity and integrity for him. This does not mean, however, that he will elude the remarkable doubt, inherent in the means of expression which are his, which forces him to consider from a very special angle, within himself and for himself alone, the work he intends to do. In order to be viable, this work demands to be *situated* in relationship to certain other already existing works and must, in its turn, open up new paths. Making all due allowances, it would, for example, be just as pointless to protest against the assertion of a poetic determinism, whose laws cannot be promulgated, as against that of dialectical materialism. Speaking personally, I am convinced that the two kinds of evolution are strictly similar and, moreover, that they have at least this much in common: *they are both unsparing.* Just as Marx' forecasts and predictions—as far as almost all the external events which have transpired since his death are concerned—have proved to be accurate, I can see nothing which would invalidate a single word of Lautréamont's with respect to events of interest only to the mind. By comparison, any attempt to explain social phenomena other than by Marx is to my mind as erroneous as any effort to defend or illustrate a so-called "proletarian" literature and art at a time in history when no one can fairly claim any real kinship with the proletarian culture, for the very excellent reason that this culture does not yet exist, even under proletarian regimes. "The vague theories about proletarian culture, conceived by analogy with and antithesis to bourgeois culture, result from comparisons between the proletariat and the bourgeoisie, in which the critical spirit is wholly lacking. . . . There can be no

doubt but that a time will come in the evolution of the new society when economics, culture, and art will have the greatest freedom of movement—of progress. But on this subject we can only offer the most fantastical conjectures. In a society which will have rid itself of the overwhelming concern of providing for its daily bread, where communal laundries will wash everyone's clothes, where the children— all the children—well fed, healthy, and happy will absorb the basics of science and art as they do the air and sunlight, where there will no longer be any 'useless mouths,' where man's liberated egotism—an extraordinary force—will be concerned only with the knowledge, the transformation, and the betterment of the universe—in this society, the dynamic nature of the culture will not be comparable to anything the world has ever known in the past. But we shall reach this stage only after a long and painful transition, which lies almost entirely before us." [5]

These admirable remarks seem to me to answer once and for all the charges made by certain fraudulent and wily characters who in France today, under the dictatorship of Poincaré, pass themselves off as proletarian writers and artists, under the pretense that in what they paint or write there is nothing but ugliness and misery, as well as to answer those who cannot conceive of anything beyond base reportage, the funerary monument, and the sketch of prison, who know of nothing else to do but wave the ghost of Zola in front of our eyes—Zola whom they pick over like vultures without however diminishing him to the slightest degree and who, shamelessly castigating here everything that lives and breathes, suffers, hopes, and despairs, are opposed to any kind of serious research, do their level best to prevent any discovery and, under the pretense of giving what they know cannot be received—the immediate and general knowledge of what is being created—are not only the worst contemners of the mind but also the most certain counterrevolutionaries.

[5] Leon Trotsky, "Revolution and Culture," in *Clarté*, November 1, 1923.

Louis Aragon

Louis Aragon was born in Paris, in 1897. First a Dada, then one of the founders of the Surrealist movement, he is best known as a poet and novelist. His preface to the first major exhibition of collages (Galerie Goemans, 1930) approaches art criticism more than most Surrealist texts, and expresses more clearly than usual typically Surrealist positions on the avant-garde, life, and the art of the past. His ideas are particularly pertinent to the late 1960s, and early 70s, when the "death of painting" and a tendency against formalism are again in ascendence, and revolutionary theory is again of necessity invading the arts.

In 1930, Aragon attended the Second International Congress of Revolutionary Writers in Kharkov, where he denounced aspects of Surrealism, although he continued in the movement until 1932, when his conflicting interests in art and politics provoked "L'Affaire Aragon," a *cause célèbre* culminating in his resignation from Surrealism.

The collage exhibition itself included Arp, Braque, Dali, Duchamp, Ernst, Gris, Magritte, Man Ray, Miró, Picabia, Picasso, and Tanguy; the catalogue reproduced works by El Lissitsky and Alexander Rodchenko, though Kasimir Malevich—the third and major Russian to work in post-Cubist collage—is not mentioned; the Germans are also conspicuously absent.

Excerpts from *Challenge to Painting*

Man does not seem to be endowed with an infinite faculty for wonder. If he were, he could only begin by wondering at his most common modes of thinking. "The bread is on the table," he will say to announce that he just put it there, as well as to illustrate his grammars, without understanding what makes his words sound so strange and so distant. And if everything so extraordinarily ordinary were by chance to find someone who sensed its unusualness, its paralyzing unusualness, that someone would be labeled "sick"; the doctors, when called, would murmur psychasthenia, and the speaking voice would resume: I just said that the bread is on the table.

Excerpts from Challenge to Painting *by Louis Aragon. Translated by the editor from* La Peinture au défi [*catalogue for* Exposition de Collages] (*Paris: Galerie Goemans, Librairie José Corti, March 1930*). *Courtesy of Louis Aragon.*

The Gauls, nevertheless, were afraid the sky would fall on their heads, and fortunately one can, from time to time, quiet a brat by telling him about the Ogre, with great gnashing of teeth. Similarly, poets tired of the customary scorn suddenly brandish thunderclaps of stupefaction. The marvelous awakes where laughter is quenched. No, the bread is no longer on the table, or it is no longer the table, and it is certainly no longer bread. *Marvelous: intervention of super-natural beings into a poem* (Larousse); the real nature of the marvelous is that man is without doubt the least amazed. It suffices for him to think that this or that returns to the marvelous so everything is in order and he can go back to sleep. Catalogues of marvels have been listed. No one has ever wondered what they have in common.

Certainly the marvelous appears to the person who can consider it slowly as a dialectical urgency born of another, lost urgency. The marvelous is opposed to the mechanical, to that which is so good that it is no longer noticeable, and thus it is generally believed that the marvelous is the negation of reality. This rather summary view is conditionally acceptable; certainly the marvelous is born of the refusal of *one* reality, but also of the development of a new relation-ship, a new reality liberated by that refusal. I would like to propose an hypothesis concerning the real nature of this relationship. If my hypothesis proves sufficient, it will have permitted the projection of an inexplicably neglected problem. Thus I will risk this: the rela-tionship born of the negation of the real by the marvelous is essen-tially of an ethical nature, and the marvelous is always the material-ization of a moral symbol in violent opposition to the morality of the world from which it arises. . . .

It is Surrealism's duty to make the point of the marvelous in 1930. Modern poetry is essentially atheist. That is, one task is sacred to it: the de-Christianization of the world by its own means, probably means whose efficacity the world strangely underestimates. Attacking sym-bols is not a puerile enterprise but can harmlessly pass for one. There is room to hope that everywhere, whether in the shadow of a fan or in ironwork railings, a handful of fanatics will make all allusions to the infamous cross disappear, and I dare say that surveyors will be found to invent a way that streets can meet without *crossing*. So much the worse for ancient dreams: those who must borrow the accent and pretext of the Jesus-Marys to express themselves will have to be annihilated. Today the most beautiful painting in the world, if it represents a religious subject, is incomprehensible to me as a paint-ing. The subject hides it. I prefer to it the stupidest of the stillest still lives. But the modern fantastic henceforth seizes upon everything close to us. Thus it mocks the hypocritical word of resignation that for so long has helped the priests bring their slaves, hands bound, to the feet of kings and industrialists: my kingdom is not of this world.

Yes, the kingdom of apparitions is of this world, today it *is* this world, and the serious or mocking men who handle the creaking gates open them to new phantoms, who carry strange rays of light in their footsteps, in the folds of their mantles. Watch out for the period that's coming! This world is already cracking, it bears within it some unknown principle of negation, it is crumbling. Follow the rising smoke, the specters' lashings in the midst of the bourgeois universe. A bolt of lightning is lurking beneath the bowler hats. Truly, there is diabolism in the air.

* * *

Do the feats attributed to the prestidigitor of Nazareth shock you? Undoubtedly turning water into wine will always be more successful than the contrary. But how meagre is this poetry that has a chalice for overture, god's useless thunder for refrain. As soon as the human imagination turns elsewhere, how much greater, more monstrous, closer to miracles everything is. The helmet descending into the court of the Castle of Otranto[1] is great enough to hide in its shadows all Golgotha's paltry machinations.

That said, we can discuss miracles.

What characterizes the miracle, what proclaims the miraculous, that quality of the marvelous, is undoubtedly a bit of surprise, as it has been feebly put. But it is much more, in every sense the word can be given—an extraordinary displacement.[2] The dead displaced from their tombs, giants from their size, sylphs from their lightness, roses from the season. The miracle is an unexpected disorder, a surprising disproportion. And it is in this regard that it is the negation of the real, that, once accepted as a miracle, it becomes the conciliation of the real and the marvelous. The new relationship thus established is surreality, a thousand times defined, and always differently definable, that real line that links all the virtual images surrounding us. All the above had to be set forth in order to begin to discuss the course of Surrealism today, to explain the general significance of an enterprise that presents itself in the forefront of so particular an artistic manner, and by pictorial example, a technical consideration.

It is curious that almost no one has seemed to be aware of a singular occupation, the consequences of which are not yet wholly appreciable, in which certain men these days have offered a systematic method more reminiscent of magical operations than those of painting. Besides which, it questions personality, talent, artistic propriety, and all

[1] Editor's note: *The Castle of Otranto*, a famous 18th-century novel of the supernatural, by Horace Walpole.
[2] *Surreality will be, moreover, the function of our will to the displacement of everything.* (André Breton, "Avis au lecteur," *La Femme 100 Têtes.*)

sorts of other ideas that were nestling unsuspected and undisturbed in cretinized brains. I am talking about what is called, for simplicity's sake, *collage,* although the use of glue is only one of its characteristics and not even an essential one.[3] Undoubtedly there is something mind-boggling about this subject, for in all the voluminous criticism devoted, for example, to Cubism since its birth, only a few superficial words are found to document the existence of the *papiers collés,*[4] the term which designated the first appearance of collage, by which Braque's and Picasso's restlessness was revealed in 1911. Now it is necessary to clarify that collage, as it is understood today, is something entirely different from the Cubist *papier collé.* But the latter already posed certain questions that the former poses still. It is important to remark this critical insolvency in regard to an activity that absorbed a good part of the thought of the most admired painters of a whole generation; the few words, given as excuse more than explanation, do not even suffice to establish the plastic interpenetration one had a right to expect at a time when considerations of this order were fashionable among the commentators. To better understand what has been produced for the last twenty years, and following by preference an historical course, we must begin by speaking of collage as it appeared at its birth.

I don't know whether it was Braque or Picasso who first, in desperation, employed a wallpaper, a newspaper, or a ready-made stamp to complete or begin a painting which was to make art-lovers shudder, and if, in fact, desperation was the cause. It is probably useless to interrogate these two contemporaries on a priority that is less important than the spirit which initially appealed to glue and to the reality of borrowing. Do the two men themselves remember? I have heard Braque talk about what was then called a *certainty*—the glued element, around which the painting was to be constituted in a completely different perspective than it would have been had this element been imitated. Having gazed, in the miserable room at the Hotel Roma where Braque was painting, upon the drawings that filled the risks of the ramshackle partition, I know what emotion could have presided over that choice of paper which this painter suddenly preferred to painting. I am not sure that the justification he gave it then really took that emotion into account. In any case, I will never believe (even if Picasso contradicts me)[5] that the same preoccupations, the same

[3] Editor's note: *colle*—glue, in French.

[4] Editor's note: *papier collé*—pasted, or glued, papers; this phrase is left untranslated in order to distinguish Cubist from Surrealist and Dada collage.

[5] At the very beginning, Picasso introduced into a painting, in order to imitate the caning of a chair, a [false wood-grained] paper which covered the painting where the wood of the chair was to be represented. He found it useless to imitate laboriously what was already imitated; to imitate an object, the object itself could

rigor or the same arbitrariness, could have directed Picasso's and Braque's hands at that moment, when I can affirm that these two men are so perfectly different and so little reducible to a common denominator. In any case, it seems that only Picasso persisted in the direction where many others have since been engaged. The paintings he makes now, which reinstate the collage esthetic, no longer respond to the original plastic considerations. We will return to that later.

From these first collages issued two distinct categories of work— those where the glued element merits attention through its form, or more exactly, through its representation of an object; the other where it is used because of its material. Certainly the latter hardly constitutes anything but pictorial works where problems of color are in question, where everything depends on enrichment of the palette, and perhaps on a criticism of the palette, on a whim. The first type, on the contrary, predicts the collages to come, where the expressed is conveyed by the manner of expression, where the depicted object plays the role of a word. In any case, we may consign to the latter those poems written around 1917 which constitute what has been improperly called Cubist poetry; they have nothing to do with Cubism, but they do present an analogy with the *papiers collés*, the use of ready-made expressions as a lyrical element; and this analogy announces a possibility beyond Cubism which will be realized later, when the painting still qualified as *literary* is finally considered a real language and no longer a matter of taste.[6] What did these searchers first understand of what they made, when they tried false wood, cards, sand, emery paper, bits of mirror? No matter. Some playing, others challenged, they had taken a great leap since that first appearance of glue. The plastic pretext allowed them to make little of the innumerable prejudices and hesitations. Once the principle of collage was admitted, painters had passed unaware from white to black magic. It was too late to retreat.

be used. And it also pleased him to attach a piece of old newspaper, add to it a few lines of charcoal, and let it be the picture. The extreme, arrogant poverty of materials had always enchanted him. Herein lies the grandeur of Cubism at that time: anything, perishable or not, served these painters to express themselves, and so much the better if it was worthless, if it disgusted the world. Later, people got used to the *papiers collés*, because they saw in them maquettes for paintings to be made, or, as Picasso told me recently, the anatomy plates of a painting. Nothing is more false. The *papier collé* is an end in itself. Picasso regrets that next, all the painters imitated the effect of the *papier collé* with painting. And its attraction is such that one can hardly be surprised.

[6] It would have been desirable that parallel to considerations related to painting, the author of this article could have sketched at least the major historical lines of collage in literature. Certainly the author does not wish to show here the trial of one form of expression, but of expression in general, of its ends. Thus he regrets being limited to painting and reserves the chance to return in a methodical fashion to the problem of collage in literature in the course of a study which will complete the present article, and will permit the vastest generalizations.

* * *

One can imagine a time when the problems of painting, and, for example, those who have made a success of Cézannism, will seem as strange, as old-fashioned as the prosodic torments of poets can seem from now on. One can imagine a time when painters, who have already stopped grinding their own colors, will find it infantile and undignified to stretch their own canvases, when that personal touch, which today endows their work with value, is recognized only in the documentary sense of a manuscript, an autograph. One can imagine a time when painters will not even have others use color for them, will no longer draw. Collage gives us a foretaste of these times. Certainly handwriting is heading for the same distant end. That needs no discussion.

At the time of the Dada movement, and even a little before then, this insight into the future of painting saw light thanks very particularly to two figures still more different from each other than Braque and Picasso: Marcel Duchamp, Francis Picabia. And a personage who passed for an eccentric before disappearing mysteriously— Arthur Cravan, deserter from seventeen nations, now embraced by legend. Then the painting process was taken so far, the negation of painting taken so violently, that the impossibility of painting imposed itself on painters. Perhaps it is unfortunate that the sterilizing (and here this word is apt) influence of Marcel Duchamp did not put an end pure and simple to painting and was used most strictly against Duchamp himself; that's the way he is. However, Duchamp's example, that silence so irritating to those who speak, will have put a whole generation ill at ease, and may have killed by shame many paintings that would have been nicely painted. It still follows that the day after that re-creation of the Beauty that was Cubism, a Beauty so special, so defined that its forefathers, Duchamp, Picabia, who saw this crystallization take place before their own eyes, having reflected on the constant mechanism of taste, on the foundations of taste, cling to a fundamental element of art and notably of painting, in predicting the personality process. The significant steps in this process: Duchamp adorning the Mona Lisa with mustaches and signing it, Cravan signing a urinal, Picabia signing an ink spot and titling it "Holy Virgin," [7] are, for me, the logical consequences of that initial gesture of collage. What is now being sustained is the negation of the technique, on one hand, as in collage, and, added to that, the personality technique; the painter, if it is still necessary to call him that, is no

[7] Editor's note: the Duchamp original was lost and Picabia made a reproduction (without the original goatee) which was published, like the "Holy Virgin," in his review, *391*. It was Duchamp, and not Cravan, who exhibited a urinal at the 1917 Independents exhibition in New York signing it "R. Mutt."

longer bound to his painting by a mysterious physical relationship an-
alogous to generation. And born of these negations is an affirmative
idea which has been called *the personality of choice*. A manufactured
object can be as easily incorporated into a painting as constitute a
painting in itself. An electric light becomes a young girl for Picabia.
We see that these painters really employ objects like words. The new
magicians have re-invented incantation. And when they still paint, all
the feeling of the material is abandoned. It doesn't matter who spreads
the ripolin for Picabia. As for Duchamp, he just invented a system of
playing roulette, and his last painting will be the illustrated plate of
an action edition retained for the exploitation of this system, a plate
which is a collage with the photograph of the author.[8]

Undoubtedly when Picabia spoke of the inkspot he had signed, he
did not fail to attract attention to the *inimitable* quality of such
splashings. He congratulated himself that his ink spot could not be
copied as well as a Renoir. By which means such enterprises are still
presented as an essential criticism of painting's inventions to our day.
The Cubists also hurled themselves at this inimitability, but they
thought they could domesticate it. The monster suddenly pretended to
stay alone in its cage.

* * *

Painting has not always existed, an origin can be assigned it, and
our ears are assailed often enough with its development, with its
crowning periods, so that we can suppose for it not only momentary
declines, but an end, as for any other concept. Absolutely nothing
would be changed in the world if no one painted any more, though
such a view will not pass without alarming the conservative spirit of
art-lovers. Let them be reassured: we haven't the optimism to assert
that the day will come when no one will paint any longer, but what
we can project is that painting, with its ensemble of superstitions, from
subject to matter, from the spirit of decoration to that of illustration,
from composition to taste, etc., will certainly, in a not too distant time,
pass for harmless diversion reserved for young girls and old provincials,
as is true today of versification, and tomorrow will be true of novel-
writing. This is the place to make this prophesy, because it seems that
while writers have already understood that the word literature can now
only be used pejoratively, painters, on the other hand, and those who,
by their works, hasten all the more this transformation of which they
are not at all, or only partially aware, the painters are still in love with
painting, and are apt to return, with some equivocation, to their old
religion. Look at what happened to de Chirico.[9] The museum, the

[8] Editor's note: reference to the 30 "Monte Carlo Bonds" Duchamp made in
1924.

[9] Editor's note: see pp. 70–71, 114, and 208 concerning de Chirico.

spirit of comparison, lies in wait for them. Where this becomes extremely curious and exciting, like the symptom of an illness anticipated on the very day it evolves, is when the painter who has spent his life giving the impression that what he was doing was not painting (and with de Chirico, of whom it was said that he painted like a builder, this attained its summit when, with the Metaphysical Interiors, he virtually imitated the collage effect and even, following a procedure only realized much later, reproduced chromo-reproductions without daring to glue them), when this painter resumes his trade,[10] brings back painting with the little tremblings of degradation that betray his hand. Even today it is obvious that every author of collages, without exception, also paints paintings which are only reproductions of discoveries made with scissors and paste. But this tragedy continues: we will soon see the fifth act.

Following the chain of esthetic reflections through these last twenty years, it is important to grasp the general direction of so-called "Art's" evolution. Nothing can be deduced from a man's attitude, and the contradictions of a Derain, still more than those of a de Chirico, bear no fruit for generalization. What is important in each artist is the discovery he makes beyond the previous discoveries, and in their direction (even if at first glance it seems that nothing is there, that new men and new audacities are lacking to make one understand that this is indeed the same line being followed). It is in this sense that I understand Isidore Ducasse's thought: *"Poetry ought to be made by everyone. Not by one person. Poor Hugo! Poor Racine! Poor Coppée! Poor Corneille! Poor Boileau! Poor Scarron! Tics, tics, and tics,"* and that I ask you to adapt it to painting. Moreover, it is time to understand that the hour has come when all that passed for caprice in Ducasse's *Poésies* must be regarded as the prophetic expression of a revolution of which we are the blind perpetrators. But let us proceed. It suffices to retain from all of this the fact that art has truly ceased

[10] Perhaps it is time to explain the horror I have of Giorgio de Chirico's recent painting. Having expressed it, I have heard it said, by people who have just discovered this painter, that I am incapable of understanding him, incapable of following him (according to a certain Waldemar George), or, more simply, that I must own old de Chirico paintings for whose sake I fear the concurrence of the new; the truth is, however, that I detest the new paintings. De Chirico alone will understand me: just as, for him, *"The fact of serving oneself, for breakfast, fresh figs covered with crushed ice,"* is *"an act so grave that, according to his code, he deserved a ten-to-fifteen-year prison sentence,"* for me, the fact of painting *this* after having painted *that,* deserves, in my penal system, fifteen to twenty years of confinement and the amputation of the right hand. This last punishment would leave to de Chirico the leisure to dictate in his cell an interminably beautiful work like his [1929 novel] *Hebdomeros.* The painter and his writer's genius, as the book gang says, and in fact the genius of the painter today, is marvelously expressed in writing, when he abandons the tricks and delectations of painting and confides himself to intelligence, instead of getting back to his trade.

to be individual, even when the artist is an irreducible individualist, since we can neglect individuals and follow, across moments of their thoughts, a vast reasoning which borrows men's interpretations only ephemerally, and if out of this sentence I am writing, there rings in the ears of journalists only this fragmentary proposition: *art has truly ceased to be individual,* far be it from me to complain.

Thus it is that discoveries do not belong only to their discoverers, that there is no room to insist, as painters often demand of the historian, upon an exaggerated account of questions of priority, and that although I am assured that collage was occasionally employed in Germany, in Switzerland, from 1915 (says one), 1914 (outbids the other), I am not interested in tentatives without tomorrows—these concern only the encyclopedias.[11] One can even play at seeking out collage's secular ancestors: more than one would be found among the curios of impostors, caricaturists and forgers. The modern collage does not require our attention on account of this parentage, which is not much of anything. It requires our attention for what it has devised that is absolutely opposable to painting, beyond painting; for what it represents of human possibility; for its replacement of a debased art with a mode of expression unknown in force and range; for its reinstatement of the true direction to an old pictorial course which keeps the painter from surrendering to narcissism, to art for art's sake, by leading him toward the magic practices which are the origin and justification of plastic representation, forbidden by several religions. There will be no shortage of monomaniacs—painters or aesthetes—to attribute to me who knows what black designs against painting and painters. They will have misunderstood me. Besides, I can hardly be responsible for the evolution of an art which one would seek in vain to corrupt, and is it not clear (I think I can pose the problem this way) that these considerations tend to open to painters a loftier destiny than that career of petty entertainment to which routine, and salesmen, seek to confine it? Certainly the course of the society in which we live leads painters progressively toward that stage of slavery, of prostitution, to which the Venetian artists of the 16th century were reduced. Today the patrons rarely have their portraits painted, nor do they retrace their military exploits in kilometric compositions, but they do insist that the paintings with which they enliven their walls match their furniture. The style of the Café du Dome or of bourgeois apartments can only be complemented by a Brancusi or a Miró. This is strange, unjust, but impossible to deny. Painting turns to comfort, flatters the

[11] I prefer to note that in 1916, in Nantes, Jacques Vaché made collages with bits of cloth on postcards, in editions of twelve, that he sold for two francs apiece, and which represented scenes of military life of the times, with very elegant persons, very *Vie Parisienne* women. I would be grateful if those who possess these would make themselves known.

tasteful man who has bought it. It is a luxury. Painting is jewelry. Now
it is possible for painters to free themselves from this domestication by
money. Collage is poor. For a long time still, its value will be denied.
It masquerades as gratuitously reproducible. Everyone thinks he could
do as much. And if the painters are capable of voluntarily perpetuating
and aggravating this discredit, perhaps they will arrive at making
what is stupidly called the expression of reality, and their works will
be worth nothing any more, absolutely nothing any more for those
who thought they had the right to adorn their walls with human
thought, with living thought, reviving those slave decorations which
one hardly sees these days, except at the Folies-Bergère, representing
a supper at Païva's.

Yes, painters mechanically repeat the gestures of magic ceremonies,
the reason for which is forgotten, without attributing to them the
slightest significance. They are interested only in ceremonial beauty.
There is no great mental difference between Braque and Soutine and
an English Pre-Raphaelite. And as they resign themselves so easily
to the fact that their paintings will finally adorn the Primavera
Studios, the House of Citroën, and the abysses of American stupidity,
there is no longer any distinction to be made between modern painters
and those of the worst periods, from Veronese to Gandhara. Every-
thing proceeds as though a great secret had been lost. Isn't that what
André Derain meant lately when he told André Breton that story of
the white point? [12] He himself, like de Chirico, to whom at one time
and in many regards he can be compared, sought through magic that
secret he sensed nearby. Perhaps he put it in the hands of the
Chevalier X,[13] now in Moscow, which is so un-alive, so unreal, that
one can only insist that it represents a human being holding a real
newspaper, folded and glued so that we are still more aware what a
mannequin he is? This collage, one of the first I know, seems to respond
to a preoccupation diametrically opposed to that of the Cubists, and
undoubtedly it should be compared to those wax voodoo dolls one
sticks with pins. It was not given to André Derain to know more.

[12] "Derain speaks with emotion of that *white point* with which certain Flemish
and Dutch 17th-century painters highlighted a vase, a fruit. The point, always
mysteriously and admirably placed, could not have been actually seen by them.
In fact, it bears no relation to the color of the object or the lighting, and nothing
justifies its presence compositionally. (We know that the artists in question fre-
quented alchemical laboratories.) This observation is capital. If a candle is lit in
the night and removed from my eye until I can no longer distinguish its flame,
the form of this flame and the distance separating it from me will escape me. It
is nothing but a white point. The object that I paint, the being before me, is
visible only when I make this white point appear on it. Everything rests on
placing the candle accurately." (André Breton, *Les Pas Perdus:* "Idées d'un
peintre.")
[13] Editor's note: *Chevalier X* is the title of a collage painting by Derain in which
a painted man holds a real newspaper.

He turned to painting nice little ladies, like Fabiano, a little better. Is there really for each man a moment when everything vacillates, when even the most harshly self-critical, the most penetrating, the most clairvoyant person, like the most limited, confused, or futile one, suddenly loses sight of the two or three truths that guide him, and changes into a flute player nursing his trills? Too bad, what will count is what preceded that moment.

<p style="text-align:center">* * *</p>

Words expressing evil are destined to assume useful meanings. Ideas improve. The sense of words participates in this.

Plagiarism is necessary. Progress implies it. It bears down on an author's sentences, uses his expressions, erases a false idea, replaces it with an accurate one.

A maxim, if well made, demands no correction. It demands development.

For me these phrases of Isidore Ducasse contain all expressive morality. For everyone, the moral of collage.

When and where did collage appear? I believe, despite the tentatives of several early Dadaists, that homage must be paid to Max Ernst, at least for the two forms of collage most removed from the principle of the *papier collé*—the photographic collage and the illustration collage. At first, this discovery had a tendency to be generalized, and the German Dada publications, notably, contained collages signed by at least ten authors. But this procedural success arose more from amazement at the *system* than from the necessity to express something at all costs. Very soon the use of collage was limited to a few men, and it is certain that the whole atmosphere of collage at that time was found in the mind of Max Ernst and Max Ernst alone. The rest of the German Dadas were divided by grave problems. We know that social preoccupations put an end to their union, at the time of the 1918 Revolution, and to their activity, during the revolutionary failure and inflation. At the time, several of them thought they could resolve the problem of the usefulness of art by the adaptation of artistic means to propagandistic ends. Thus the collage gave birth to those photomontages, as they are called in Russia and Central Europe, particularly used by the Constructivists. It is not for me to neglect a phenomenon which *pure* painters disdain, but which marks one of the oscillations of the painting of our time, and which is above all a symptom of the necessity to be significant, characteristic of the forms in evolution of thought at this stage of human reflection.

Max Ernst's collage exhibition in Paris in 1920[14] was perhaps the first

[14] Editor's note: this exhibition of collages, at the Galerie Sans Pareil, was actually held in May, 1921, not in 1920.

manifestation to permit the perception of the resources and the thousands of possibilities in an entirely new art, here in this city where Picasso never could exhibit the constructions in wire, cardboard, bits of cloth, etc. that he has always made without interesting anyone, pursuing, in a manner deserving examination, the idea first expressed in the *papier collé*. One must make an inventory of the processes Max Ernst used then in order to understand where the collage stood at that point. Ernst employed: photographic elements glued onto a drawing or painting; drawn or painted elements superimposed on photographs; images cut out and incorporated in a painting or another image; photographs, pure and simple, of an arrangement of objects made incomprehensible by photography.[15] That does not suffice to characterize these collages: we still must take into account the fact that the borrowed elements serve in different manners, depending upon whether they represent what they already depicted, or whether, by a sort of absolutely new metaphor, they represent something absolutely different. Thus those strange flowers formed by wheels, those complex anatomical scaffoldings were born. Thus an embroidery pattern here advantageously represents the turf of a race course, and elsewhere, hats constitute a caravan. Where Max Ernst's thought must be seized is at that place where, with a little color, a pencil line, he tries to acclimate the phantom that he has just precipitated into a foreign landscape, or at that point where he puts in the hand of a new arrival an object that the other cannot touch. It is also very necessary to take into account certain collages where painting outweighs what has been given to it, where everything is repainted, where the décor may be entirely painted. It is probably not by chance that I use the language of the Theatre:

[15] Don't forget the written element. The title, carried for the first time beyond description by de Chirico, becoming with Picabia the distant term of a metaphor, took on with Max Ernst the proportions of a poem. *The proportions* are used literally: from the word to the paragraph. No one ever made his paintings say more than Max Ernst, *but this is no longer painting*. Without doubt this is really the most disconcerting thing that can be done, to make a painting which then ceases to be one. I will cite some examples of title-poems. The first two are read with the collage and are visible, on its surface, or in the margin. The third is written on the back: it is not seen with the collage. I don't note this difference merely for love of detail. I think it must be related to the considerations Ernst expresses:

...*The dog that shits the well-coiffed dog despite rough terrain caused by an abundant snow the woman with the beautiful throat song of the flesh/*
... *It is already the twenty-second time that Lohengrin has abandoned his fiancée for the first time/ there where the earth has stretched its rind over four violins/ we will never see each other again/ we will never fight the angels/ the swan is very peaceful/ he rows with all his might to reach Leda/*
... *The transfiguration of the chameleon on Mount Tabor happens in an elegant limousine while angels and canaries flee from the houses of man and the very holy garb of our Lord exclaims De Profundis three times before whipping the flesh of exhibitionists/*

the actors play a role in a scene where the props for several possibilities are planted. I have often thought that an immense and marvelous drama resulted from the arbitrary succession of all these pictures, as the juxtaposition of the early de Chiricos must result in a city for which the plan could be drawn. Did not Max Ernst, when he published *La Femme 100 Têtes* at the end of 1929, embody this thought, which came to me at the Sans Pareil exhibition? Here the painter borrows a personage from an old illustration, just as the playwright uses a flesh and blood actor whom he has not had to create from scratch. But the drama lies in that conflict of disparate elements when they are reunited in a real frame where their own reality is displaced. This has been drawn to resemble a man, but that—an unmalicious landscape—does not tolerate the violence being done to it, does not tolerate being haunted by that man. It is characteristic to note that Max Ernst, since 1918–20, has made nothing but *pure* collages, if one can put it that way, for Eluard's poems, for *Les Malheurs des Immortels;* and that *La Femme 100 Têtes* is, finally, owed to only one technique, in which nothing is drawn by the author [see Ernst, pp. 118–40].

All those painters who can be called Surrealist, and this too is significant, have used collage at least in passing. If some of their collages are closer to the *papier collé* than to the collage we meet with Max Ernst, because they are hardly more than a modification of the paintbox, nevertheless, for most of them, the collage plays an important role, and one sees it appear at a decisive moment of the evolution it stakes out. Arp, who, under the title *Fatagaga,* made collages in collaboration with Max Ernst, closer to the spirit of the latter, sought to glue papers at random, then used cut-out papers. There is a similarity between his collages and his paintings, because of the simplified character of the latter, which owes nothing to the impasto, the trembling hand which replaces personality for many painters. Arp has his reliefs executed by a carpenter, it is pure concession if he colors them himself, and when they are bought, they can be repainted without bothering the author. These pictorial customs are new, and it is pure idiocy to be astonished by them. From now on, why use pigments? A pair of scissors and some paper—there's the only palette that doesn't lead back to the school bench. This is the way Man Ray[16] made *Revolving Doors,* a whole book of cut-out colored papers. Cut-out paper enters almost all of Yves Tanguy's paintings around 1926, either for its color or to depict actual collages of objects, though always anecdotal in the painting. Malkine employed pasted papers and object collages. André Masson used sand and

[16] One must include with collages the cameraless photographic process invented by Man Ray (*Rayographs*), the results of which are unpredictable. This is a philosophic operation of the same character, beyond painting, and with no real relationship to photography.

feathers to produce an effect recalling ancient Peruvian textiles. Magritte has used pasted papers, and, very recently, illustration collage.[17] And a place apart must be reserved for Francis Picabia's collages.

We know that painting vanished so far into his hands that around 1920 the painter contented himself with setting between the framing edges a few threads, which soon seemed to him an exaggerated luxury. The taste for the ephemeral, so contrary to that painters' instinct which makes them brood ignobly over their own products, was so strong in Picabia that he made a picture with chalk on a blackboard expressly *so that* it could be publicly erased. One might have thought that once Dada had passed like a storm, Picabia would return to better sentiments, on the strength of several canvases painted in ripolin, which looked like oils. But to think this was to know him ill, to be absolutely unacquainted with that extraordinary taste for derision that is his. One then saw Picabia, like a scholar monkey in that circus of false painting, set up objects particularly unsuitable for the Louvre, objects which will, nevertheless, invade the Louvre, for everything is predestined, except for the laugh that Picabia sometimes utters. These objects were made of Pipoz straws and their paper sleeves, toothpicks, diaper pins. From bunches of flowers to landscapes—nothing was spared.

Around the same time, it happened that Picasso did a very grave thing. He took a dirty shirt and attached it to a canvas with needle and thread. And since with him everything turns into a guitar, this became a guitar by example. He made a collage with nails projecting from the painting. He had a crisis, two years ago, a real collage crisis: I heard him complain then, because all the people who came to visit him and saw him bring alive old bits of net and cardboard, threads and corrugated iron, rags gathered from the rubbish, thought to do him a favor and brought him remnants of magnificent materials *to make into paintings*. He didn't want them, he wanted the real offal of human life, something poor, dirty, despised.

A funny man, Miró. Many things in his paintings recall what is not painted; he makes paintings on colored canvas, painting there only a white patch, as though he had not painted in that spot, as though the canvas were the painting. He deliberately draws the lines of the stretcher on the painting, as though the stretcher were crooked on the canvas. Last year, he happened, quite naturally, to make nothing but collages, which are closer to Picasso's collages and to Miró's paintings than to anything else. The paper is generally not wholly glued; its edges are free, it waves and flutters. Asphalt was one of Miró's favorite

[17] Is there a connection between the collage and the use of writing in painting as Magritte practices it? I see no way to deny it.

elements in 1929. It is difficult to say whether Miró's collages imitate his painting or whether his paintings imitated in advance the effects of collage, as Miró gradually came to practice it. I am inclined toward the last interpretation.

Salvador Dali's use of collage probably best defies interpretation. He paints with a magnifying glass; he knows how to imitate a chromo-reproduction to the point where the effect is infallible: the parts of the glued chromos pass for painted, while the painted parts pass for glued. Is he trying thus to perplex the eye, and does he rejoice over errors provoked? One can conceive of it, but without finding any explanation for this double game, which can not be attributed to the painter's despair before the inimitable, nor to his laziness before the all-expressed. It is also certain that the incoherent aspect of a Dali painting, in its ensemble, recalls the particular incoherence of collage. I attempted above to reduce Max Ernst's collages to plastic poems. If, with a psychological end in mind, one wanted to sketch a similar manoeuver in regard to Dali's paintings, it would be necessary to claim that each one was a novel. There too Dali is associated with that anti-pictorial spirit which not long ago made painters, then critics, cry out, and which, today, invades painting. This is what there is to retain from this suite of facts to which we are witness and which might seem chaotic to those who do not see the essential connection. . . .

* * *

The marvelous must be made by all, and not by one alone. This transcription of the Ducassian thought explains and determines what was just said at such length.

André Breton

Breton's judgements of Surrealist plastic art were not always the most perceptive, since his writings were so often colored by current enmities among the group, and by dominant literary preoccupations. He did, however, make some effective "poem-objects" of his own, beginning in 1935, when the various types of three-dimensional fantasies listed in his text below became a Surrealist trademark; in 1924 he had already projected the idea of executing in three dimensions the hybrid images seen in dreams. The idea of a *concrete* irrationality was typical of the 1930s, when so much Surrealist painting, that of the originally more abstract members as well as of newcomers, was concerned with making visions tangible. For instance, Dali's films, objects, and ultra-realistically rendered dream scenes are the clearest *illustrations* of Surrealist theory, whereas in the 1920s the work of Ernst, Arp, Masson and Miró were more typical in their inclination to a freer abstract expression.

"Crisis of the Object" was first published in a special issue of *Cahiers d'Art*, May, 1936, on the occasion of the "Exposition Surréaliste d'objets" at the Charles Ratton Gallery, Paris, May 22–29, 1936. This show had been preceded in 1933 by another object exhibition at the Galerie Pierre Colle, which offered, among other things, "disagreeable objects, sexes, phobias, interuterine memories, taciturn conflicts, sausages, hammers, palaces, fried eggs, failed portraits, breads, photos, tongues . . ." The essay was later included in a revision of Breton's book *Surrealism and Painting* (New York, Paris, 1945) [new augmented edition, Paris: Gallimard, 1966].

Crisis of the Object

We regret not yet having at our disposal a volume of comparative history which would avail us of the parallel development, during the last century, of scientific ideas on the one hand, poetic and artistic ideas on the other. As a guide, I will take two dates, most significant ones for literature: 1830, which has been fixed as the apogée of the

"Crisis of the Object" by André Breton. Translated by the editor from "Crise de l'objet," Cahiers d'Art 2, nos. *1–2 (1936): 21–22, 24, 26. Also published in* Le Surréalisme et la Peinture *(Paris: Editions Gallimard, 1965). Copyright © 1965 by Editions Gallimard. Courtesy of Editions Gallimard.*

romantic movement; 1870, the point of departure, with Isidore Ducasse and Arthur Rimbaud, for the *nouveaux frissons* [new shudders] that were to be felt more and more strongly up to the present. It is particularly interesting to observe that the first of these dates coincides with the discovery of non-Euclidian geometry, which shakes the very foundations of the Cartesian-Kantian edifice and, as has been said, opens up rationalism. This "overture" to rationalism seems to correspond closely to the earlier overture to realism under the pressure of ideas properly called romantic: need for the fusion of the mind and world of the senses, call to the marvelous. Similarly, one can not help but be struck by the fact that it was in 1870 that mathematicians conceived of a "generalized geometry" which integrates Euclidian geometry into a uniform system like any other and does justice to its transitory negation. A *surmounted contradiction* is involved here, like those which Ducasse or Rimbaud, in another realm, then took as a springboard intended to provoke a total overthrow of sensibility: the route of all rational habits, eclipse of good and evil, distinct reservation about the cogito, discovery of the daily marvelous. The split between the geometric personality and the poetic personality is simultaneously effected. The pressing need to "deconcretize" the various geometries so as to free the researcher into all directions and permit the ulterior coordination of the results obtained, is rigorously superimposed on the need in art to break down the barriers separating the *déjà vu* from the visible, the commonly proved from the provable, etc. In this regard, modern scientific and artistic thought present the same structure: the real has been too long confused with the given, for one like the other spreads out in all directions of the possible and tends to become one with it. Applying the Hegelian adage: "Everything real is rational and everything rational is real," one can expect the rational to merge at all points with the course of the real, and, in fact, today's reason proposes nothing so much as the continuous assimilation of the irrational, during which assimilation the rational is constantly called upon to re-organize itself so as to be both strengthened and augmented. In this sense it must be conceded that *Surrealism* is necessarily accompanied by *surrationalism,* which doubles and measures it. M. Gaston Bachelard's recent introduction into the scientific vocabulary of the word *surrationalism,* which aspires to account for a whole method of thinking, lends additional actuality and vigor to the word "surrealism," the acceptance of which had remained strictly artistic until now. Once again one of the two terms verifies the other: this demonstrates sufficiently the common fundamental spirit animating man's investigations in our time, whether they are those of a poet or a scholar.

From either point of view, the development is the same—an idea breaking with a 1000-year tradition, an idea that is no longer reductive but infinitely inductive and extensive, the object of which, instead

Paul Eluard

Paul Eluard (1895–1952) met Breton in 1918 and, as one of the original group associated with the review *Littérature*, was a major figure in both Dada and Surrealism for the following twenty years. He was very close to the painters in the movements, especially Picasso and Max Ernst, perhaps due in part to the translucent and very visual imagery of his poems. In 1912–13 Eluard himself had made a series of curiously proto-Surrealist drawings, and later he assembled an important collection of Surrealist art.

Eluard met both Man Ray and Max Ernst in 1921, the latter in Cologne, where he chose collages to illustrate a book of his poetry; a year later they published another book in which the poems "illustrated" the collages, and Ernst accompanied the poet to the Far East in 1924. When Miró and Ernst were condemned by Breton for designing sets for the Ballets Russes in 1926, Eluard took their part and defended them in *La Révolution Surréaliste,* saying "the purest spirits remain with us." In turn, it was on Eluard's behalf that Ernst left the Surrealist movement in 1938, when the poet broke with Breton over the former's pro-Stalinism. The Man Ray text below made up the preface to a book of his drawings and Eluard's poems, *Les Mains Libres* (Paris: Jeanne Bucher, 1937). The Miró text was first published in *Cahiers d'Art* 12, no. 1 (1937); all three appeared under *"Peintres"* in *Donner à Voir,* (Paris: Gallimard, 1939).

Food for Vision

BEYOND PAINTING

Around 1919, when the imagination sought to rule and subdue the dismal monsters strengthened by war, Max Ernst resolved to bury old Reason, which had caused so many discords and disasters, not under its own ruins—from which it makes monuments—but under the free representation of a freed universe.

It is not far—as the crow flies—from cloud to man; it is not far—

Food for Vision: *"Beyond Painting," "Hands Free,"* and *"Miró's Beginnings"* by *Paul Eluard. Translated by the editor from* Donner à Voir *(Paris: Editions Gallimard, 1939). Courtesy Editions Gallimard.*

from, and succeed in differing from the objects which surround us, by simple *change of role.* Still, nothing is less arbitrary if we bear in mind that it is only the very special act of taking this role into consideration which permits the resolution of Renouvier's "dilemma of substance": passage from substantive to substance through the medium of a third term, "specialized substantive."

It would be falling back into the trap of rationalism to claim to compare mathematical objects—catalogued by their constructors in the sterile standard terms: *Allure of elliptical function P^1 (U) for $G^2 = O$ and $G^3 = 4$*—with poetic objects, which answer to more attractive designations. Let us observe, in passing, that the philosophy which gave life to poetic objects moved with a steady rush from abstract to concrete when one part of contemporary art (abstraction) persisted in taking the opposite direction and—by the publication of similar documents—put itself in the position of seeing its realizations decisively outclassed.

jects which assume their places within the framework of the surrealist exhibition of May 1936 [1] are, above all, likely to *lift the prohibition* resulting from the overpowering repetition of those objects which meet our glance daily and persuade us to reject as illusion everything that might exist beyond them. It is important to strengthen at all costs the defences which can resist the invasion of the feeling world by things men use more out of habit than necessity. Here as elsewhere, the mad beast of *custom* must be hunted down. These means are at hand; common sense can only create the world of concrete objects on which its odious supremacy is based, although undermined and badly guarded on all sides. Poets and artists meet with scholars at the heart of those "fields of force" created in the imagination by the reconciliation of two different images. This ability to reconcile two images permits them to surpass the usually limiting consideration of the object's known life. In their eyes, the object, no matter how complete, returns to an uninterrupted succession of *latencies* which are not peculiar to it and which invoke its transformation. For them the conventional value of this object disappears behind its representational value, which leads them to emphasize its picturesque side, its evocative power. "What," writes M. Bachelard, "is belief in reality, what is the idea of reality, which is the primordial metaphysical function of the real? It is essentially the conviction that an entity exceeds its immediate known quantity, or, to put it more clearly, it is the conviction that *there is more to be found in the hidden real than in the immediate known quantity.*" Such an affirmation is sufficient to justify strikingly the surrealist course leading to the instigation of a *total revolution of the object:* acting to divert the object from its ends by coupling it to a new name and by signing it, which entails requalification by choice (Marcel Duchamp's "ready-mades"); by showing it in the condition in which external agents such as earthquakes, fire and water have sometimes left it; by retaining it because of the very uncertainty of its previous assignment or the ambiguity resulting from its totally or partially irrational conditioning, which gains dignity by discovery (found object) and leaves an appreciable margin in the case of the most active kind of interpretation (Max Ernst's interpreted found object); and finally, by reconstructing it from all the fragments, starting with dispersed elements captured from the immediate known quantity (surrealist object, properly speaking). Perturbation and deformation are in demand here for their own sakes, though it is acknowledged that only constant and lively readjustment of the *law* can be expected of them.

Objects thus reassembled have in common the fact that they derive

[1] Mathematical objects, natural objects, primitive objects, found objects, irrational objects, ready-made objects, interpreted objects, incorporated objects, mobile objects [photographic reproductions in *Cahiers d'Art,* May 1936].

of being set on this side for once and for all, is re-created until it is lost beyond view. In the last analysis this idea could not find a surer generatrix than the anxiety inherent in a time when human brotherhood is more and more lacking, while the best organized systems—social systems included—seem frozen in the hands of their directors. This idea is absolved from all connection with everything previously considered definitive, smitten with its own movement.

This idea is essentially characterized by the fact that it incorporates an unprecedented *will to objectification*. Let us understand, in effect, that mathematical "objects" just like poetic "objects," refer to something quite other than their plastic qualities in the eyes of those who constructed them; and even if they happen to satisfy certain esthetic exigencies, it would be no less of an error to try and appreciate them in that context. For example, in 1924, when I proposed the fabrication and circulation of objects appearing in dreams, I envisaged the accession of those objects into concrete existence as more of a means than an end, despite the unusual aspect they might assume. Certainly I was prepared to expect from the multiplication of such objects a depreciation of those whose *convenient utility* (although often questionable) encumbers the supposedly real world; this depreciation particularly seemed to me very apt to release the *powers of invention* which, in terms of all we know about dreams, are magnified when in contact with objects of oneiric origin, truly tangible desires. But aside from the creation of such objects, the goal I pursued was no less than the objectification of the activity of dreaming, its passage into reality. An analogous will to objectification, this time concerning the unconscious activity of sleep, came to light through the "objects of symbolic function" defined in 1931 by Salvador Dali, and, in a general manner, through all those objects arising from these two connected categories.

All the pathos of intellectual life today is contained in this will to objectification which knows no truce and which would renounce itself by lingering over the value of its past conquests. Reason cannot cling long to acquisition and thus neglect the contradiction which is always prepared to supply it with experience. The pursuit of experience is important above all: reason will always follow, its phosphorescent blindfold over its eyes.

Just as contemporary physics tends to be based on non-Euclidian systems, the creation of "surrealist objects" responds to the necessity of establishing, in Paul Eluard's decisive phrase, a veritable "physics of poetry." Likewise, there will now be found, side by side on the tables of the mathematical institutes of the world, objects—some constructed on Euclidian ideas, others not; but both equally confusing to the layman—that maintain to no lesser degree the most passionate and equivocal relationships in space, as we generally conceive it. The ob-

by images—from man to what he *sees*, from the nature of real things
to the nature of imagined things. They are of equal value. Matter,
movement, need, desire are inseparable. The honour of living is well
worth some exertion to give life. Think of yourself as flower, fruit,
and heart of a tree, since they wear your colours, since they are one
of the necessary signs of your presence. Only when you have ceased
to ascribe ideas to it will you be granted the belief that everything
is transmutable into everything.

A truly materialist interpretation of the world cannot exclude from
that world the person who verifies it. Death itself concerns him, the
living person, the living world.

I do not know if a poet has ever been more deeply affected by these
fundamental truths than Max Ernst. And this is a prime reason to
regard and admire this painter as a very important poet. In his collages,
frottages and paintings he ceaselessly exercises the will to confuse
forms, events, colours, sensations, sentiments—the trifling and the
grave, transitory and permanent, old and new, contemplation and ac-
tion, men and objects, time and duration, element and entirety, nights,
dreams and light.

Max Ernst has mingled with and identified himself with his work.
By carrying his insight beyond this unfeeling reality to which we are
expected to resign ourselves, he ushers us as a matter of course into a
world where we consent to everything, *where nothing is incompre-
hensible.*

Hands Free

Basket, white night. And the deserted beaches of a dreamer's eyes.
The heart trembles.

Man Ray's drawings: always desire, not necessity. Not a wisp of
down, not a cloud, but wings, teeth, claws.

There are as many marvels in a glass of wine as at the bottom of
the sea. There are more marvels in an eager hand held out than in
all that separates us from what we love. Let us not perfect or em-
bellish what is opposed to us.

A mouth around which the earth turns.[1]

Man Ray paints in order to be loved.

Miró's Beginnings

When the bird of day just freshly flying came to nest in the colour
tree, Miró tasted the pure air, the fields, milk, herds, simple eyes and
tenderness of the glorious breast gathering the mouth's cherry. No

[1] Editor's note: reference to Man Ray's painting *L'observatoire.*

windfall was ever better to him than an orange and mauve road, yellow houses, pink trees, the earth, on this side of a sky of grapes and olives which will breach four walls and boredom for a long time.[2]

When I first met one of the two women I have known best—have I known any others?—she had just fallen in love with a painting by Miró, *The Spanish Dancer*.[3] A more naked picture cannot be imagined: on the virgin canvas, a hat pin and a wing feather.

First morning, last morning, the world begins. Shall I isolate, obscure myself in order to reproduce more faithfully quivering life? Words that I would like outside cling to me at the heart of this innocent world which speaks to me, sees me, listens to me, and whose most transparent metamorphoses Miró has always reflected.

[2] Editor's note: reference to Miró's early, Spanish paintings.
[3] Editor's note: *Portrait of a Dancer*, 1929, whereabouts unknown.

Artists

Jean Arp

Jean (Hans) Arp (1887–1966) was brought up in Alsace and arrived in Zurich in 1915, in time to become a founder of the Dada movement there. He spent the early 20s in Germany, Switzerland and France, settling in Paris in 1925. Everyone's friend, yet esthetically very much unlike most of his colleagues, Arp was a charter member of the Surrealist movement, although in the 20s he also participated in the abstract-concrete art movement (*Abstraction-Création; Cercle et Carré*)—a feat, since the aims of the two groups seemed diametrically opposed.

Arp continued to be associated with the Surrealists as well as the abstractionists and maintained a combination of abstract purity and witty innocence strongly rooted in fantasy throughout his life. At the heart of all his work lay a fusion (and at times a deliberate confusion) of natural and artificial elements, an anthropomorphicizing or metamorphosis of inanimate objects. While Arp's contribution to the plastic arts cannot be called literary in any sense, he himself emphasized the unity of his poetry and sculpture, especially during the Surrealist period. In the poem below, besides the obvious connection between the "stones" and sculpture, images of cloud, mouth, leaf, and root evoke Arp's contemporary sculptures, such as *Bell and Navels* (1931) or *To Be Lost in the Woods* (1932), and especially the slightly later *Concretions.* When this poem was first published, it was interwoven with four line drawings.

The Air Is a Root

The air is a root.
The stones are filled with tenderness. bravo.
bravo. the stones are filled with air.

"The Air Is a Root" by Jean Arp. Translated by the editor from "L'Air est une racine," Le Surréalisme au service de la Révolution, no. 6 (May 1933), p. 33. Courtesy of Mme. Marguerite Arp.

the stones are watery branches.
on the stone replacing the mouth
　grows the skeleton of a leaf. bravo.
A stone voice face to face and foot to foot
　with a stone glance.
the stones are tormented like flesh.
the stones are clouds for their second
　nature dances to them on their third nose.
　bravo. bravo.
when the stones scratch themselves, nails grow
　on the roots. bravo. bravo.
the stones awoke to eat the exact
　hour.

Arp first met Max Ernst in 1914 at the Werkbundaustellung in Cologne, and they became fast friends. It was Arp, from Zurich, who acquainted Ernst with the arrival of Dada, and in 1919–20 the two of them collaborated, in Cologne, on a photo-collage series dubbed *Fatagaga* (FAbrication de TAbleaux GArantis GAzométriques). In 1925, when Ernst "discovered" the *frottage* medium (see p. 208), both he and Arp were living in Paris. In 1926 Jeanne Bucher published a portfolio of Ernst's frottage drawings under the title *Natural History*, a reference to the forests, moons, suns, animals, flowers, shells, and plants that were the basis of Ernst's mature work. Not only the long friendship, but the mood and subject matter of this portfolio, made Arp the natural author of its introduction, in which he incorporates images from the drawings and their titles into the text. Since 1926, *Natural History* has been republished in various formats: by Jean Jacques Pauvert, Paris, 1960, and by the Galerie der Spiegel, Cologne, 1964, and in Max Ernst's *Beyond Painting* (New York: Wittenborn, 1948).

Introduction to Max Ernst's Natural History

　this introduction contains the pseudo-introduction the original the variants of the original the pseudo-original as well as the variants of the pseudo-original the apocrypha and the incorporation of all these

"Introduction to Max Ernst's Natural History" by Jean Arp. Anonymous translation from Jean Arp, On My Way *(New York: George Wittenborn, Inc., 1948), pp. 38–39. Courtesy of Mme. Marguerite Arp and George Wittenborn, Inc.*

texts in an original arpocryphum with apocopated whiskers as well as fifty calcinated medals and fifty suns of fifty years because the medal rises.—the medal of light rises.—fifty suns and fifty medals rise.—the wheels turn.—the wheels turn.—fifty suns and fifty medals rise while the pseudo-sun after fifty years of service retires into the calcinated wheels of light.—the wheels turn no more.—the wheels turn no more.

it is man who has replaced alarm-clocks by earthquakes showers of jordan almonds by showers of hail. the shadow of man encountering the shadow of a fly causes a flood. thus it is man who has taught horses to embrace one another like presidents kings or emperors sucking each other's beards licking each other's snouts plunging their tongues into patriotic profundities. the passerby who sees these equine kisses thinks that peace has been established on earth forever.

with his eleven and a half tails of cotton his eight legs of bread his hundred eyes of air his four hearts of stone he goes a-hunting the flying cyclopean moustache without any limbs. but as this moustache is actually intelligible the hunter always comes home baffled. with the help of his eleven and a half tails man counts ten and a half objects in the furnished room of the universe: scarecrows with volcanoes and geysers in their buttonhole show cases of eruptions displays of lava string systems of solar currency labeled abdomens walls razed by poets the palettes of the caesars thoroughly still (and dead) lives the stables of the sphynxes the eyes of the man turned to stone while squinting at sodom the scars of . . .

enter the continents without knocking but with a muzzle of filigree leaves never grow on the trees. like a mountain in bird's-eye view they have no perspective no soap no hybrid plastron no scotch cheeks no crypt. the spectator always finds himself in a false position before a leaf. he has the impression of carrying his head in his umbilicus his feet in his mouth his unwashed eyes in his hands. as for the branches trunks and roots I declare them to be fantasmagorias bald men's lies. branches trunks and roots do not exist.

like a lion who scents a succulent pair of newly-weds the seismic plant desires to make a meal of the dead man. in his millennial den made up as a foetus it whirls with lust like the white juice of the end with the black juice of the start and the ferocity of its gaze chases the navels around the earth. the limetree grows tractably on boarded plains. the chestnut and the oak start out under the banner of d.a.d.a. that is to say, domine anno domine anno. the cypress is not a dancer's calf in the ecclesiastical ballet.

while the ferocious lion scents a succulent pair of newly-weds the lime-tree grows tractably on the boarded plains. when a traveler and a mountain meet in the sky they become confounded with one another. the mountain takes itself for the traveler and the traveler takes himself for the mountain. these encounters always end in a bloody brawl in

which the traveler and the mountain tear out each other's trees. the chestnut and the oak start out under the sign of the vegetable banner. the cypress is a dancer's calf in an ecclesiastical ballet.

the idol dreams in the sea and the rain. harnessed in fours ahead of the four preceding like ventriloquists' cemeteries or fields of honor the insects emerge.

and now only eve remains to us. she is the white accomplice of newspaper filchers. here is the cuckoo the origin of the clock. the sound of his jaws is like the sound of a violent fall of hair. and so we count among the insects vaccinated bread the chorus of cells lightning flashes under fourteen years of age and your humble servant.

the marine sky has been decorated by expressionist paperhangers who have hung a shawl with frost-flowers on the zenith. in the season of the harvest of conjugal diamonds huge cupboards with mirrors are found floating on their back in the oceans. the mirrors of these cupboards are replaced by waxed floors and the cupboard itself by a castle in spain. these mirrored cupboards are rented as rings to midwives and storks to make their innumerable rounds in and as tabourets to two gigantic rusty feet which rest upon them and sometimes tap a few steps *pam pam*. that is why the seas are called pampas because pam means *pas* (step) and two *pas* make *pam pam*.

and so you see that one's honorable father can be consumed only slice by slice. impossible to finish him in a single luncheon on the grass and even the lemon falls on its knees before the beauty of nature.

Hans Bellmer

Hans Bellmer, a German born in Poland in 1902, first visited Paris in 1936 and settled there in 1938. He began to manipulate and photograph his dummies, or "dolls," in Berlin in the early 30s, originally inspired by Olympia, the artificial daughter of Coppelius in *The Tales of Hoffman*, as directed by Max Reinhardt. The spherical joints with which he "explored the physical consciousness" were seen in sixteenth-century dolls at the Kaiser Friedrich Museum.

Bellmer's nymphet (resembling his wife, who died in 1938) was constructed of wood, metal, and papier mâché; its ball-joints, referred to in the text below, allowed the body parts to be assembled and re-assembled in varied postures. Combined with additional objects or materials (the roses, lace, hair, and glass eye mentioned in the text), they were photographed in theatrical pantomimes; these were reproduced in *Minotaure,* no. 6, December, 1934, where they were much admired by the Surrealists. The same year Bellmer privately published in Berlin a book of photographs which the text below introduced. In 1936, GLM published Robert Valençay's French translation, from which the following has been rendered; it was also reprinted in *Cahiers GLM*, no. 1, 1936, pp. 20–24.

Bellmer joined the Surrealists at the height of their obsession with the found and the irrational object. *The Doll*, with its strong erotic, fetishistic, even sado-masochistic overtones, as well as the frank textual account of the artist's "abnormal" sexual preoccupations, were guaranteed to attract the French group. The fantastic juxtaposition of pubescent limbs has been Bellmer's major theme ever since, and in 1965 one of the original mannequins was cast in aluminum and offered in a small edition.

Birth of the Doll

Perhaps a more authentic anguish adheres to forbidden photography. Why not do it? But finally this new zeal is accompanied by certain annoyances, and it suffices to state that in precisely this manner little girls entered my mind. To tell the truth, certain objects

"Birth of the Doll" by Hans Bellmer. Translated by the editor from [Robert Valençay's French translation of the German original] "Naissance de la Poupée," Cahiers GLM, no. 1 (1936), pp. 20–24. Courtesy of Hans Bellmer.

from their domain had always aroused my lust, even if these were as fragile as the black eggs of Easter and their pink sugar pigeons and biscuits, which were promising but luckily to no advantage. They were hollow. Their seduction confessed deception in advance. It was sufficient in itself, assumed the lovely suspicious odor of the superfluous.

Of course white pigeons, roses, and clasped hands denied nothing to the maternal souvenir album. But if one made an abstraction of confectionary baroque, a single multicolored glass marble could expand such ideas in an obviously more disturbing direction. Although less confidential, it offered itself entirely to the eye, allowing the spirals of its intimacy to be seen in frozen ecstasy.

It was captivating. The thoughts aroused by its tension lent the marble a supernatural force, until it soared, vitreous, in space. Attracted by this prodigy, a band of lace encompassed the marble, the lost leg of a little doll curved lightly over it, a fragment of a cigar box reared up in a menacing vertical and, toward the top, its "flor fina" disappeared under a caress of corkscrew curls. In the midst of it all, a breast rose against a brittle fan, and a bow of ribbon pierced the pink or green aureole of the ring that kept the whole thing together.

The dream was destroyed, erased by the banal crumpling of a paper, and it vanished into thin air like a mist, like flies, across the heart carved in the bathroom door.

The marble remained in my fingers as suspicious as a girl's giggle behind the hedges. In a word, I was no longer able to find the mysterious ways of these little darlings insignificant. What transpired by the staircase or the cracks in doors when they were playing doctor up there in the loft, what oozed from those juicy enemas, if I dare say it—the sour juice of strawberries, in short, all that could easily be taken for seduction, even stimulate desire.

It must be recognized how reluctantly I was brought to this, that I restrained the too painful memory of all that could not be learned about them. And like me, no one would have lost all mistrust of such brats. When their legs stayed there, doing nothing but dawdling, one could hardly ask any more of their splay-footed allure, especially around the knees, than a resemblance to playful goats. Seen from the front or from the side, their profile already provided much less to laugh about; the frail curve of the calf was encouraged by the padding of the knee, venturing to a curious convexity. But the crowning confusion was when they stiffened unexpectedly, comparing their pretentious function to the course of a hoop in flight, only to end by hanging naked outside open-work laces and rumpled pleats, enjoying each other in the aftertaste of their game. Nothing in all this sustained the comparison to the little tarts with the pleated collars in the

pastry shop. On the contrary, those little girls' legs were surrounded by an intangibility with which my great magician's Me collided, rebounding like their balls.

There were no spoils to be expected from this side; at most one could, in passing, underhandedly obtain the unaccustomed sound of a name that remained available like the epitome of the inexpressible. For my language had borrowed a raucous sound from streams of the firey water of the imaginary, so that the art of oaths spat from a rattling throat and hoarseness would have stifled in a cloud of ridicule had it tried to appropriate so precious a medley.

Unquestionably these little girls were not reassuring. At little expense, with a fortuitous flutter of pink pleats, they changed one into an ordinary sort of boy in dark pants and dull shoes, whose proportions were obtrusively exaggerated in the light of one's disenchanting contemplation of oneself. Nor was bitterness lacking when one of these finicky jointed females deigned to lower herself to the level of our world, when in the dark mazes of a dwelling made of chairs, crates, ironing boards covered with sheets, the heart was caught beating.

Indeed, it was implied that one was not the first to have certain fugitive contacts, without this good fortune relating to a strange and personal participation: the favor of chance did not dispel proper worth. But the memory of these contacts left too many desires, which, with a corrosive perseverance, began to turn on a more definite end. Let us anticipate: her popularized initials on board fences and walls were too dry for me. They lacked, above all, the convincing and meritorious precision of careful workmanship, and, like the rough draft of a clear vein of brass or of my phantoms knocking on the walls, could claim no great value. Probably collective usage had made them sterile, and before the eyes of too many passers-by, this sign had lost its ability to endow curiosity with anything but very timid sensations.

If the promise was not there, it had instead to be sought inside like the panoramas in my mirror boxes. But little girls (we came back to the same idea) were neither boxes, nor alarm clocks, and offered not the least trick that would allow me to turn the intentions attached to their charms into destructible or creative activities.

Believe me: the Mississippi no longer flowed into the stream under my window: the jumble of my old drawer and the spots on the wall paper were no longer anything but ironic souvenirs of past fertility, when inactivity was accomplished by the vague fear that in the end this pink realm would totally escape me.

Certainly in the years that followed, I sometimes underhandedly obtained a flimsy fragment of the dream in a careless drawing, or in a woman's play. But very little of all that subsisted. Nothing in comparison with the wealth of that enchanted garden whose distant odor

had so rapidly depreciated my magician's faculties. I should not sup-
pose that the fabulous distance the dolls retained was an essential
element of this extreme fragrance that wasted away proportionately
as their inaccessibility decreased? Would it not be in the doll's very
reality that the imagination would find the joy, ecstasy and fear it
sought? Would it not be the final triumph over those adolescents with
wide eyes turning away if, beneath the conscious stare that plunders
their charms, aggressive fingers were to assail their plastic form and
slowly construct, limb by limb, all that had been appropriated by the
senses and the brain?

Adjust their joints one to the other, skim off the images of infantile
poses through balls and their radius of rotation, follow very gently
the contour of small valleys, taste the pleasure of curves, make pretty
things, and, not without some slight resentment, spill the salt of
deformation. Finally, to refrain from staying motionless before the
interior mechanism, defoliate the thoughts retained of little girls,
and expose the core of those thoughts preferably by the navel: pan-
orama in the belly's depth revealed by multicolored electric illumina-
tion. Would this not be the solution?

Victor Brauner

Victor Brauner (1903–66) came to Paris from Roumania and was introduced to the Surrealists by Yves Tanguy in 1933. His first exhibition was held the next year. Brauner's long-standing obsession with the single eye (a favorite Surrealist device implying inner and outer vision), and the fact that after painting numerous pictures of one-eyed personages since 1931, he lost one of his own eyes in an accident in 1938, has become a Surrealist legend. There is a theatrical quality that runs through all of Brauner's imagery, whether it is presented in a frontal, frieze-like, decorative manner, or in the indeterminately shallow stage space of his misty, atmospheric "dream" pictures. His ubiquitous hybrid figures refer to primitive cultures as well as to oneiric experience, and the titles of his paintings often stress astrology, occultism, and a consuming interest in ancient civilizations.

On the Fantastic

I. IN PAINTING

You will like my painting

— 1—because it is nocturnal,
— 2—because it is fascinating,
— 3—because it is lyrical,
— 4—because it is symbolic,
— 5—because it is magic, hermetic, alchemical,
— 6—because it is attractive,
— 7—because it is seductive,
— 8—because it is passionate, impassioned,
— 9—because it is mad, sorceress,
—10—because it is phantasmal, mysterious, disquieting,
—11—because it is made with immense love,
—12—because its unknown world is peopled with somnambulists, incubi, succubi, lycanthropes, *éphialtes,* phantoms, specters, sorcerers, seers, mediums, and a whole fantastic population,
—13—because it is a dream world,
—14—because it is insinuating, obsessing, by its nebulous infusion;

"On the Fantastic in Painting, in Theatre" by Victor Brauner. Translated by the editor from *"Le Fantastique en peinture, au théatre,"* VVV, nos. 2–3 (1943–44). Courtesy of David Hare, editor, VVV.

—15—because each drawing, each painting is an adventure, a departure toward the unknown,

—16—because it lends itself to endless contemplation.

—17—because it is prophetic,

—18—because it is above mannerism,

—19—because it is dislocating, always self-renewing,

—20—because it is the very principle of becoming, and thus dialectic.

—21—because its time is the other time, where the past meets the future.

—22—because it is the continuation of the continual, mobile perpetuum of stimulation or of imagination;

—23—because it is physiological, functional,

—24—because it is devouring,

—25—because it is overestimating,

—26—because it is fairy-like,

—27—because it is erotic, subtle,

—28—because it is primitive,

—29—because it is mythical,

—30—because it is incandescent, burning, liquid,

—31—because it is the communication vessel of fire and water, being misty, vaporous, rainy, ectoplasmic, protoplasmic,

—32—because it is materialist,

—33—because it makes objective chance conscious,

—34—because it is subconscious, irrational,

—35—because it is delirious, obsessive,

—36—because it is the most faithful seismograph of the cataclysms of my sensibility.

—37—because it is inexhaustible like a great thought,

—38—because it is in the natural state of nature,

—39—because it is free—and you have no fear of liberty,

—40—because it is romantic, of a new and powerful romanticism which is to come and which will liberate man,

—41—because it is surrealist, assimilating the greatest physical, chemical, physiological, psychological, psychoanalytical conquests and all science in development, and because it has freed all the conventional frontiers, globing in itself the highest ethical values of man.

II. IN THEATRE

The stage will be black, ceiling and floor as well, a matte and opaque black.

Characters from a fantastic world: invented characters, part man, beast and plant, etc. These characters will be on stage almost permanently, and they will move in rhythm with the texts. Movements of a particular order, regulated by original laws.

They will be able to appear and disappear spontaneously or very slowly, or by decomposing. They will walk in the air, as in dreams, undergoing metamorphoses to attain anticipated aspects. They will have varied optical qualities, will be able to be more or less nebulous

and abstract or, on the contrary, concrete, in their very real daylight. Appearances and disappearances will thus catch all their meaning.

The spectacle ought to look as it would look through binoculars, before the object is focused, soft. Now and then a normal living person will intervene: by contrast, an element of displacement is obtained. Another striking contrast: one character dressed and one nude.

Strange, unformed voices, coming from mysterious places. Celestial voices, subterranean voices, voices tonelessly amplified. Whispers, cries, sighs, tears.

Now and then objects will appear, in poetic association with the texts.

Search for the original presentation of objects: anomalous pieces of matter move alone, group, forming a simple and concrete object.

The contrary.

The actors each carry an element, depositing it according to a pre-ordained pattern, constructing an object. Destruction of the object, following the inverse mechanism.

Example: LAUTRÉAMONT'S text (three Marguerites episode). A rain of daisies. Three immense daisies appear at the moment when the death of the three girls is announced. They remain on the stage for some time. An enormous carpenter's plane falls rapidly and smashes the bird in the cage. At this moment, there will be a formidable explosion.

The spectacle's phantom characters will rhythmically perform a singular dance, the music being inspired by peculiar noises, cries of animals, wings of birds, claws of bears scratching the pavement, clacking of teeth, sounds of dry leaves—in general all the sounds of the elements.

Sentences will be presented like luminous advertisements. Letters in the air, by projection. Projections harmonized with people. Shadows of fantastic animals.

Objects that speak.

Objects that move.

Giorgio de Chirico

Giorgio de Chirico (born in Greece, 1888, lives in Rome) was never a member of the Surrealist movement, but no other painter had so much influence on its art. He was "discovered" by various Dada artists around 1919, when, ironically, his own art was already in decline. De Chirico had lived in Paris from 1912–15 but by 1919 had returned to Italy. Breton and Eluard knew him first by correspondence. Work from de Chirico's mature "Metaphysical" period (c. 1913–19) was frequently reproduced in *La Révolution Surréaliste* between 1924 and 1929, though his relations with the Surrealists were strained from 1925 on (see Aragon, pp. 42–43); for in 1920 he had regressed to a heavy-handed neo-classical style based on a fervent admiration for the Italian fifteenth-century masters and an obsession with their tempera techniques. It is this about-face which he attempted to justify in the 1922 letter to Breton reprinted below.

On the other hand, de Chirico's Metaphysical period provided for the Surrealists the first visual counterpart to the poetic "reconciliation of two distant realities" found in Lautréamont's writings. (Breton called Lautréamont and Chirico "the fixed points that sufficed to determine our straight line.") De Chirico juxtaposed in a somber, romantic fashion the arcades, columns and broken statuary of antiquity against the trains, flags, railroad stations, mathematical objects, maps, mannequins, and memorial sculpture of modern times; the confrontation took place in sharp, empty spaces, where the time always seems to be a vacant, sleeping noon. Breton himself owned a major painting—*The Enigma of a Day,* which hung in his Paris apartment for a decade, exerting the most powerful attraction over both poets and painters. Its tilted, exaggerated perspectives, its ominous silence and dislocation, its strange, pellucid light, and dry but somehow rough and direct, even painterly, illusionism formed the basis for the "poetic" branch of Surrealist painting— notably that of Dali, Magritte, Tanguy and Delvaux.

The two texts reproduced here indicate the gulf between de Chirico's early innovation and his later rejection of it. The first, written between 1911 and 1915, reflects the erotic, unreal, penumbral quality of the Metaphysical paintings to which the headings directly refer. (After 1920 this quality re-appeared

only in his 1929 "novel," *Hebdomeros*.) For example, "The Song of the Station" includes references to the drawings, little flags, geometry, fountain, square, and toys that are his standard vocabulary in such paintings of the period as *The Enigma of the Hour, The Delights of the Poet,* and *Ariadne's Afternoon.* In "The Mysterious Death" he mentions the ubiquitous clock tower, in "Holiday" the cannon, railway station, clock and train, all of which appear in the 1914 canvas *Philosopher's Conquest,* now in the Art Institute of Chicago. "The man with the anguished look" probably refers to the artist's father, an engineer who planned the Thessalian railroads and whose presence is evoked in many paintings by railroad references and draftsman's tools. "The statue of the conqueror in the square," mentioned in "The Statue's Desire" below, appears in the painting owned by Breton.

Manuscript from the Collection of Jean Paulhan

MEDITATIONS OF A PAINTER
WHAT THE PAINTING OF THE FUTURE MIGHT BE

What will the aim of future painting be? The same as that of poetry, music and philosophy: to create previously unknown sensations; to strip art of everything routine and accepted, and of all subject-matter, in favor of an esthetic synthesis; completely to suppress man as a guide, or as a means to express symbol, sensation or thought, once and for all to free itself from the anthropomorphism that always shackles sculpture; to see everything, even man, in its quality of *thing.* This is the Nietzschean method. Applied to painting, it might produce extraordinary results. This is what I try to demonstrate in my pictures.

When Nietzsche talks of the pleasure he gets from reading Stendhal, or listening to the music from Carmen, one feels, if one is sensitive, what he means: the one is no longer a book, nor the other a piece of music, each is a *thing* from which one gets a sensation. That sensation is weighed and judged and compared to others more familiar, and the most original is chosen.

A truly immortal work of art can only be born through revelation.

Schopenhauer has, perhaps, best defined and also (why not) explained such a moment when in *Parerga und Paralipomena* he says, "To have original, extraordinary, and perhaps even immortal ideas, one has but to isolate oneself from the world for a few moments so completely that the most commonplace happenings appear to be new and unfamiliar, and in this way reveal their true essence." If instead of the birth of *original, extraordinary, immortal* ideas, you imagine the birth of a work of art (painting or sculpture) in an artist's mind, you will have the principle of revelation in painting.

In connection with these problems let me recount how I had the revelation of a picture that I will show this year at the *Salon d'Automne,* entitled *Enigma of an Autumn Afternoon.* One clear autumnal afternoon I was sitting on a bench in the middle of the Piazza Santa Croce in Florence. It was of course not the first time I had seen this square. I had just come out of a long and painful intestinal illness, and I was in a nearly morbid state of sensitivity. The whole world, down to the marble of the buildings and the fountains, seemed to me to be convalescent. In the middle of the square rises a statue of Dante draped in a long cloak, holding his works clasped against his body, his laurel-crowned head bent thoughtfully earthward. The statue is in white marble, but time has given it a gray cast, very agreeable to the eye. The autumn sun, warm and unloving, lit the statue and the church façade. Then I had the strange impression that I was looking at all these things for the first time, and the composition of my picture came to my mind's eye. Now each time I look at this painting I again see that moment. Nevertheless the moment is an enigma to me, for it is inexplicable. And I like also to call the work which sprang from it an enigma.

Music cannot express the *non plus ultra* of sensation. After all, one never knows what music is about. After having heard any piece of music the listener has the right to say, and can say, what does this mean? In a profound painting, on the contrary, this is impossible: one must fall silent when one has penetrated it in all its profundity. Then light and shade, lines and angles, and the whole mystery of volume begin to talk.

The revelation of a work of art (painting or sculpture) can be born of a sudden, when one least expects it, and also can be stimulated by the sight of something. In the first instance it belongs to a class of rare and strange sensations that I have observed in only one modern man: Nietzsche. Among the ancients perhaps (I say perhaps because sometimes I doubt it) Phidias, when he conceived the plastic form of Pallas Athena, and Raphael, while painting the temple and the sky of his *Marriage of the Virgin* (in the Brera in Milan), knew this sensation. When Nietzsche talks of how his *Zarathustra* was conceived, and he

says "I was *surprised* by Zarathustra," in this participle—surprised—is contained the whole enigma of sudden revelation.

When on the other hand a revelation grows out of the sight of an arrangement of objects, then the work which appears in our thoughts is closely linked to the circumstance that has provoked its birth. One resembles the other, but in a strange way, like the resemblance there is between two brothers, or rather between the image of someone we know seen in a dream, and that person in reality; it is, and at the same time it is not, that same person; it is as if there had been a slight transfiguration of the features. I believe that as from a certain point of view the sight of someone in a dream is a proof of his metaphysical reality, so, from the same point of view, the revelation of a work of art is the proof of the metaphysical reality of certain chance occurrences that we sometimes experience in the way and manner that *something* appears to us and provokes in us the image of a work of art, an image, which in our souls awakens surprise—sometimes, meditation—often, and always, the joy of creation.

THE SONG OF THE STATION

Little station, little station, what happiness I owe you. You look all around, to left and right, also behind you. Your flags snap distractedly, why suffer? Let us go in, aren't we already *numerous enough?* With white chalk or black coal let us trace happiness and its enigma, the enigma and its affirmation. Beneath the porticoes are windows, from each window an eye looks at us, and from the depths voices call to us. *The happiness of the station* comes to us, and goes from us transfigured. Little station, little station, you are a divine toy. What distraught Zeus forgot you on this square—geometric and yellow—near this limpid, disturbing fountain. All your little flags crackle together under the intoxication of the luminous sky. Behind walls life proceeds like a catastrophe. What does it all matter to you?

Little station, little station, what happiness I owe you.

THE MYSTERIOUS DEATH

The steeple clock marks half past twelve. The sun is high and burning in the sky. It lights houses, palaces, porticoes. Their shadows on the ground describe rectangles, squares, and trapezoids of so soft a black that the burned eye likes to refresh itself in them. What light. How sweet it would be to live down there, near a consoling portico or a foolish tower covered with little multicolored flags, among gentle and intelligent men. Has such an hour ever come? What matter, since we see it go!

What absence of storms, of owl cries, of tempestuous seas. Here Homer would have found no songs. A hearse has been waiting forever. It is black as hope, and this morning someone maintained that during the night it still waits. Somewhere is a corpse one cannot see. The clock marks twelve thirty-two; the sun is setting; it is time to leave.

A HOLIDAY

They were not many, but joy lent their faces a strange expression. The whole city was decked with flags. There were flags on the big tower which rose at the end of the square, near the statue of the great king-conqueror. Banners crackled on the lighthouse, on the masts of the boats anchored in the harbor, on the porticoes, on the museum of rare paintings.

Towards the middle of the day *they* gathered in the main square, where a banquet had been set out. There was a long table in the center of the square.

The sun had a terrible beauty.

Precise, geometric shadows.

Against the depth of the sky the wind spread out the multicolored flags of the great red tower, which was of such a consoling red. Black specks moved at the top of the tower. They were gunners waiting to fire the noon salute.

At last the twelfth hour came. Solemn. Melancholic. When the sun reached the center of the heavenly arch a new clock was dedicated at the city's railroad station. Everyone wept. A train passed, whistling frantically. Cannon thundered. Alas, it was so beautiful.

Then, seated at the banquet, they ate roast lamb, mushrooms and bananas, and they drank clear, fresh water.

Throughout the afternoon, in little separate groups, they walked under the arcades, and waited for the evening to take their repose.

That was all.

African sentiment. The arcade is here forever. Shadow from right to left, fresh breeze which causes forgetfulness, it falls like an enormous projected leaf. But its beauty is in its line: enigma of fatality, symbol of the intransigent will.

Ancient times, fitful lights and shadows. All the gods are dead. The knight's horn. The evening call at the edge of the woods: a city, a square, a harbor, arcades, gardens, an evening party; sadness. Nothing.

One can count the lines. The soul follows and grows with them. The statue, the meaningless statue had to be erected. The red wall hides all that is mortal of infinity. A sail; gentle ship with tender flanks; little amorous dog. Trains that pass. Enigma. The happiness of the banana tree: luxuriousness of ripe fruit, golden and sweet.

No battles. The giants have hidden behind the rocks. Horrible

swords hang on the walls of dark and silent rooms. Death is there, full
of promises. Medusa with eyes that do not see.

Wind behind the wall. Palm trees. Birds that never came.

THE MAN WITH THE ANGUISHED LOOK

In the noisy street catastrophe goes by. He had come there with his
anguished look. Slowly he ate a cake so soft and sweet it seemed he
was eating his heart. His eyes were very far apart.

What do I hear? Thunder rumbles in the distance, and everything
trembles in the crystal ceiling; it is a battle. Rain has polished the
pavement: summer joy.

A curious tenderness invades my heart: oh man, man, I want to
make you happy. And if someone attacks you I will defend you with
a lion's courage and a tiger's cruelty. Where do you wish to go; speak.
Now the thunder no longer rumbles. See how the sky is pure and the
trees radiant.

The four walls of the room broke him and blinded him. His icy
heart melted slowly: he was perishing of love. Humble slave, you are
as tender as a slaughtered lamb. Your blood runs on your tender
beard. Man, I will cover you if you are cold. Come up. Happiness will
roll at your feet like a crystal ball. And all the *constructions* of your
mind will praise you together. On that day, I too will command you,
seated in the center of the sun-filled square, near the stone warrior and
the empty pool. And towards evening, when the lighthouse shadow
is long on the jetty, when the banners snap, and the white sails are as
hard and round as breasts swollen with love and desire, we will fall
in each other's arms, and together weep.

THE STATUE'S DESIRE

"I wish at any cost to be alone," said the statue with the eternal look.
Wind, wind that cools my burning cheeks. And the terrible battle
began. Broken heads fell, and skulls shone as if they were of ivory.

Flee, flee toward the square and radiant city. Behind, devils whip
me with all their might. My calves bleed horribly. Oh the sadness of
the lonely statue down there. Beatitude.

And never any sun. Never the yellow consolation of the lighted
earth.

It *desires.*

Silence.

It loves its strange soul. It has *conquered.*

And now the sun has stopped, high in the center of the sky. And
in everlasting happiness the statue immerses its soul in the contempla-
tion of its shadow.

There is a room whose shutters are always closed. In one corner there is a book no one has ever read. And there on the wall is a picture one cannot see without weeping.

There are arcades in the room where he sleeps. When evening comes the crowd gathers there with a hum. When the heat has been torrid at noon, it comes there panting, seeking the cool. But he sleeps, he sleeps, he sleeps.

What happened? The beach was empty, and now I see someone seated there, there on a rock. A *god* is seated there, and he watches the sea in silence. And that is all.

The night is deep. I toss on my burning couch. Morpheus detests me. I hear the sound of a carriage approaching from far off. The hoofs of the horse, a gallop, and the noise bursts, and fades into the night. In the distance a locomotive whistles. The night is deep.

The statue of the conqueror in the square, his head bare and bald. Everywhere the sun rules. Everywhere shadows console.

Friend, with vulture's glance and smiling mouth, a garden gate is making you suffer. Imprisoned leopard, pace within your cage, and now, on your pedestal, in the pose of a conquering king, proclaim your victory.

A Letter

Rome, Wednesday

My dear friend,
I am very moved by everything you tell me in your fine letter. For a long time I was working without hope. Now first of all I must enlighten you on one point: concerning my present painting. I know that in France (and even here), there are people who say that I am making museum pieces, that I have lost my way, etc.; this was inevitable and I expected it: but I have a clear conscience and am filled with inner joy, for I know that the value of what I am doing today will appear, sooner or later, even to the blindest observers. Isn't my making your acquaintance already a good sign? The best sign I could have wished for.
And now, my dear friend, I am going to tell you about my current

"A Letter" by Giorgio de Chirico. Translated by the editor from "Une lettre de Chirico," Littérature, n.s. no. 1 (March 1922), pp. 11–13. Courtesy of Giorgio de Chirico. Another translation is in James Thrall Soby, Giorgio de Chirico.

painting. You must have noticed that for some time, something has changed in the arts; let us not speak of neo-classicism, of return, etc.; there are men, among whom you too probably belong, who having arrived at a limit in their art, have asked themselves: where are we going? They have felt the need of a more solid base; they have disavowed nothing; that magnificent romanticism we created, my dear friend, those dreams and visions which troubled us and which, without control, without suspicion, we have cast onto canvas or paper, all those worlds we have painted, drawn, written, sung, which are your poetry, that of Apollinaire and some others, my paintings, those of Picasso, Derain and some others, they are still there, my dear friend, and the last word on them has yet to be said, the future will judge them far better than our contemporaries, and we can sleep easily. But one question, one problem has been tormenting me for three years: the problem of *métier* [profession]. That is why I have set out to copy in the museums; why I have spent entire days, summer and winter, in Florence and Rome before the Italian masters of the fourteenth and fifteenth centuries, studying and copying them; I have buried myself in ancient treatises on paintings, and I have seen, yes, I have finally seen, that terrible things are happening today in painting, and that if painters continue on this course, we are headed for the end. First I discovered (I say discovered because I am the only one to say it) that the chronic and mortal malady of painting today is oil, the oil that is believed to be the basis of all good painting; Antonello da Messina, who, according to history, brought the secret of oil painting to Italy from Flanders, never did so; this misunderstanding is based on the fact that the Flemish, especially the Van Eyck brothers, used for pressing the glaze on their tempera, emulsions of which linseed or nut oil was a small part, but the basis of their painting was tempera or distemper, to which they sometimes added oils and especially resins or still other substances like honey, casein, fig milk, etc.; thus without any doubt, Dürer, Holbein, Raphael, Pietro Perugino, and I think even Rubens and Titian never *painted in oil* as it is conceived today. When I understood this, I set out with the patience of an alchemist to filter my varnishes, grind my colors, preparing my canvases and panels, and I saw the enormous difference that resulted: the mystery of color, light, the lustre, all the magic of painting (which, let it be said without angering you, dear friend and great poet) is, in my opinion, the most complicated and most magical art there is, all these virtues of painting, I say, prodigiously augmented as though lit by a new light; and I thought sadly of the impressionists, of the Monets, the Sisleys, the Pissarros, of all the painters who thought they could resolve the problem of light with their technique, while on their palette they bore the very source of shadow! And I also painted; I paint very slowly, it is true, but how much better! I recently made a portrait of myself,

of which I will send a photo; it is something which could take its place in the Louvre. I say that not to praise myself, but because I think it true. Excuse my long peroration on painting, and also the poor French of a peninsular barbarian. For today, I do not want to tire you any more. In a few days I shall send you the photographs, and then I shall write you at length; I still speak of your poetry, of my projects, and of my arrival in Paris, which I hope to realize this spring.

Again, I thank you, I embrace you.

Your friend, G. DE CHIRICO
1922.

Joseph Cornell

Joseph Cornell (born 1903) has never been an official Surrealist, nor, for that matter, has he been associated with any group. A retiring, lifetime resident of Flushing, New York (he lives on Utopia Parkway), he has long made collages, objects, and boxes that invoke a white rather than a black magic. The boxes in particular exert an extraordinary silence and beauty approaching that of de Chirico's tableaux, though Cornell's work is more fragile, more intimate, and more whimsical than the Italian's heavier, classically oriented painting. It encompasses a broad range of evocation from enchanted toys to a more cosmic viewpoint. Cornell's is an ivory tower, though for all its subtlety it is an American one, related, as William Rubin has noted, to the tradition of *trompe l'oeil* and memorabilia peculiar to Harnett and Peto. His main connection with orthodox Surrealism was the exposure to Max Ernst's photoengraving collages, which inspired him to bring his own work into the Julien Levy Gallery in New York in the early 30s.

The scenario for *Monsieur Phot,* which was to be a stereoscopic film, was written in 1933 and never filmed. (Later he did make some films in collaboration with Rudy Burckhardt). The scenario includes the same air of taking place in a glass case, the same kind of curiously old-fashioned or detached images (the bird, the glass, the piano, the violin, the camera, the gun, the marble statues, the chandelier, the snow, the Victorian parlor the child, the musical references) as do Cornell's boxes.

Monsieur Phot (Scenario)

The voices will be silent and the rest of the picture will be in sound. New York City about 1870. A park on a winter afternoon. In front of a large equestrian statue, the base of which is protected by an iron picket fence, stands a row of nine street urchins facing the camera. One holds a basket of clean laundry, another stands beside a harp. The recently melted snow has left puddles of water among the car tracks in the foreground.

The urchins are giving their attention to a photographer and his

"Monsieur Phot" by Joseph Cornell. From Julien Levy, ed., Surrealism (*New York:* Black Sun Press, 1936), pp. 77–88. Courtesy of Joseph Cornell.

apparatus shown at almost close-up distance on the left edge of the field of vision. His high silk hat is lying by his paraphernalia on the wet cobblestones.

Some bickering among the boys causes the photographer to emerge from under his black sheet, and he threads his way fastidiously through the puddles to the group of urchins. The photographer is heavily bearded in the style of his time and his manner is one of excessive politeness. He is wearing a wing collar and formal afternoon dress.

Close-up of photographer and boys. His politely remonstrative gestures reveal that he must have absolute order and quiet from them.

Original scene. The polite photographer picks his way back to his camera and goes under the black sheet again.

At this point we are permitted to view the scene through the lens of the polite photographer's black box. Perfect order prevails among the urchins, when, at regular intervals, a group of pigeons fly monotonously five or six times in and out of the field of vision. Then the photographer is interrupted by a passing horse-car.

(From now on the film will be in color).

Before there is time to press the bulb, a pheasant of gorgeous plumage runs excitedly into the scene. The urchin with the laundry chases it, disappearing for a moment or so with his basket at the left, then taking his place in line again.

Quiet again prevails when suddenly the basket of laundry seems to have become animated and the above mentioned pheasant finally extricates itself from a train of white linen. It flutters in the air striking with its beak at the boys who shield their faces pitifully with their arms but do not fight back.

Close-up of boys and bird. The photographer strides into the scene and beats off the pheasant with his silk hat. The urchins bestow upon him looks of heart-rending gratitude. The polite photographer helps to reassemble the linen. (Here ends the passage in color.)

On returning to his camera, the photographer must wait patiently for a horse-car to pass slowly. The scene is still viewed through his camera. Calm again reigns when the urchin with the harp seats himself quietly on a stool and begins playing Reynaldo Hahn's lovely *"Si mes vers avaient des ailes!"* The others stand attentively and are not distracted by the music.

Close-up of the photographer emerging as in a trance from the black sheet. His eyes are moist and he is deeply moved. He remains frozen for awhile in an attitude of gentle ecstasy. Fade-out into the original scene without the view through the photographer's camera.

The urchin at the harp is the sole survivor of the group. He continues to play as the polite photographer industriously packs his apparatus. He then dons his hat (he wears no overcoat), shoulders the apparatus, and, waiting for another horse-car to pass, carefully crosses the

puddles toward the boy. He stops for a moment and turns toward the back of the harp player who is oblivious of his presence.

Close-up of the head and shoulders of the photographer looking down upon the urchin in tenderest compassion, tears streaming down his cheeks and spotting his immaculate white wing collar.

Original scene. The photographer goes on his way past the statue into the distance. The playing continues. It is becoming dark. Snow is beginning to fall.

An hour later. It is now so dark that we can but barely distinguish the boy at the harp through the falling snow.

Another hour later. Complete darkness except for a few street lights in the distance. The rippling music of the harp sounds like a fountain playing into water. The bleakness of the past two hours has been punctuated by the passing of an occasional horse-car. We hear the far-off approach, see what we can of a dimly lighted interior through the snow covered windows, and hear the distant crunching of the heavy wheels swallowed up by the night.

Just as the sound of one of these cars fades, the voice of a rich mezzo-soprano floats out upon the night air, singing in French the melody, "Si mes vers avaient des ailes!" which is superbly accompanied by the harp.

With the song ended, there is to be noted a change in the playing of the music. With each repetition there is more feeling poured into the execution, until a more transcendently beautiful interpretation is scarcely imaginable. The music stops suddenly. Complete silence. After some moments a horse-car is heard approaching, passing, and swallowed up again by the night. The snow is still falling.

The huge parlor of a hotel of the Victorian period. Windows the height of the room line the walls on each side. The floor is covered with figured carpet. Large, elaborate chandeliers and ornate decorations give the impression of a ballroom. In the foreground, to the left, is a piano with a dust cover. Morning sunlight is streaming in through the windows on the left and a Sunday calm reigns.

On the left edge of the field of vision, seated in a chair which is half turned toward the camera, is discovered the sole occupant of the vast hall, the polite photographer. He wears formal morning clothes and is examining some photographs.

Close-up looking over the photographer's shoulder. The first photograph we are permitted to view is one of the horse-car of the previous scene; the urchins are peering out of the windows and some pigeons are resting upon the horses' harness, while the harp and basket of laundry repose on the car roof. Another photograph reveals the former park scene covered with snow up to the hoofs of the statue of the horse, giving the effect of the horseman riding through the snow. The

harp is lying over the rider with all its strings broken, so that it looks as if the rider's outstretched hand had just struck the last note on the wrecked instrument. As the photographer has lingered over this photograph the tender and poignant passages from Strauss' "Tales from the Vienna Woods" have been heard. The photographer displays considerable emotion.

(The film will be in color from now on).

The next photograph is a close-up view of the gorgeous pheasant aflutter among the white linen. At this point, to the end of the episode, will be played that section of Stravinsky's "Fire-Bird" which so marvelously suggests the bird's flight into the distance.

In the meantime a maid in an immaculate, starched white uniform has entered the background on the left, working towards the photographer with a feather duster. As she nears him, she brandishes the duster, (the feathers of which are identical in size and color to the pheasant) so vigorously around her white uniform that the amazing coincidence causes the photographer to jump to his feet, dropping the collection of pictures. The maid pays no attention to him and in a few moments exits to the right, dusting as she goes.

Close-up of head and shoulders of photographer. There is a nonplussed expression on his countenance and perspiration trickles down his face dropping upon his immaculate white collar.

Original scene. The photographer turns in the direction of the maid and follows her with his eyes. Then he gathers up his pictures and slowly seats himself again. (Here ends the passage in color and the Stravinsky music).

Through the doorway at the end of the hall there enters a young man in concert clothes. He is accompanied by an attendant who removes the dust cover from the piano and then retraces his steps. They pay no attention to the photographer who is likewise undistracted by their presence.

The young man seats himself at the piano and strikes some very grand chords. He is an artist of the pigeon-flight school. At first one supposes that he is just warming up, but this sort of preliminary playing seems to be all of which he is capable.

Suddenly a breeze or strong draught causes the chandeliers to start jangling like Japanese wind bells, filling the hall with very agreeable music. They are supplemented with incidental music from the orchestra, Tschaikowsky's *"Danse de la Fée Dragée,"* charmingly appropriate. The pianist looks up angrily and waits for this impromptu concert to stop. After a minute or so of impatience, he makes a rapid exit through the doorway. The attendant reappears, replaces the dust cover, and exits. He is not surprised at the music of the chandeliers.

The photographer becomes suddenly alert as the music ceases very gradually. He glances up curiously. His countenance is benign and

serene. He gathers his photographs and walks slowly towards the other end of the room, along the windows at the left.

The reflection of the chandeliers in the mirror at the end of the room catches his eye.

Close-up of the photographer on the left edge of the field of vision, looking into the mirror. By means of a fade-out the reflection of the chandeliers in the hall becomes the chandeliers in the interior of . . .

* * *

A large, sumptuous glass and china establishment seen through plate glass windows. (This episode opens with color.)

Slightly to the left of the center of the window is discovered the urchin of the harp peering into the depths of this forest of exquisite glass and ceramics.

Suddenly from somewhere inside, the gorgeous pheasant darts into view. It flies at terrific speed in and out of the chandeliers and pieces of priceless glassware as if they were branches of his native wood. At times it swoops gracefully past the counters, grazing the pieces by a hair's breadth. When it flies slowly, the boy traces the movements with his finger on the plate glass.

As the bird nestles in one of the glass pieces or vases to rest awhile there is heard some music which engages the attention of the urchin. It sounds like distant harp music. The urchin becomes tense as he recognizes its source.

Close-up of a fountain at the rear of store. It is made of thin blown glass and through its fantastic shape water plays into a glass basin. The music caused by the falling drops of water is strongly reminiscent of the haunting waltz of Debussy, *"La plus que lente."* The close-up has permitted us to realize better the fairylike and supernatural atmosphere of the glass store. In this miraculous setting we feel that anything might happen. We are so enchanted that two or three minutes of the close-up, just as it is, do not seem too long. Suddenly the fountain stops playing and there is a tense, nervous silence of about half a minute; then a violent fluttering and beating of wings, mingled with the rolling of a snare-drum, which also continues for about half a minute. Several deafening reports of a gun are heard in rapid succession, accompanied by the pandemonium of a million pieces of falling glass.

Original scene outside the window. The urchin, shading his eyes with his hands, is searching for the cause of the fracas since the whole scene seems just as peaceful and undisturbed as ever.

Fade-out into the hotel parlor before the mirror. The camera moves back enough to take in the doorway. We now discover the cause of the preceding disturbance. The pianist stands in the doorway with an old-fashioned gun in his hand, surveying the debris of the glass from

all the chandeliers which is scattered on the carpet. There is a distracted and slightly remorseful look upon his face.

The photographer walks through the doorway, turning to the left. Each is oblivious of the other.

Original view, long shot from the other end of the hall.

The pianist lays his gun against the wall and slowly advances to the piano. He is bravely restraining his emotion, which is on the point of overcoming him. He removes the dust cover and slowly walks to a pile of the shattered glass. He covers the pile of glass very carefully with the dust cover. Then to the tender and poignant passages of "Tales from the Vienna Woods" he walks slowly towards the doorway and exits.

<p style="text-align:center">✱ ✱ ✱</p>

A street corner at night, at which time it takes on an appearance of supernatural beauty. Enclosed by a low latticework fence are two lamp posts placed among life-sized marble statues of women in classical poses. The bluish light from the gas flames gives the statues the appearance of figureheads on old ships, illumined by phosphorescent seas. Snow is falling.

Within this enclosure the urchin of the harp is discovered restored to his beloved instrument, from which issues the strain of *"Si mes vers avaient des ailes!"* with a new significance. At times the notes sound like sobs heroically stifled. There is an occasional passerby who takes no notice of the playing. An occasional horse-car is heard in the distance.

The selection is played through about three times, becoming softer with each repetition.

The scene is one of inexpressibly serene and satisfying beauty. Fade-out.

EPILOGUE

The epilogue will be entirely in color and the action carried out as in a ballet.

An old-fashioned stage setting seen through a portal. There is an aisle through the center, flanked by a row of decorative lamp posts behind which is dense foliage reaching to the ceiling. Seated by each lamp post is an urchin at a harp.

The action commences with the urchins playing ensemble an ineffectual ballet selection, such as Lincke's "Glowworm." When they finish they applaud vigorously, bravos and whistles mingling with the applause.

As the applause dies out, we hear being played by the unseen orchestra the kind of soft string music that accompanies a stage mer-

maid as she reposes in a glass tank filled with water and nonchalantly reads from a book and devours a piece of fruit.

As the music continues, there emerges from the background a form. As it approaches down the aisle, it is seen to be a camera on wheels behind which is the polite photographer on roller skates, under his black sheet. As they near the footlights, the black sheet flies into the air. The photographer grabs wildly at it several times, almost losing his balance each time. He finally grasps the sheet as the gorgeous pheasant flies out from under it, but in so doing crashes to the floor. The camera continues on its course, toppling over the footlights out of view into the orchestra pit. There is a glorious sound effect as the camera lands in a drum, upsetting triangles, glockenspiels, etc., and causing false, bewildered notes by the frightened musicians. The music ceases.

The urchins leave their harps and hurry to the aid of the photographer. They help him to his feet and support him to prevent another mishap as he exits to the left. In the meantime, four of the urchins with violins have seated themselves apart and expertly play the scherzo movement from Debussy's string quartet.

The urchins all return now to their harps. The harpist nearest the footlights suddenly breaks into a short solo, the invigorating "Tic-Toc-Choc" of Couperin. He is applauded.

The regular lights now go off and the lamp posts become illuminated. In the dimmer light, we notice that something has appeared on the left side of the stage in the foreground. The regular lights go on again. The new object on the stage turns out to be the piano and pianist of the ballroom scene. The pianist's back is toward us. On the shiny black piano stands a large, magnificent, highly polished glass dome enclosing a pheasant of brilliant plumage in a natural setting. An attendant is just leaving the stage with a dust cover.

The pianist goes through some gyrations of the hot-cha school of singing, thumb-licking, rope-weaving, etc. The urchins give him their attention as he starts striking impressive chords in his affected manner. They become bored, however, and in less than a minute drown him out with an infectious galop of 1870 vintage. The pianist rises angrily. The urchins stand and meet his gaze.

As the pianist rises, the photographer appears at the right wearing his high silk hat and pointing a gun toward the piano. The photographer fires, demolishing the glass bell. The lights go out instantly and there is complete silence.

When the lights of only the lamp posts go on after some moments there remains nothing to be seen but snow falling on baskets of clean laundry scattered in the aisle and stretching into the distance.

Salvador Dali

Salvador Dali (born 1904, lives in New York and Cadaques, Spain) is the most enigmatic figure among the many enigmatic figures attracted to Surrealism. He arrived in Paris from Spain, having already worked in a Surrealist style and contacted the movement, in the fall of 1929, a time when Surrealism was reorienting itself. He found immediate favor with Breton and became a new prodigal to replace the other, ungrateful members then challenging their leader's authority. Dali's eclectic painting style, which incorporated elements of Ernst, Chirico, Tanguy, Miró and Antoni Gaudí was aimed less at art than at the expression of his own remarkable psyche. He idolized Meissonnier and the nineteenth-century academicians and despised "modern" art, calling Cézanne "a very dirty painter," yet Breton predicted that "it is perhaps with Dali that all the great mental windows are opening," and chose to construe Dali's later blatantly neo-Fascist ideas as an apologia for Surrealism's Freudian-Marxism.

Nevertheless, in the early 30s, Dali painted a series of extraordinary works (*The Persistence of Memory, Illumined Pleasures, The Invisible Man*) which have since come to epitomize Surrealism for the layman. His miniaturist's technique is so faithful to oneiric realism that in some cases it is virtually impossible to tell pasted photographs from painted elements. In 1934 his writings and his public behaviour had become so reactionary that they were an embarrassment to the movement and he was expelled, though still allowed to participate in exhibitions. By the end of the decade the last connections with Dali were severed by the Surrealists, and since then he has produced some of the most pretentious and mawkish paintings of the postwar period, including neo-Renaissance religious paintings in which he and his wife Gala (formerly the wife of the poet Paul Eluard) play starring roles.

The first text is one of Dali's least eccentric, and it constitutes, in fact, one of the most readable critical essays on Surrealist art. Dali played a major part in the development of the Surrealist object as it appeared in the 1930s, when a preference for illusionist styles led naturally to the making of actual objects that reproduced "dream photographs." Dali outdid himself in cleverness tinged with infantile eroticism in such contributions as the *Venus de Milo of the Drawers* (1936), a cast of the statue with breasts, stomach and knees

opening into drawers with knobs of white fur, or the full-scale *Rainy Taxi,* made for the 1938 International Surrealist Exhibition.

The Object as Revealed in Surrealist Experiment

In my fancies, I like to take as the point of departure for surrealist experiments the title of a Max Ernst picture, "Revolution by Night." If in addition to how nearly quite dream-like and almost overwhelming these experiments were originally, one considers the nocturnal, the splendidly blinding, power of the word more or less summing up our future, the word "Revolution," nothing could be less subjective than this phrase, "Revolution by Night." After all, that the review which for several years recorded the experiments should have been called *The Surrealist Revolution* must be significant.

The years have modified the surrealist concept of the object most instructively, showing as it were in image how the surrealist view of the possibilities of action on the external world have been and may still be subject to change. In the early experiments with poetic solicitation, automatic writing and accounts of dreams, real or imaginary articles appeared to be endowed with a real life of their own. Every object was regarded as a disturbing and arbitrary "being" and was credited with having an existence entirely independent of the experimenters' activity. Thanks to the images obtained at "The Exquisite Corpse," [1] this anthropomorphic stage confirmed the haunting notion of the metamorphoses—inanimate life, continuous presence of human images, &c.—while also displaying the regressive characters determining infantile stages. According to Feuerbach, "primitively the concept of the object is no other than the concept of a second self; thus in childhood every object is conceived as a being acting freely and arbitrarily." As will be seen in the sequel, the objects come gradually to shed this

"*The Object as Revealed in Surrealist Experiment*" by Salvador Dali. Translated by David Gascoyne in This Quarter 5, no. 1 (September 1932): 197–207. Courtesy of Salvador Dali.

[1] The experiment known as "The Exquisite Corpse" was instigated by Breton. Several persons had to write successively words making up a sentence on a given model ("The exquisite / corpse / shall drink / the bubbling / wine"), each person being unaware of what word his neighbour might have had in mind. Or else several persons had to draw successively the lines making up a portrait or a scene, the second person being prevented from knowing what the first had drawn and the third prevented from knowing what the first and second had drawn, &c. In the realm of imagery, "The Exquisite Corpse" produced remarkably unexpected poetic associations, which could not have been obtained in any other known way, associations which still elude analysis and exceed in value as *fits* the rarest documents connected with mental disease.

arbitrary character as the surrealist experiments proceed; when pro-
duced in dreams, they grow adapted to the most contradictory forms
of our wishes, and finally are subordinated—quite relatively, it is true
—to the demands of our own action. But it must be insisted that
before the object yields to this necessity, it undergoes a nocturnal and
indeed subterranean phase.

* * *

The early surrealist experimenters found themselves plunged into
the subterranean passages of "Revolution by Night," the passages
where *The Mysteries of New York* must have just been enacted; in
fact, dream passages still identifiable to-day. They found themselves
plunged in the post-mechanical open street, where the most beautiful
and hallucinating iron vegetation sprouts those electric blooms still
decorating in the "Modern Style" the entrances to the Paris Métro.
There they were stricken with oblivion and, owing to the threat of
unintended cataclysms, became highly developed automatic puppets
such as men now risk becoming. All night long a few surrealists would
gather round the big table used for experiments, their eyes protected
and masked by thin though opaque mechanical slats on which the
blinding curve of the convulsive graphs would appear intermittently
in fleeting luminous signals, a delicate nickel apparatus like an astro-
labe being fixed to their necks and fitted with animal membranes to
record by interpenetration the apparition of each fresh poetic streak,
their bodies being bound to their chairs by an ingenious system of
straps, so that they could only move a hand in a certain way and the
sinuous line was allowed to inscribe the appropriate white cylinders.
Meanwhile their friends, holding their breath and biting their lower
lips in concentrated attention, would lean over the recording apparatus
and with dilated pupils await the expected but unknown movement,
sentence or image.

On the table, a few scientific instruments employed in a system of
physics now forgotten or still to be elaborated, endowed the night with
their different temperatures and the different smells of their delicate
mechanisms, having been made a little feverish by the fresh and cool
taste of the electricity. There was also a woman's bronze glove and
several other perverted articles such as "that kind of white, irregular,
varnished half-cylinder with apparently meaningless bulges and hol-
lows," which is mentioned in *Nadja*,[2] and further the cage Breton
describes in *Wandering Footsteps:* "I have in mind the occasion when
Marcel Duchamp got hold of some friends to show them a cage which
seemed to have no birds in it, but to be half-full of lumps of sugar. He
asked them to lift the cage and they were surprised at its heaviness.

[2] Editor's note: novel by Breton, published in 1928.

What they had taken for lumps of sugar were really small lumps of marble which at great expense Duchamp had had sawn up specially for the purpose.[3] The trick in my opinion is no worse than any other, and I would even say that it is worth nearly all the tricks of art put together."

The semi-darkness of the first phase of surrealist experiment would disclose some headless dummies and a shape wrapped up and tied with string, the latter, being unidentifiable, having seemed very disturbing in one of Man Ray's photographs (already then this suggested other wrapped-up objects which one wanted to identify by touch but finally found could not be identified; their invention, however, came later)[4] But how can one give the feel of the darkness which for us shrouded the whole business? Only by mentioning the way the surrealists were strongly attracted by articles shining with their own light—in short, phosphorescent articles, in the proper or improper meaning of that word. These were a paper-cutter decorated with ears of wheat, casts of naked women hung on the walls, and T squares and biscuits forming a Chirico "metaphysical interior." It is of no importance that some of these things had been covered with the luminous paint used on watch faces to make the hands and figures shine in the dark. What matters is the way in which the experiments revealed *the desire for the object,* the tangible object. This desire was to get the object at all costs out of the dark and into the light, to bear it all winking and flickering into the full daylight. That is how the *dream objects* Breton called for in his *Introduction to a Speech on the Poverty of Reality* were first met with.

He then said:

It should be realized that only our belief in a certain necessity prevents us from granting to poetic testimony the same credence we give, for example, to an explorer's story. Human fetishism is ready to try on the white topee or stroke the fur cap, but it displays quite another attitude when *we* come back full of *our* adventures. It absolutely requires to believe that what it is told about has *actually happened.* That is why I recently suggested that as far as is feasible one should manufacture some of the articles one meets only in dreams, articles which are as hard to justify on the ground of utility as on that of pleasure. Thus the other night during sleep, I found myself at an open-air market in the neighbourhood of Saint-Malo and came upon a rather unusual book. Its back consisted of a wooden gnome whose white Assyrian beard reached to his feet. Although the statuette was of a normal thickness, there was no difficulty in turning the book's pages of thick black wool. I hastened to buy it, and when I woke up I was sorry not to find it beside me. It would be com-

[3] Editor's note: Duchamp's object *Why Not Sneeze?* (1921).
[4] Editor's note: Man Ray's *The Enigma of Isidore Ducasse* (1920), cloth and rope over a sewing machine.

paratively easy to manufacture it. I want to have a few articles of the same kind made, as their effect would be distinctly puzzling and disturbing. Each time I present one of my books to some selected person, I shall add some such object to my gift.

For thereby I may assist in demolishing the thoroughly hateful trophies of the concrete and add to the discredit of "rational" people and things. I might include ingeniously constructed machines of no possible use, and also maps of immense towns such as can never arise while human beings remain as they are, but which nevertheless would put in their place the great capitals now extant and to be. We could also have ridiculous but perfectly articulated automatons, which, though not doing anything in a human way, would yet give us proper ideas of action.

It is at least possible that the poet's creations are destined very soon to assume such tangibility and so most queerly to displace the limits of the so-called real. I certainly think that one must no longer underrate the hallucinatory power of some images or the imaginative gift some men possess independently of their ability to recollect.

* * *

In the second phase of surrealist experiment, the experimenters displayed a desire to interfere. This intentional element tended more and more to tangible verification and emphasized the possibilities of a growing relation to everydayness.

It was in the light of this that the inquiry concerning the day-dream which love is pre-eminently (*The Surrealist Revolution,* No. 12) took place. It is significant that the inquiry was undertaken at the very moment when surrealism was bestowing an ever more concrete meaning on the word "Revolution." In the circumstances, it cannot be denied that there is a dialectical potentiality in the fancy whereby the title of Max Ernst's picture, "Revolution by Night," is converted into "Revolution by Day" (such an apt motto for the second phase of surrealist experiment!), it being understood and emphasized that the day meant must be the exclusive day of dialectical materialism.

The proof of the existence of the desire to interfere and of the (ill intentioned) intentional element just mentioned is provided in the overwhelming assertions which André Breton makes in the *Second Manifesto* [see above, pp. 27–35] with the assurance natural to those who have become fully conscious of their mission to corrupt wickedly the foundations of the illegitimate, assertions which have necessarily had their effect on art and literature.

* * *

The awareness I was given in *The Visible Woman* that certain fulfilments were imminent led me to write, quite individually and personally, however: "I think the time is rapidly coming when it will be

possible (simultaneously with automatism and other passive states) to systematize confusion thanks to a paranoiac and active process of thought, and so assist in discrediting completely the world of reality." This has led me in the course of things to manufacture quite recently some articles still undefined which, in the realm of action, provide the same conflicting opportunities as the most remote mediumistic messages provide in the realm of receptivity.

But the new phase of surrealist experiment is given a really vital character and as it were defined by the *simulations of mental diseases* which in *The Immaculate Conception,* André Breton and Paul Eluard have contrasted with the various poetic styles. Thanks to simulation in particular and images in general, we have been enabled, not only to establish communication between automatism and the road to the object, but also to regulate the system of interferences between them, automatism being thereby far from diminished but, as it were, liberated. Through the new relation thus established our eyes see the light of things in the external world.

Thereupon, however, we are seized with a new fear. Deprived of the company of our former habitual phantoms, which only too well ensured our peace of mind, we are led to regard the world of objects, the objective world, as the true and manifested content of a new dream.

The poet's drama as expressed by surrealism has been greatly aggravated. Here again as we have an entirely new fear. At the limit of the emerging cultivation of desire, we seem to be attracted by a new body, we perceive the existence of a thousand bodies of objects we feel we have forgotten. That the probable splitting of the personality is due to loss of memory is suggested by Feuerbach's conception of the object as being primitively only the concept of second self, all the more so that Feuerbach adds, "The concept of the object is usually produced with the help of the 'you' which is the 'objective self.'" Accordingly it must be the "you" which acts as "medium of communication," and it may be asked if what at the present moment haunts surrealism is not the possible body which can be incarnated in this communication. The way in which the new surrealist *fear* assumes the shape, the light and the appearance of the terrifying body the "objective self" should be compels us to think so. This view is further supported by the fact that André Breton's next book, amounting to a third surrealist manifesto, will be entitled with the clarity of a magnetized meteor, a talisman-meteor, *The Communicating Vessels.*

* * *

I have recently invited the surrealists to consider an experimental scheme of which the definite development would have to be undertaken collectively. As it is still individual, unsystematized, and merely suggestive, it is only put forward at present as a starting-point.

1. *The Transcription of Reveries.*

2. *Experiment Regarding the Irrational Acquaintance of Things:* Intuitive and very quick answers have to be given to a single and very complex series of questions about known and unknown articles such as a rocking-chair, a piece of soap, &c. One must say concerning one of these articles whether it is:

> Of day or night,
> Paternal or maternal,
> Incestuous or not incestuous,
> Favourable to love,
> Subject to transformation,

Where it lies when we shut our eyes (in front or behind us, or on our left or our right, far off or near, &c.),
What happens to it if it is put in urine, vinegar, &c., &c.

3. *Experiment Concerning Objective Perception:* Each of the experimenters is given an alarm-watch which will go off at a time he must not know. Having this watch in his pocket, he carries on as usual and at the very instant the alarm goes off he must note where he is and what most strikingly impinges on his senses (of sight, hearing, smell and touch). From an analysis of the various notes so made, it can be seen to what extent objective perception depends upon imaginative representation (the causal factor, astrological influence, frequency, the element of coincidence, the possibility of the result's symbolical interpretation in the light of dreams, &c.). One might find, for instance, that at five o'clock elongated shapes and perfumes were frequent, at eight o'clock hard shapes and purely phototypical images.

4. *Collective Study of Phenomenology* in subjects seeming at all times to have the utmost surrealist opportuneness. The method which can be most generally and simply employed is modelled on the method of analysis in Aurel Kolnai's phenomenology of repugnance. By means of this analysis one may discover the objective laws applicable scientifically in fields hitherto regarded as vague, fluctuating and capricious. It would in my opinion be of special interest to surrealism for such a study to bear on *fancies* and on *caprice*. They could be carried out almost entirely as polemical inquiries, needing merely to be completed by analysis and co-ordination.

5. *Automatic Sculpture:* At every meeting for polemics or experiment let every person be supplied with a fixed quantity of malleable material to be dealt with automatically. The shapes thus made, together with each maker's notes (of the time and conditions of production), are later collected and analysed. The series of questions

regarding the irrational acquaintance of things (cf. Proposal 2 above) might be used.

6. *Oral Description of Articles* perceived only by touch. The subject is blindfolded and describes by touching it some ordinary or specially manufactured article, and the record of each description is compared with the photograph of the article in question.

8. *Making of Articles* on the strength of descriptions obtained according to the preceding Proposal. Let the articles be photographed and compared with the original articles described.

9. *Examination of Certain Actions* liable owing to their irrationality to produce deep currents of demoralization and cause serious conflicts in interpretation and practice, e.g.:

(a) Causing in some way any little old woman to come along and then pulling out one of her teeth,

(b) Having a colossal loaf (fifteen yards long) baked and left early one morning in a public square, the public's reaction and everything of the kind until the exhaustion of the conflict to be noted.

10. *Inscription of Words on Articles,* the exact words to be decided upon. At the time of *Calligrammes*[5] the typographical arrangement was made to suit the form of articles, which was one way of fitting the shapes of articles to the writing. Here I am proposing that the writing should be made to take the shape of the articles and that one should write directly on articles. There is not the slightest doubt that specific novelties would arise through the *direct* contact with the object, from this so very material and novel unifying of thought with the object—the novel and continuous flowering of fetishist "desires to verify" and the novel and constant sense of responsibility. Surely the poetry written on fans, tombs, monuments, &c., has a very particular, a very clearly distinct, style? I don't want to exaggerate the importance of such precedents or of the realist error to which they give rise. Of course I am not thinking of occasional poems, but, on the contrary, of writings devoid of any obvious or intentional relation to the object on which they are read. Thus writing would exceed the limits of "inscription" and entirely cover over the complex, tangible and concrete shapes of things.

Such writing could be on an egg or on a roughly cut slice of bread. I dream of a mysterious manuscript written in white ink and completely covering the strange, firm surfaces of a brand-new Rolls-Royce. Let the privilege of the prophets of old be conferred on every one: let every one be able to read from things.

In my opinion this writing on things, this material devouring of

[5] Editor's note: Guillaume Apollinaire's poems in representational shapes.

things by writing, is enough in itself to show how far we have travelled since Cubism. No doubt, we became accustomed during the Cubist period to seeing things assume the most abstract intellectual shapes; lutes, pipes, jam-pots, and bottles were seeking to take the form of the Kantian "thing in itself," supposedly invisible behind the quite recent disturbances of appearance and phenomena. In *Calligrammes* (the symptomatic value of which has not yet been realized) it was indeed the shapes of things which were seeking to take the very form of writing. Nevertheless one must insist that although this attitude is a relative step forward towards the concrete, it is still on the contemplative and theoretical plane. The object's action is allowed to influence, but there is no attempt at acting on the object. On the other hand, this principle of action and of practical and concrete taking part is what presides unceasingly over the surrealist experiments and it is our submission to this principle which leads us to bring into being "objects that operate symbolically," objects which fulfil the necessity of being open to action by our own hands and moved about by our own wishes.[6]

[6] [This footnote is a partial translation of Dali's "Objets Surréalistes," from *Le Surréalisme au service de la révolution*, no. 3, 1931, pp. 16–17—ED.] Typical Surrealist Objects Operating Symbolically:

Article by Giacometti.—A wooden bowl, having a feminine depression is suspended by means of a fine fiddle-string over a crescent, one tip of which just touches the cavity. The spectator finds himself instinctively compelled to slide the bowl up and down over the tip, but the fiddle-string is not long enough for him to do so more than a little.

Article by Valentine Hugo.—Two hands, one white-gloved, the other red, and both having ermine cuffs, are placed on a green roulette cloth from which the last four numbers have been removed. The gloved hand is palm upwards and holds between thumb and forefinger (its only movable fingers) a die. All the fingers of the red hand are movable and this hand is made to seize the other, its forefinger being put inside the glove's opening which it raises slightly. The two hands are enmeshed in white threads like gossamer which are fastened to the roulette cloth with red- and white-topped drawing pins in a mixed arrangement.

Article by André Breton.—An earthenware receptacle filled with tobacco on which are two long pink sugared almonds is placed on a little bicycle saddle. A polished wooden globe which can revolve in the axis of the saddle causes, when it moves, the end of this saddle to come into contact with two orange-coloured celluloid antennae. The sphere is connected by means of two arms of the same material with an hour-glass lying horizontally (so that the sand does not move) and with a bicycle bell intended to ring when a green sugared almond is slung into the axis by means of a catapult behind the saddle. The whole affair is mounted on a board covered with woodland vegetation which leaves exposed here and there a paving of percussion caps, and in one corner of the board, more thickly covered with leaves than the rest, there stands a small sculptured alabaster book, the cover of which is ornamented with a glazed photograph of the Tower of Pisa, and near this one finds, by moving the leaves, a cap which is the only one to have gone off: it is under the hoof of a doe.

Article by Gala Eluard.—There are two oscillating and curved metal antennae.

But our need of taking an active part in the existence of these things and our yearning to form *a whole* with them are shown to be emphatically material through our sudden consciousness of *a new hunger* we are suffering from. As we think it over, we find suddenly that it does not seem enough to devour things with our eyes and our anxiety to join actively and effectively in their existence brings us to want to *eat them*.

The persistent appearance of eatables in the first surrealist things painted by Chirico—crescents, macaroons, and biscuits finding a place among complex constructions of T squares and other utensils not to be catalogued—is not more striking in this respect than the appearance in the public squares, which his pictures are, of certain pairs of artichokes or clusters of bananas which, thanks to the exceptional cooperation of circumstances, form on their own, and without any apparent modification, actual surrealist articles.

But the predominance of eatables or things that can be ingested is disclosed to analysis in almost all the present surrealist articles (sugared almonds, tobacco, coarse salt in Breton's; medical tablets in Gala's; milk, bread, chocolate, excrement and fried eggs in mine; sausage in Man Ray's; light lager in Crevel's). The article I find most symptomatic from this point of view—and this precisely because of the complex indirectness—is Paul Eluard's, although in his there is an apparently not very edible element, a taper. Wax, however, is not only one of the most malleable substances, and therefore very strongly invites one to act upon it, but also wax used to be eaten in former times, as we learn from certain eastern tales; and further from reading certain Catalan tales of the Middle Ages, it may be seen that wax was used in magic to bring about metamorphoses and the fulfilment of wishes. As is well-known, wax was almost the only material which was employed in the making of sorcery effigies which were pricked with

At each end of them are two sponges, one in metal, the other real, and they are breast-shaped, the dugs being represented by red-painted little bones. When the antennae are given a push, the sponges come just in touch, one with flowers in a bowl, the other with the bristle tips of a metal brush.

The bowl is placed in a sloping box containing other things which correspond to additional representations. There is a stretched red elastic membrane, which vibrates for a long time on the slightest touch, and a small flexible black spiral looking like a wedge hangs in a little red cage. A deal paint-brush and a chemist's glass tube divide the box into compartments.

Article by Salvador Dali.—Inside a woman's shoe is placed a glass of warm milk in the centre of a soft paste coloured to look like excrement.

A lump of sugar on which there is a drawing of the shoe has to be dipped in the milk, so that the dissolving of the sugar, and consequently of the image of the shoe, may be watched. Several extras (pubic hairs glued to a lump of sugar, an erotic little photograph, &c.) make up the article, which has to be accompanied by a box of spare sugar and a special spoon used for stirring leaden pellets inside the shoe.

pins, this allowing us to suppose that they are the true precursors of articles operating symbolically. Moreover, the meaning of its con-substantiality with honey has to be seen in the fact that honey is much used in magic for erotic purposes. Here, then, the taper very likely plays the part of an intestinal morphological metaphor. Finally, by extension, the notion of eating wax survives nowadays in a stereo-typed process: at séances of theatrical hypnotism and conjuring which display certain magical survivals, it is quite common to see candles swallowed. In the same way also, the edible meaning of one of Man Ray's recent articles would be revealed—an article in the middle of which a candle only has to be lit for it to set fire to several elements (a horse's tail, strings, a hoop) and cause the collapse of the whole. If one takes into account that the perception of a smell is equivalent in the phenomenology of repugnance to the perception of the taste the thing which smells may have, so that the intentional element, which is the burning of the article, may be interpreted as a round-about desire to eat it (and so obtain its smell and even its ingestible smoke), one sees that burning a thing is equivalent, *inter alia,* to making it edible.

To sum up, the surrealist object has undergone four phases so far:

1. The object exists outside us, without our taking part in it (anthro-pomorphic articles);

2. The object assumes the immovable shape of desire and acts upon our contemplation (dream-state articles);

3. The object is movable and such that it can be acted upon (articles operating symbolically);

4. The object tends to bring about our fusion with it and makes us pursue the formation of a unity with it (hunger for an article and edible articles).

Dali's "retrograde technique," as he himself called it, was justified as the necessary vehicle for his "paranoiac critical method," expounded in this text, a section of the book *La Femme Visible,* published in 1930 by Editions Surréalistes. It should be noted that his use of the term paranoia bears only the most distant relation to its medical usage, or even to its contemporary popular usage. Here it applies to a game, or sort of Rorschach test procedure applied to double or triple images, the visual pun so integral to Surrealism. According to Dali, the whole world could, and should, be seen in this hallucinatory manner by which inspiration is "forced." The technique has obvious antecedents in the original concept

of automatic writing as expounded in *The First Surrealist Manifesto* (see above, pp. 10–27). By 1935 he had reversed the procedure, claiming that all pictures meant the same thing rather than something different each time.

The title of this essay is derived from an image in his and Buñuel's film, *An Andalusian Dog* (see below, pp. 102–7). The stinking ass and the recurrent ants and flies that swarm over the carcass reflect more than one of Dali's prime obsessions— with putrescence, coprophagy, impotence, scatological themes, and extreme and unpleasant neurotic states. The "Modern Style" buildings mentioned are the Art Nouveau architecture and ornament from which Dali's biomorphic shapes at least partially derive. In 1933 he published an article in *Minotaure* on the "delirious architecture of Art Nouveau."

The Stinking Ass

To Gala Eluard

It is possible for an activity having a moral bent to originate in a violently paranoiac will to systematize confusion.

The very fact of paranoia, and particularly consideration of its mechanism as a force and power, brings us to the possibility of a mental attack which may be of the order of, but in any case is at the opposite pole to, the attack to which we are brought by the fact of hallucination.

I believe the moment is at hand when, by a paranoiac and active advance of the mind, it will be possible (simultaneously with automatism and other passive states) to systematize confusion and thus to help to discredit completely the world of reality.

The new images which paranoiac thought may suddenly release will not merely spring from the unconscious; the force of their paranoiac power will itself be at the service of the unconscious.

These new and menacing images will act skilfully and corrosively, with the clarity of daily physical appearances; while its particular self-embarrassment will make us yearn for the old metaphysical mechanism having about it something we shall readily confuse with the very essence of nature, which, according to Heraclitus, delights in hiding itself.

"The Stinking Ass" by Salvador Dali. *Translated by J. Bronowski in* This Quarter *5, no. 1 (September 1932): 49–54. Courtesy of Salvador Dali.*

Standing altogether apart from the influence of the sensory phenomena with which hallucination may be considered more or less connected, the paranoiac activity always employs materials admitting of control and recognition. It is enough that the delirium of interpretation should have linked together the implications of the images of the different pictures covering a wall for the real existence of this link to be no longer deniable. Paranoia uses the external world in order to assert its dominating idea and has the disturbing characteristic of making others accept this idea's reality. The reality of the external world is used for illustration and proof, and so comes to serve the reality of our mind.

Doctors agree that the mental processes of paranoiacs are often inconceivably swift and subtle, and that, availing themselves of associations and facts so refined as to escape normal people, paranoiacs often reach conclusions which cannot be contradicted or rejected and in any case nearly always defy psychological analysis.

The way in which it has been possible to obtain a double image is clearly paranoiac. By a double image is meant such a representation of an object that it is also, without the slightest physical or anatomical change, the representation of another entirely different object, the second representation being equally devoid of any deformation or abnormality betraying arrangement.

Such a double image is obtained in virtue of the violence of the paranoiac thought which has cunningly and skilfully used the requisite quantity of pretexts, coincidences, &c., and so taken advantage of them as to exhibit the second image, which then replaces the dominant idea.

The double image (an example of which is the image of a horse which is at the same time the image of a woman) may be extended, continuing the paranoiac advance, and then the presence of another dominant idea is enough to make a third image appear (for example, the image of a lion), and so on, until there is a number of images limited only by the mind's degree of paranoiac capacity.

I challenge materialists to examine the kind of mental attack which such an image may produce. I challenge them to inquire into the more complex problem, which of these images has the highest probability of existence if the intervention of desire is taken into account; and also into the problem, even graver and more general, whether the series of these representations has a limit, or whether, as we have every reason to think, such a limit does not exist, or exists merely as a function of each individual's paranoiac capacity.

All this (assuming no other general causes intervene) is certainly enough for me to contend that our images of reality themselves depend upon the degree of our paranoiac faculty, and yet that theoretically a man sufficiently endowed with this faculty may at will see the

form of any real object change, exactly as in voluntary hallucination, but with this (destructively) important difference, that the various forms assumed by the object in question are universally open to control and recognition as soon as the paranoiac has merely indicated them.

The paranoiac mechanism whereby the multiple image is released is what supplies the understanding with the key to the birth and origin of all images, the intensity of these dominating the aspect which hides the many appearances of the concrete. It is precisely thanks to the intensity and traumatic nature of images, as opposed to reality, and to the complete absence of interpenetration between reality and images, that we are convinced of the (poetic) impossibility of any kind of *comparison*. It would be possible to compare two things only if they admitted of no sort of mutual relation, conscious or unconscious. If such a comparison could be made tangible, it would clearly illustrate our notion of the arbitrary.

It is by their failure to harmonize with reality, and owing also to the arbitrary element in their presence, that images so easily assume the forms of reality and that the latter in turn adapts itself so readily to the violences of images, which materialist thought idiotically confuses with the violences of reality.[1]

Nothing can prevent me from recognizing the frequent presence of images in the example of the multiple image, even when one of its forms has the appearance of a stinking ass and, more, that ass is actually and horribly putrefied, covered with thousands of flies and ants; and, since in this case no meaning is attachable to the distinct forms of the image apart from the notion of time, nothing can convince me that this foul putrefaction of the ass is other than the hard and blinding flash of new gems.

Nor can we tell if the three great images—excrement, blood and putrefaction—are not precisely concealing the *wished for* "Treasure Island."

Being connoisseurs of images, we have long since learned to recognize the image of desire in images of terror, and even the new dawn of the "Golden Age" in the shameful scatologous images.

In accepting images the appearance of which reality strives painfully to imitate, we are brought to *desire ideal objects.*

Perhaps no image has produced effects to which the word *ideal* can more properly be applied than the tremendous image which is the

[1] What I have in mind here are, in particular, the materialist ideas of Georges Bataille, but also, in general, all the old materialism which this gentleman dodderingly claims to rejuvenate when he bolsters it up with modern psychology.

staggering ornamental architecture called the "Modern Style." No collective effort has produced a dream world so pure and so disturbing as the "Modern Style" buildings, these being, apart from architecture, the true realization in themselves of desires grown solid. Their most violent and cruel automatism pitifully betrays a hatred of reality and a need for seeking refuge in an ideal world, just as happens in infantile neurosis.

This, then, is something we can still like, the imposing mass of these cold and intoxicating buildings scattered over Europe and despised and neglected by anthologies and scholarship. This is enough to confound our swinish contemporary aestheticians, the champions of the execrable "modern art," and enough too to confound the whole history of art.

It has to be said once for all to art critics, artists, &c., that they need expect nothing from the new surrealist images but disappointment, distaste and repulsion. Quite apart from plastic investigation and other buncombe, the new images of surrealism must come more and more to take the forms and colours of demoralization and confusion. The day is not far off when a picture will have the value, and only the value, of a simple moral act, and yet this will be the value of a simple *unmotivated act*.

As a functional form of the mind, the new images will come to follow the free bent of desire at the same time as they are vigorously repressed. The desperate activity of these new images may also contribute, simultaneously with other surrealist activities, to the destruction of reality, and so benefit everything which, through infamous and abominable ideals of all kinds, aesthetic, humanitarian, philosophical, &c., brings us back to the clear springs of masturbation, exhibitionism, crime, and love.

We shall be idealists subscribing to no ideal. The ideal images of surrealism will serve the imminent crisis of consciousness; they will serve Revolution.

Luis Buñuel and Salvador Dali

Dali had known Luis Buñuel slightly at the University of Madrid, and the two of them wrote the scenario for *An Andalusian Dog* in three days, in Paris in 1928, by making up dreams and discussing them. Buñuel has since said that the film was "the result of conscious psychic automatism and to that extent it does not recount a dream, although it profits from a mechanism analogous to dream. . . . NOTHING, in the film, SYMBOLIZES ANYTHING." Saying that it would "not exist if Surrealism did not exist," he complained of the "imbecile crowd" who found "beautiful or poetic something that is at heart only a desperate, passionate incitement to murder." *L'Age d'Or* (*The Golden Age*), a second film made by Dali and Buñuel, soon after their first attempt, has been called "the pinnacle achievement of the Surrealist cinema. . . . the representation of the total passion of a human event pushed beyond previously known limits" (Toby Mussman), in which "the whole fabric of society is torn apart, layer by layer, tissue by tissue" (Henry Miller).

Dali's contributions to the film's imagery reappear in his paintings: pianos, swarming ants, mud, armpits, keys, the severed hand, the painting by Vermeer, hair growing in the place of mouth or eyes, bicycling figure seen from the rear, and the cyclist's "white apron." It was Buñuel, however, who was responsible for *An Andalusian Dog*'s cinematic innovations. Born in 1900, he had come to Paris to study music but became completely absorbed in the film. His musical training has been credited with the remarkable sense of time and timing, the temporal fusions which continue to mark his films and are an integral part of avant-garde cinema. Throughout his career, Buñuel continued to subscribe to Surrealist ideas, saying, in 1953: "In the hands of a free spirit, the cinema is a magnificent and dangerous weapon. . . . A film is like an involuntary imitation of a dream."

An Andalusian Dog (1929)

PROLOGUE

ONCE UPON A TIME . . .

A balcony at night.

A man is sharpening his razor. He looks up at the sky through the window and sees . . .

A thin cloud advancing on the full moon.

Then the wide-eyed face of a girl. The razor blade approaches one of her eyes.

The thin cloud now passes over the moon.

The razor blade crosses the girl's eye, slicing it in two.

End of prologue.

EIGHT YEARS LATER

A deserted street. It is raining.

A character dressed in a dark gray suit appears on a bicycle. His head, back, and loins are swathed in short white aprons. A black-and-white striped rectangular box is strapped to his chest. He pedals mechanically, hands on his knees, handlebars free.

The same character seen from the back and down to his thighs; a longitudinal superimpression of the street down which he is riding away from the camera.

He rides toward the camera until the striped box fills the screen. An ordinary room on a third floor of the same street. A girl dressed in bright colors sits in the middle, attentively reading a book. Suddenly she starts, listens curiously, and throws the book onto a nearby couch. The book remains open. On one page is a reproduction of Vermeer's *The Lace Maker*. The girl is now convinced that something is happening; she rises, turns halfway around, and walks quickly to the window.

The other character has just stopped below, in the street. Unresisting, by inertia, he falls with the bicycle into the gutter, in a pile of mud.

"An Andalusian Dog" by Luis Buñuel and Salvador Dali. Translated by the editor from "Un Chien Andalou," La Révolution Surréaliste, no. 12 (December 1929), pp. 34–37. Courtesy of Salvador Dali. Another translation is in This Quarter *5, no. 1 (September 1932).*

With a gesture of anger, of bitterness, the girl rushes down the stairs to the street.

Close-up of the man stretched out on the ground, expressionless, in the exact position in which he fell.

The girl leaves the house, rushes to the cyclist, and kisses him frantically on the mouth, eyes and nose. It rains so hard that the scene disappears.

Dissolve with the diagonal stripes on the box superposed on those of the rain. A pair of hands armed with a small key open the box and take from it a necktie wrapped in tissue paper. It must be noted that the rain, the box, the tissue paper and the necktie all have diagonal stripes; only the size varies.

The same room.

The girl is standing beside the bed, contemplating the clothes worn by the man—aprons, box, and hard collar with a plain dark tie—all laid out on the bed as though worn by a person reclining there. The girl finally decides to pick up the collar, from which she removes the plain tie to replace it with the striped one that she just took out of the box. She puts it back in the same place and then sits down very close to the bed, in the pose of someone mourning a corpse.

(*Note—The bed, that is the cover and the pillow, are lightly rumpled and creased, as though a human body really rested there.*)

The girl has the feeling someone is standing behind her and she turns to see who it is. Unsurprised, she sees the cyclist, without any of his accessories, staring fixedly at something in his right hand. His stare is quite anxious.

The girl approaches and looks in turn at what he has in his hand. Closeup of the hand, swarming with ants which are coming out of a black hole in the center. None of the ants falls off.

Dissolve to the hairs in the armpit of a girl stretched out on the sand of a sunny beach.

Dissolve to a sea urchin whose mobile spines move gently.

Dissolve to the head of another girl, a violently plunging shot surrounded by an iris which opens to show this girl in the midst of a group of people trying to storm a police line.

In the center of the circle, this girl is trying to pick up with a stick a severed hand with painted fingernails that lies on the ground. One of the policemen approaches and harshly reprimands her; he leans down and picks up the hand, which he wraps carefully and puts into the box that the cyclist carried. He returns both to the girl and gives her a military salute when she thanks him.

It must be noted that the moment the policeman returns the box to her she is overwhelmed by extraordinary emotion which completely

isolates her from everything. She seems under the spell of strains of some distant religious music; music heard, perhaps, in her earliest childhood.

The public, its curiosity satisfied, begins to disperse in all directions.

This scene will have been witnessed by the characters we left in the third-floor room. They are seen through the windows of the balcony, from which the end of the scene described below was visible. When the policeman returns the box to the girl, the two on the balcony also seem overwhelmed by the same emotion, to the point of tears. Their heads move as though following the rhythm of that impalpable music.

The man looks at the girl with a gesture that seems to say, "Did you see? Didn't I tell you so?"

She looks back down at the street, where the other girl now stands alone, as though nailed to the spot, in a state of absolute inhibition. Cars pass at breakneck speeds. Suddenly one of them runs over her, frightfully mutilating her. Then, decisively, as though he had every right to do so, the man approaches his companion, looks her lasciviously straight in the eye and puts his hands on her breasts, over her jersey. *Closeup* of the lascivious hands on the breasts, which then emerge from beneath the jersey. A terrible expression of almost mortal anguish is reflected on the man's face. Blood dribbles from his mouth onto the girl's bare breast.

The breasts disappear, turning into thighs, which the man continues to stroke. His expression has changed. His eyes gleam with lewdness and malice. His wide open mouth closes until it is as miniscule and tight as a sphincter.

The girl withdraws into the room, followed by the man, still in the same posture.

With a vigorous gesture, she suddenly escapes from his arms and is freed from his bold grasp.

His mouth contracts in anger.

She realizes that an unpleasant or violent scene is starting. She recoils, step by step, into a corner, where she entrenches herself behind a small table.

With the gesture of a melodramatic villain, he looks all around, searching for something. At his feet he sees a piece of rope and picks it up with his right hand. His left hand also seeks and grasps an identical rope.

Flattened, terrified, against the wall, the girl watches her aggressor's manoeuvres. He advances on her, dragging with great effort something attached to the ropes.

The following move across the screen: first, a cork, then a melon,

two parochial schoolteachers, and finally two magnificent pianos.[1] The pianos are filled with the corpses of donkeys, whose hooves, tails, rumps, and excrement overflow the cases. As one piano passes, a huge donkey's head can be seen leaning on the keyboard.

The character painfully dragging this load strains desperately toward the girl. He upsets chairs, tables, a standing lamp, etc. The donkeys' rumps catch on everything. The light suspended from the ceiling, bumped in passage by a fleshless bone, continues to swing until the end of the scene.

When the man is on the point of reaching the girl, she evades him with a leap, and flees. Her attacker drops the ropes and goes after her. The girl opens a door and disappears into the next room, but not fast enough to lock herself in. He succeeds in getting his hand in the crack, where it is caught by the wrist.

Inside the room, pushing the door harder and harder, the girl gazes at the hand, which contracts painfully *in slow motion,* and at the ants which reappear and spread over the door.

Immediately she turns her head to the interior of the new room, which is identical to the first except for the lighting, which gives it a different air: the girl sees . . . The bed on which reclines the man, whose hand is still caught in the door.

He is dressed in the aprons and the box on his chest. He is motionless, his eyes wide open, and he wears a superstitious expression that seems to say: "Now something really extraordinary is going to happen!"

AROUND THREE IN THE MORNING

A new character, seen from the back, has just stopped on the landing, near an apartment door. He presses the bell at the door of the apartment where these events are taking place. Neither the electric knocker nor the bell are seen, but in their place are two hands shaking a silver cocktail shaker. Their action is instantaneous, as when a bell is pushed in an ordinary film.

The man in bed shudders.

The girl goes to open the door.

The newcomer goes straight to the bed and imperiously orders the man to get up. He obeys, so sullenly that the other is obliged to grab him by the cloaks and force him to rise.

After having torn off the aprons, one by one, he throws them out the window. The box follows, as do the straps, which the patient tries in vain to save from catastrophe. And that leads the newcomer to punish the cyclist by sending him to stand face to the wall.

The newcomer will have executed all his actions with his back com-

[1] Editor's note: "Pianos à queue": buggering pianos (literally, "tailed pianos").

pletely turned. Then he turns around for the first time to go look for
something on the other side of the room.

Sub-title that reads:

SIXTEEN YEARS AGO

At this point the photography becomes misty. The newcomer moves
in slow motion and one sees that his features are identical to the
other's: they are one person, except the newcomer seems younger and
more pathetic, as the other must have looked a number of years ago.

The newcomer goes to the back of the room, *preceded by the camera
on wheels.* A desk, toward which the newcomer is moving, enters our
field of vision. Two books and other scholarly objects are on the desk,
their positions and moral import to be carefully determined.

He takes the two books and returns to rejoin the cyclist. At this
point everything returns to normal and the soft focus and slow motion
disappear.

Having approached the cyclist, the newcomer orders him to cross
his arms, puts a book in each hand and orders him to stay that way,
as punishment.

The punished man now wears an acutely treacherous expression. He
turns toward the newcomer. The books he holds become revolvers.

The newcomer looks at him with greatly increasing tenderness.

The cyclist, threatening the other with his weapons, forces him to
raise his hands, and despite his doing so, fires both revolvers at him.

Closeup of the newcomer falling mortally wounded, his features
contracting in pain (the soft focus returns and the fall forward is in
slow motion still more pronounced than before).

From a distance, one sees the wounded man falling, but this time
he is not in the room, but in a park. At his side, seated immobile and
seen from the back, is a woman with bare shoulders, leaning slightly
forward. As he falls, the wounded man tries to grasp and caress these
shoulders: one of his hands, trembling, is turned toward himself; the
other brushes the skin of the bare shoulders. Finally he falls to the
ground.

Long shot. Some passersby and park-guards rush to help him. They
lift him in their arms and take him away through the woods.

Have the passionate cripple intervene.

And we return to the same room. A door, the one where the hand
was caught, opens slowly. The girl we know appears. She closes the
door behind her and watches attentively the wall against which the
murderer stood. The man is no longer there. The wall is intact, without

any furniture or decoration. The girl makes a gesture of vexation and impatience.

The wall reappears; in the middle of it there is a small black spot. This small spot, seen up close, is a death's head moth.

Full closeup of the moth.

The death's head on the moth's wings covers the whole screen.

The cyclist abruptly appears, quickly putting his hand to his mouth as though losing his teeth.

The girl watches him scornfully.

When he takes his hand away, his mouth has disappeared.

The girl seems to say to him: "Good! And now?" and touches up her lipstick.

The man's face is seen again. Hairs are beginning to grow where his mouth was.

The girl, perceiving this, stifles a cry and suddenly looks at her armpit, which is completely hairless. Scornfully, she sticks her tongue out at him, throws a shawl over her shoulders and opening the door beside her, goes into the next room, which is a huge beach.

Near the water a third character is waiting. They greet each other amiably and stroll along the edge of the waves.

Shot of their legs and the waves breaking at their feet.

The camera follows on wheels. The waves gently wash up at their feet, first the straps, then the striped box, next the aprons and, finally, the bicycle. This shot continues an instant, while the waves wash nothing more ashore. They continue their stroll up the beach, blurring little by little, while in the sky the following words appear:

WITH SPRINGTIME

All is changed.

Now a horizonless desert is seen. Planted near the center, engulfed in sand up to their chests, the cyclist and the girl are seen, blind, their clothes torn, devoured by the sun's rays and a swarm of insects.

Oscar Dominguez

Oscar Dominguez (1906–1957) had a "Surrealist exhibition" in 1933, in his native Tenerife, before establishing direct contact with the official, Parisian group. He came to Paris late in 1934 and immediately joined the movement. The next year he invented a new technique that was most exhaustively developed by Max Ernst—"decalcomania," or, as Dominguez called it, "decalcomania without object." (Ink or paint was spread on a paper then covered by a second sheet, and the resulting patterns evoked strange landscapes, recalling the ink-blot pictures of the eighteenth-century British artist Alexander Cozzens.) From the decalcomania's atmospheric and crystalline surfaces, Dominguez developed his "cosmic" period, to which the text below relates. Paintings from 1938–39 bore such titles as *Memory of the Future, Nostalgia of Space,* and *Lancelot 28°.* Dominguez was for a while a singularly effective maker of Surrealist objects, and Marcel Jean has suggested that the polyhedral images in these paintings may have been suggested by the mathematical objects discovered in the Institut Henri Poincaré by Max Ernst, and photographed by Man Ray for the Surrealist object exhibition in 1936; these were concrete illustrations of abstract formulas in space geometry. The Surrealists as a group were fascinated by scientific language at the time and the following text is typical. Dominguez' mention of "two-dimensional" or "postage-stamp beings" leads one to wonder if they had read Edwin Abbott's famous *Flatland.*

The Petrification of Time

Ever since Einstein introduced into physics the conception of space-time, reconciling in a kind of dialectic synthesis two apparently irreducible concepts, the proper physical interpretation to give to this four-dimensional *continuum* has been discussed at length. For the mathematician, a universe of four dimensions is simply the representation of a function of type:

$$F\ (x_1\ x_2\ x_3\ x_4) = O$$

"The Petrification of Time" by Oscar Dominguez. Translated by the editor from "Le Pétrifaction du Temps," La Conquête du Monde par L'image (Paris: Editions de la Main à Plume, 1942), p. 27. Courtesy of Noël Armand.

For example, a *four-dimensional sphere* will be represented by the known equation:

$$x_1^2 + x_2^2 + x_3^2 + x_4^2 = R^2$$

R representing the radius of the sphere. But for the physicist, the x variables have an equivalent in physical reality which must be precisely stated. Thus, in Minkowski's four-dimensional universe, the first three variables are mingled with the three known dimensions of space, and the fourth is time, t, multiplied by the speed of light, o, and by the imaginary unity, $i = \sqrt{-I}$. If this mixture is highly satisfying from the purely formal and mathematical viewpoint, from the intuitive viewpoint it presents an agonizing aspect full of strange things.

Man is so made that he can see and touch the thickness, the length and the height of a body, that is, he can have perfect intuition of the variables x_1, x_2, and x_3. But on the other hand, he has not the slightest possibility of doing so with the fourth dimension of our universe. The English physicist A. Eddington supposes that a man endowed with an ingenious mechanism, by virtue of which his right eye travels at 200.000 km per second in relation to his left eye, would be in optimum conditions to have an intuition of the fourth dimension. While awaiting someone so disposed, we can only research the lesser realizations, which, while not representing a direct intuition of the fourth dimension, will, nevertheless, offer suggestive *projections* or *representations*. Thus, for example, the two-dimensional beings (postage-stamp beings) who would live in a flat world, could conceive of the existence of *cubes in four dimensions,* by means of their projection into our universe of three dimensions.

<p style="text-align:center">✳ ✳ ✳</p>

In the same order of ideas, we have found that certain surfaces, called *lithochronic,* open a window into a strange four-dimensional world by constituting a kind of *solidification of time.*

Let us imagine for a minute any three-dimensional body, an African lion for example, between any two moments of its existence. Between the lion L_o, or lion at the moment $t = O$, and the lion L_f or final lion, is located an infinity of African lions, of diverse aspects and forms. Now if we consider the ensemble formed by all the points of lion to all its instants and in all its positions, and then if we trace the enveloping surface, we will obtain an *enveloping super-lion* endowed with extremely delicate and nuanced morphological characteristics. It is to such surfaces that we give the name *lithochronic.* They constitute a kind of *movement to the solid state* by hybrid, spatial and temporal crystallization of the object placed thus at the very heart of its fundamental dialectic, the representation of which, purely spatially con-

gealed until then, thereafter gives way before the synthetic expression of its future.

This is not the only way to obtain *lithochronic surfaces*. Let us bring two three-dimensional bodies into contact, for example a sculpture representing a nude woman, and a typewriter, and trace the enveloping surface. This too will be a *lithochronic surface*. One can imagine, besides, that this enveloping surface is an elastic material and displaces the typewriter following a determined curve, logarithmic spiral, cubic parabola, sinusoïde, etc. . . . The result would still be a *lithochronic surface*, a surface rendered still more disquieting by the existence of complicated and unexpected geodesics.

Objective chance will also play a determining role in the choice of elements to superimpose.

The strange straw-stuffed crawfish, fossils, shell-fish, elephants stuffed with horsehair, etc. . . . waiting with the most intense anguish for the hands of a poet to set them free into space, that space where *Marie-Luise* left the authentically convulsive lithochronic surface of her suicide forever, the day when she threw herself into the void from the top floor of the great tower.

Marcel Duchamp

Marcel Duchamp (1887–1968) was defined in a dictionary of Surrealism (see below, p. 207) as "the most intelligent and (for many) the most troublesome man of this first part of the 20th century." He made his last painting in 1918 and completed his masterpiece—the "Large Glass" (*The Bride Stripped Bare by Her Bachelors, Even*)—in 1923. From then on he made occasional gestures, or objects, but increasingly devoted his time to playing chess. Thus, strictly speaking, he did not take active part in the Surrealist movement, though he did arrange group exhibitions and continued to be associated with Surrealist artists and writers. On the other hand, were it not for Duchamp, virtually the founder of Dada even before its name had been "found" by the Zurich group in 1916, some of Surrealism's most fundamental tenets might not have existed. His importance to all modern movements since 1912 has been such that he could justifiably be included in almost any survey. His fine French hand can be discerned in the evolution of everything from pop art to earthworks.

The core of Duchamp's innovation was to declare, by means of the "readymades" (unchanged manufactured objects simply "selected" to be art) begun in 1913, that *anything is art if an artist says it is*. It followed that anyone could be an artist, that the subconscious was as valid a creative source as the conscious mind, and that anything in life was grist to an artist's mill. He opened the way for the endless train of "found" objects integral to the Surrealist esthetic, although most Surrealists demanded of their finds a certain exotic quality that Duchamp's asceticism rejected.

In the first text below, Duchamp defines the creative process more than thirty years after he himself had, ostensibly, ceased to create (a last major tableau, made in the interim, has just come to light and is permanently exhibited at the Philadelphia Museum). In the second, he gives acutely observed thumbnail sketches of the Dada and Surrealist artists whom he knew from their beginnings within the context of an art evolution he did so much to alter. They were written for the catalogue of the Société Anonyme Inc.: Museum of Modern Art, a collection of modern art founded in 1920 and assembled by Katherine Dreier with the advice of Duchamp and Man Ray. The collection is now at the Yale University Art Gallery. Both of the texts below also appear in *Marchand Du Sel; Ecrits de Marcel*

Duchamp, Michel Sanouillet, ed. (Paris: Le Terrain vague, 1958).

The Creative Act

Let us consider two important factors, the two poles of the creation of art: the artist on one hand, and on the other the spectator who later becomes the posterity.

To all appearances, the artist acts like a mediumistic being who, from the labyrinth beyond time and space, seeks his way out to a clearing.

If we give the attributes of a medium to the artist, we must then deny him the state of consciousness on the esthetic plane about what he is doing or why he is doing it. All his decisions in the artistic execution of the work rest with pure intuition and cannot be translated into a self-analysis, spoken or written, or even thought out.

T. S. Eliot, in his essay on "Tradition and Individual Talent," writes: "The more perfect the artist, the more completely separate in him will be the man who suffers and the mind which creates; the more perfectly will the mind digest and translate the passions which are its material."

Millions of artists create; only a few thousands are discussed or accepted by the spectator and many less again are consecrated by posterity.

In the last analysis, the artist may shout from all the rooftops that he is a genius; he will have to wait for the verdict of the spectator in order that his declarations take a social value and that, finally, posterity includes him in the primers of Art History.

I know that this statement will not meet with the approval of many artists who refuse this mediumistic role and insist on the validity of their awareness in the creative act—yet, art history has consistently decided upon the virtues of a work of art through considerations completely divorced from the rationalized explanations of the artist.

If the artist, as a human being, full of the best intentions toward himself and the whole world, plays no role at all in the judgment of his own work, how can one describe the phenomenon which prompts the spectator to react critically to the work of art? In other words how does this reaction come about?

This phenomenon is comparable to a transference from the artist to the spectator in the form of an esthetic osmosis taking place through the inert matter, such as pigment, piano or marble.

"The Creative Act" by Marcel Duchamp. A lecture given to the American Federation of Arts, Houston, Texas, 1957, and published in Art News *56, no. 4 (Summer 1957 [misdated 1956]). Courtesy of Marcel Duchamp and* Art News.

But before we go further, I want to clarify our understanding of the word "art"—to be sure, without an attempt to a definition.

What I have in mind is that art may be bad, good or indifferent, but, whatever adjective is used, we must call it art, and bad art is still art in the same way as a bad emotion is still an emotion.

Therefore, when I refer to "art coefficient," it will be understood that I refer not only to great art, but I am trying to describe the subjective mechanism which produces art in a raw state—à l'état brut —bad, good or indifferent.

In the creative act, the artist goes from intention to realization through a chain of totally subjective reactions. His struggle toward the realization is a series of efforts, pains, satisfactions, refusals, decisions, which also cannot and must not be fully self-conscious, at least on the esthetic plane.

The result of this struggle is a difference between the intention and its realization, a difference which the artist is not aware of.

Consequently, in the chain of reactions accompanying the creative act, a link is missing. This gap which represents the inability of the artist to express fully his intention; this difference between what he intended to realize and did realize, is the personal "art coefficient" contained in the work.

In other words, the personal "art coefficient" is like an arithmetical relation between the unexpressed but intended and the unintentionally expressed.

To avoid a misunderstanding, we must remember that this "art coefficient" is a personal expression of art "à l'état brut," that is still in a raw state, which must be "refined" as pure sugar from molasses, by the spectator; the digit of this coefficient has no bearing whatsoever on this verdict. The creative act takes another aspect when the spectator experiences the phenomenon of transmutation; through the change from inert matter into a work of art, an actual transubstantiation has taken place, and the role of the spectator is to determine the weight of the work on the esthetic scale.

All in all, the creative act is not performed by the artist alone; the spectator brings the work in contact with the external world by deciphering and interpreting its inner qualifications and thus adds his contribution to the creative act. This becomes even more obvious when posterity gives its final verdict and sometimes rehabilitates forgotten artists.

Notes on Surrealist Artists: Société Anonyme

JEAN (HANS) ARP
Sculptor, Painter, Writer

Based on the metaphysical implications of the Dadaist dogma, Arp's *Reliefs* between 1916 and 1922 are among the most convincing illustrations of that anti-rationalistic era. The important element introduced then by Arp was "humor" in its subtlest form; the kind of whimsical conceptions that gave to the Dada Movement such an exuberant liveliness as opposed to the purely intellectual tendencies of Cubism and Expressionism. Arp showed the importance of a smile to combat the sophistic theories of the moment. His poems of the same period stripped the word of its rational connotation to attain the most unexpected meaning through alliteration or plain nonsense. His contribution to Surrealism, his *Concrétions,* show his masterly technique in the use of different materials, and in many instances are like a three-dimensional pun—what the female body "might have been." For Arp, art is Arp.

1949

GIORGIO DE CHIRICO
Painter, Writer, Illustrator

Witnessing the rise of new esthetics, in contact with the different expressions of the "heroic" period in the early part of the twentieth century, de Chirico found himself in 1912 confronted with the problem of following one of the roads already opened or of opening a new road. He avoided Fauvism as well as Cubism and introduced what could be called "metaphysical painting." Instead of exploiting the coming medium of abstraction, he organized on his canvases the meeting of elements which could only meet in a "metaphysical world." These elements, painted in the minutest technique, were "exposed" on a horizontal plane in orthodox perspective. This technique, in opposition to the Cubist or purely abstract formula in full bloom at the moment, protected de Chirico's position and allowed him to lay down the foundation of what was to become Surrealism ten years later. About 1926 de Chirico abandoned his "metaphysical" conception and

"Notes on Surrealist Artists: Société Anonyme" [Editor's title] by Marcel Duchamp. From the catalogue of The Collection of the Société Anonyme: Museum of Modern Art 1920 *(New Haven: Yale University Art Gallery, 1950). Copyright 1950 by the Associates in Fine Arts at Yale University. Courtesy of Marcel Duchamp and Yale University Art Gallery.*

turned to a less disciplined brush-stroke. His admirers could not follow him and decided that de Chirico of the second manner had lost the flame of the first. But posterity may have a word to say.

1943

MAX ERNST
Painter, Sculptor, Author

The Dada Movement was an anti-movement which corresponded to a need born of the first World War. Although neither literary nor pictorial in essence, Dada found its exponents in painters and writers scattered all over the world. Max Ernst's activities in Cologne in 1917 made him the foremost representative of the Dada painters. Between 1918 and 1921 his paintings, drawings and collages depicting the world of the subconscious were already a foretaste of Surrealism.[1] Among his technical discoveries the use of the old Chinese "frottage" or rubbing technique shows "automatic" textures of wood and different materials. When the Surrealist Movement took shape in 1924, Max Ernst was the only painter in the group of Dadas who joined the writers in the Surrealist venture. In fact his previous achievements had certainly influenced, to a great extent, the literary Surrealist exploration of the subconscious. Extremely prolific, Max Ernst has had a long Surrealist career and given through his work a complete *exposé* of the different epochs of Surrealism.

1945

MATTA
Painter

A few years before World War II Matta started his career as an architect but very soon turned completely to painting and to the Surrealist theories which, although then twenty years old, had been kept alive by the constant flow of young new talents. Matta was among the last newcomers. He did not undergo the routine schooling but at once imposed his personal vision. His first and most important contribution to Surrealist painting was the discovery of regions of space hitherto unexplored in the realm of art. Matta followed the modern physicist in the search for his new space which, although depicted on canvas, was not to be mistaken for another three-dimensional illusion. His first "period" was characterized by the slow rendering of an exploration, the fight with all the obstacles of oil painting, a medium lending itself to centuries-old interpretations. Later he succeeded in introducing in "his space" descriptive and figurative elements which

[1] Editor's note: Ernst was in the army in 1917 and only returned to Cologne at the end of 1918. His Dada contributions were made from 1919–22.

added to the completion of his important achievement. Still a young man, Matta is the most profound painter of his generation.

1946

JOAN MIRÓ
Painter

Miró came of age as an artist just at the time World War I ended. With the end of the war came the end of all the new pre-war art conceptions. A young painter could not start as a Cubist or a Futurist, and Dada was the only manifestation at the moment.

Miró began by painting farm scenes from the countryside of Barcelona, his native land. Although realistic in appearance, these first pictures were marked with a definite sense of unreal intensity.

A few years later he came to Paris and found himself among the Dadaists who were, at that time, transmuting into Surrealism. In spite of this contact Miró kept aloof from any direct influence and showed a series of canvases in which form submitted to strong coloring expressed a new two-dimensional cosmogony, in no way related to abstraction. He also made some constructions directly related to Surrealism but his real self was best exteriorized in the play of colored elements one upon another.

1946

FRANCIS PICABIA
Painter, Writer

Picabia's career is a kaleidoscopic series of art experiences. They are hardly related one to another in their external appearances, but all are definitely marked by a strong personality.

In his fifty years of painting Picabia has constantly avoided adhering to any formula or wearing a badge. He could be called the greatest exponent of freedom in art, not only against academic slavery, but also against slavery to any given dogma.

As a lad of fourteen he joined the Impressionists and showed a great talent as a young follower of an already old movement. About 1912 his first personal contribution as an artist was based on the possibilities of a non-figurative art. He was a pioneer in this field alongside Mondrian, Kupka, and Kandinsky. Between 1917 and 1924 the Dada Movement, in itself a metaphysical attempt towards irrationalism, offered little scope for painting. Yet Picabia in his paintings of that period showed great affinity with the Dada spirit. From this he turned to paint for years watercolors of a strictly academic style representing Spanish girls in their native costumes.

Later, Picabia took great interest in the study of transparency in

painting. By a juxtaposition of transparent forms and colors the canvas would, so to speak, express the feeling of a third dimension without the aid of perspective.

Picabia, being very prolific, belongs to the type of artist who possesses the perfect tool: an indefatigable imagination.

1949[2]

MAN RAY
Painter, Photographer, Writer

Before World War I Man Ray already belonged to the group of painters whose works made history in the development of revolutionary ideas in art. His paintings of 1913–1914 show the awakening of a great personality in his own interpretation of Cubism and abstract painting. He arrived in Paris in 1921, already known as a Dadaist, and joined the ranks of this active group with Breton, Aragon, Eluard, Tzara, and Max Ernst, the founders of Surrealism three years later. The change of milieu gave a new impetus to Man Ray's activities. He took up photography and it was his achievement to treat the camera as he treated the paint brush, a mere instrument at the service of the mind. It was also in Paris at the Institut Poincaré that he was attracted by the "mathematical objects always beautiful in their very nature," and he has painted many canvases bringing their inherent beauty in contact with organic themes. Today, back in Hollywood where he writes, lectures, paints, Man Ray has his place among the "old masters of Modern Art." Incidentally, the name "Société Anonyme" was suggested by Man Ray, who has been an active member from the start.

1949

[2] Editor's note: "NO BECAUSE . . ."

"Many people respond by 'yes but . . .' With Francis it was always 'no because . . . ,' the incessant windfall of each instant, a multi-faceted explosion which cut short all argument.

Francis also had a gift of total forgetfulness which permitted him to attack new paintings without the memory-influence of their predecessors,

Freshness unceasingly renewed which made of him a 'more than painter.'" [Combat-Art, Paris, December 6, 1954, p. 1. Written by Duchamp on the occasion of Francis Picabia's death.]

Max Ernst

Max Ernst, born in the Rhineland in 1891, has since been an American and a French citizen. In his art, as well, he has moved from country to country, style to style, technique to technique, and has been justly dubbed the "compleat Surrealist." In Cologne, in 1919, he founded his own Dada state. He met Breton in the Tyrol in 1921, the year of his influential collage exhibition at the Galerie Sans Pareil in Paris (see Aragon, pp. 46–48). In 1922 he settled there and became the major source of visual Surrealist art and the inventor of Surrealist collage, which differed from Dada collage in its homogeneity, its attempt to create an entirely new, though still fantastic, reality, rather than a chaotic splintering of previously known reality. His description, in "Beyond Painting," of its "discovery" and that of *frottage,* is a classic account of the Surrealist attempt to free the subconscious and relieve the "author" of any direct hand in creation, and, as such, is the visual artist's counterpart to the "automatic writing" procedure described in Breton's *First Manifesto* (see above, pp. 10–27). The Zurich text elaborates similar ideas.

Beyond Painting

I. History of a Natural History

from 5 to 7 years old[1]

Facing me I see a panel crudely painted with large black strokes on a red background, representing false mahogany and provoking associations of organic forms (a threatening eye, long nose, huge bird's head with thick black hair, etc.).

In front of the panel a black and gleaming man makes slow, comical, and, according to my memories of a time long past, joyously obscene gestures. This funny man wears my father's turned-up mustaches.

"Beyond Painting" by Max Ernst. Translated by the editor from "Au dela de la peinture," Cahiers d'Art [*Special Max Ernst issue*] (*1937*), *pp. 13–46. Excerpts from an earlier translation by the editor were published anonymously in P. Waldberg, ed.,* Surrealism (*New York: McGraw-Hill Book Company, 1964*) *and another full translation appears in Max Ernst,* Beyond Painting (New York: George Wittenborn, Inc. 1948). *Courtesy of Max Ernst.*

[1] Three visions of half-sleep published in nos. 9–10 of *La Révolution Surréaliste,* October 1927.

Having made several slow-motion leaps—legs spread, knees folded, torso bent—which disgust me, he smiles and takes from the pocket of his pants a big crayon made of some soft material I have not been able to define more precisely. He starts to work; he breathes loudly and hastily traces the black lines on the false mahogany. Quickly, he gives it some new, surprising, and despicable forms. He exaggerates the resemblance to ferocious or viscous animals to such a point that they come alive, inspiring me with horror and anguish. Satisfied with his art, the man catches and gathers his creations into a kind of vase which he paints in space for this purpose. He makes the contents of the vase revolve by moving his crayon faster and faster. The vase itself ends up by spinning and becomes a top. The crayon becomes a whip. Now I see clearly that this strange painter is my father. He wields the whip with all his might and accompanies his movements with terrible gasps of breath, like the blasts of an enormous, enraged steam engine. With frantic efforts he makes the abominable top, containing all the horrors my father has amiably been able to evoke with his frightful soft crayon, spin and leap around my bed.

One day, at the age of puberty, while seriously examining the question of how my father must have comported himself on the night of my conception, there arose in me, in response to this question of filial respect, a precise memory of that vision of half-sleep which I had completely forgotten. Since then, I have been unable to get rid of a clearly unfavorable impression of my father's conduct on the occasion of my conception, a totally gratuitous impression in any case, perhaps very unjust, but, on reflection . . .

AT THE AGE OF PUBERTY

The well-known game of purely optical representations that obsesses us in half-sleep suddenly becomes a procession of men and women, normally dressed, who come out of a distant horizon towards my bed. Before arriving, the walkers separate: women pass to the right, men to the left. Curious, I lean to the right so that not a single face will escape me. First I am struck by the extreme youth of all these women; afterwards, by the fact that they are all the same person, the face changing only slightly, the identity unchanging. Examining them carefully, face by face, I notice my mistake: many of these women are middle aged, some old, and only two or three are very young, around eighteen years old, the age compatible with my puberty.

I am too occupied by the women to pay attention to what is happening on the men's side. But *I know without seeing* that on that side I would make the opposite mistake: all these men begin by horrifying me with their precocious age and remarkable ugliness, but

on more careful examination, only my father retains the features of an old man.

I see myself lying on my bed and, at my feet stands a tall, thin woman, dressed in a very red dress. The dress is transparent, so is the woman. I am enchanted by the surprising delicacy of her bone structure. I am tempted to compliment her.

Botticelli did not like landscape painting, regarding it as a "limited and mediocre kind of investigation." He said contemptuously that "by throwing a sponge soaked with different colours at a wall one can make a spot in which a beautiful landscape can be seen." This earned him a severe admonition from his colleague Leonardo da Vinci:

"He [Botticelli] is right: one is bound to see bizarre inventions in such a smudge; I mean that he who will gaze attentively at that spot will see in it human heads, various animals, a battle, rocks, the sea, clouds, thickets, and still more: it is like the tinkling of a bell which makes one hear what one imagines. Although that stain may suggest ideas, it will not teach you to complete any art, and the above-mentioned painter [Botticelli] paints very bad landscapes.

"To be universal and to please dissimilar tastes, dark and gently shaded sections must both be found in one composition. In my opinion it does no harm to remember, when you stop to contemplate the spots on walls, certain aspects of ashes on the hearth, of clouds or streams; and if you consider them carefully you will discover most admirable inventions which the painter's genius can turn to good account in composing battles (both of animals and men), landscapes or monsters, demons and other fantastic things that will do credit to you. Genius awakes to new inventions in these indistinct things, but one must know how to depict all the members not included there, such as the parts of animals and aspects of landscape, rocks and vegetation" (*Treatise on Painting*).

On August 10, 1925 an overpowering visual obsession led me to discover the technical means which gave me a wide range for putting Leonardo's lesson into practice. Departing from a childhood memory in the course of which a false mahogany panel facing my bed played the role of optical *provocateur* in a vision of near-sleep, and finding myself one rainy day in an inn by the seacoast, I was struck by the obsession exerted upon my excited gaze by the floor—its grain accented

by a thousand scrubbings. I then decided to explore the symbolism of this obsession and, to assist my contemplative and hallucinatory faculties, I took a series of drawings from the floorboards by covering them at random with sheets of paper which I rubbed with a soft pencil. When gazing attentively at these drawings, I was surprised at the sudden intensification of my visionary faculties and at the hallucinatory succession of contradictory images being superimposed on each other with the persistence and rapidity of amorous memories.

As my curiosity was now awakened and amazed, I began to explore indiscriminately, by the same methods, all kinds of material—whatever happened to be within my visual range—leaves and their veins, the unravelled edges of a piece of sackcloth, the brushstrokes of a modern painting, thread unrolled from the spool, etc., etc. Then my eyes perceived human heads, various animals, a battle ending in a kiss (*Bride of the Wind*), rocks, *The Sea and the Rain, Earthquakes, The Sphinx in her Stable, Little Tables around the Earth, Caesar's Palette, False Positions,* an *Ice-Flower Shawl, Pampas.*

Whip Lashes and Threads of Lava, Fields of Honour, Floods and Seismic Plants, Scarecrows, The Sprinting Chestnut Tree.

Teenage Lightning, Vaccinated Bread, Conjugal Diamonds, The Cuckoo, Origin of the Pendulum, Dead Man's Meal, Wheel of Light. A Solar Money System.

The Habits of Leaves, The Fascinating Cypress.

Eve, the Only One Left to Us.

I collected the first results of the frottage process from *The Sea and the Rain* to *Eve, the Only One Left to Us* under the title *Natural History* (published by Jeanne Bucher in 1926). [See Arp introduction, p. 59.]

I emphasize the fact that in the course of a series of spontaneously exposed suggestions and transmutations (like hypnagogical visions), drawings obtained by frottage lose more and more of the character of the material explored (wood, for example) to take on the aspect of unexpectedly precise images whose nature probably reveals the initial cause of the obsession or a semblance of that cause.

FROM 1925 TO THE PRESENT

The frottage process—based on nothing other than the intensification of the irritability of the mind's faculties by appropriate technical means, excluding all conscious mental guidance (of reason, taste or morals) and reducing to a minimum the active part of what has hitherto been called the "author" of the work—was consequently revealed as the true equivalent of that which was already known as *automatic writing.* The author is present at the birth of his work as

an indifferent or passionate spectator and observes the phases of its development. Just as the role of the poet, ever since the celebrated *Letter of a Clairvoyant,* consists of taking down, as though under dictation, all that is articulated within him, so the painter's role is to outline and *project what is visible within him.*[2] By devoting myself more and more to this activity (passivity), which was later called "paranoiac criticism," [3] and by adapting the frottage process, which had at first appeared applicable only to drawing, to the medium of painting (by scraping pigment on to a colour-prepared foundation placed on an uneven surface), and by increasingly trying to restrain my own active participation in the development of the painting so as to enlarge the active part of the mind's hallucinatory faculties, I succeeded in simply attending as a spectator the birth of all my works,[4] beginning with that memorable day when I discovered frottage—August 10, 1925. Being a man of "ordinary constitution" (to use Rimbaud's term), I have done everything to *make my soul monstrous.* Blind swimmer, I have made myself a seer. *I have seen.* And I caught myself falling in love with what *I saw* and wanting to identify myself with it.

In a country the colour of *"a pigeon's breast"* I hailed the flight of *100,000 doves.* I saw them invade the black *forests* of desire and endless *walls* and *seas.*

I saw an *ivy leaf floating on the ocean* and I felt a *gentle earthquake,* and I saw a *pale dove, flower of the desert.* She *refused to understand.* A superb man and woman danced the *Carmagnole of love along a cloud.*

The dove *folded herself in her wings* and swallowed the key forever.

A string found on my table made me see a number of *young people trampling their mother,* and several *young girls* amusing themselves *in beautiful poses.*

Some very beautiful women crossing a river and crying. A man walking on the water took one young girl by the hand and jostled another. People with a rather reassuring look—indeed, *they had lain too long in the forest*—were making their *savage gestures only for charm's sake.* Someone said *"The Immobile Father."*

[2] Vasari relates that *Piero di Cosimo* often stayed immersed in consideration of a wall on which sick people had the habit of spitting; from these spots, he formed equestrian battles, the most fantastic cities and the most magnificent landscapes ever seen; he did the same with clouds in the sky.

[3] This very pretty term, destined to make its fortune because of its paradoxical content, seems to me subject to precautions, given that the notion of paranoia is employed there in a sense which does not correspond to its medical meaning. [C.f. Dali, pp. 96–100.] I prefer Rimbaud's proposition: The poet makes himself a *seer,* by a long, immense and reasoned *disorientation* of *all his senses.*

[4] Exception is made for *The Virgin Punishing the Infant Jesus* (1926), a manifesto-painting executed after an idea of A. Breton's.

Then I saw myself, *showing my father's head to a young girl.* The earth quaked softly.

I decided to erect a *monument to the birds.*

It was summer, *the beautiful season.* It was the time of *serpents, earthworms, feather-flowers, scale-flowers, tube-flowers.* It was the time when *the forest took flight and flowers argued under water.* The time of the *circumflex Medusa.**

In 1930, after having composed my novel *La Femme 100 Têtes* with systematic violence, I was visited nearly every day by the *Bird Superior,* named *Loplop,* an extraordinary phantom of model fidelity who attached himself to my person. He presented me with a *heart in a cage,* the *sea in a cage, two petals, three leaves, a flower and a young girl.* As well as *the man with black eggs* and *the man with the red cloak.* One fine autumn afternoon he informed me that one day *a Lacedaemonian had been invited to go and hear a man who imitated the nightingale perfectly. The Lacedaemonian replied: I have often heard the nightingale itself.* One evening he told me jokes which were not laughing matters: *"Joke—it is better not to reward a good deed at all than to reward it badly. A soldier had had both arms blown off in combat. His colonel offered him a gold piece. The soldier replied: 'I suppose you think, Sir, that I've only lost a pair of gloves.' "*

I had already said *hello to Satan* in 1928. An unavowable *old man was loaded down at that time with a package of clouds on his back,* while a flower in white lace, *its neck pierced by a stone,* stayed very still as it *sat on a tambourine. Why am I not that charming flower?* Why must I always change into an *earthquake,* into an *ace of hearts,* into a *shadow entering by the door.*

Dark vision: *Europe after the Rain!*

On 24 December 1933 I was visited by a *young chimaera in an evening gown.*

Eight days later I met a *blind swimmer.*

A little patience (15 days' wait) and I will be present at the *dressing of the bride.* The *bride of the wind* will embrace me in passing at a full gallop (*simple effect of touch*).

I saw *barbarians looking to the west, barbarians leaving the forest, barbarians marching to the west.* On my return from the *garden of the Hesperides* I followed with ill-concealed joy the phases of a *combat between two bishops.* It was as beautiful as the chance meeting of a sewing machine and an umbrella on a dissecting table.

I caressed:

> *The lioness of Belfort.*
> *The antipode of the landscape.*

* Editor's note: most of the italicized phrases in this and other sections of the text are the titles of paintings or other works by Ernst.

A beautiful German girl.
Wheat germ landscapes.
Lunar asparagus.
The straits of Mars.
The absolute presence.

Voracious gardens devoured by a vegetation which is the debris of wrecked airplanes.

I saw myself with the head of a kite bird, knife in hand, in the pose of Rodin's *Thinker,* so I thought, but it was actually the liberated pose of Rimbaud's *Seer.*

I saw with my own eyes *the nymph Echo.*

I saw with my own eyes the appearances of things retreating, and I experienced a calm and ferocious joy. Within the bounds of my activity (passivity) I have contributed to that general overthrow of the most firmly established and secured values which is taking place in our time.

THE INDICATING FOREST

Enter, enter, have no fear of being blinded . . .

The field of vision and action opened by "frottage" is limited only by its capacity to irritate the mind's faculties. It surpasses by far the limitations of artistic and poetic activity. On this subject, I can do no better than André Breton, to whom I shall give way:

. . . Leonardo's lesson, setting his students to copying what they saw, after long consideration (depending on their own coordination) "painted" on an old wall is far from understood. The entire passage from subjectivity to objectivity is implicitly resolved there and the range of that resolution far surpasses in human interest the range of inspiration itself. That measure has particularly concerned Surrealism. Surrealism did not depart from it, but discovered it along the way, and, with it, its possibilities of extension to all those areas which are not painting. The new associations of images, aroused by the poet, the artist, the scholar, borrow something comparable to it in order to produce a screen for a particular painting, so that this texture can concretely be that of a decrepit wall, a cloud, or anything else: a persistent sound and a vague vehicle, to the exclusion of all else, the phrase we need to hear sung. Most striking is the fact that an activity of this type which, in order to exist, necessitates the unreserved acceptance of a more or less durable passivity, far from limited to the sensory world, has been able to penetrate deep into the moral world. The luck, the happiness of the scholar or the artist when they *find,* cannot be conceived as a special case of man's good fortune, cannot be distinguished from its essence. Man will be able to direct himself on the day when, like the painter, he accepts the unchanged reproduction

of what an appropriate screen can offer in advance of his acts. This screen exists. Every life consists of these homogenous ensembles of cloudy, cracked facts, which each of us has only to scrutinize in order to read his own near future. Let him enter the whirlwind, track down the traces of events which have seemed to him particularly elusive and obscure, which have almost destroyed him. There—if his interrogation is worth the effort—all logical principles put to flight, he will meet the powers of *objective chance* which play on probability. On this screen all that man wants to know is written in phosphorescent letters, in letters of *desire*.

The purely visual exercise of this faculty which has been called "paranoiac" makes it possible to state that if the same spot, on a wall or elsewhere, is almost always interpreted differently by two distinct individuals, at the mercy of their distinct desires, it does not follow that one of them can easily make the other perceive what he discovers there. We do not see *a priori* what would hinder this first illusion of making a tour of the earth. It will suffice to respond to the most insistent vision, and also the most penetrating one, in that it must be capable of bringing into play the greatest possible number of *optical remnants*. From the little that we seek to know in this respect about the reactions of the average man, one can state that the faculty of paranoiac interpretation is far from lacking in him, although generally it exists in an uncultivated state. But he is ready, in good faith, to sanction the interpretation proposed to him; on this point he behaves like Polonius: better, if he has kept some freshness of feeling, by sharing the illusion with another, he gains a candid pleasure. There lies a source of profound communication between people that involves only a disengagement from all that masks and troubles it. The objects of reality exist not only as such: from the consideration of the lines that compose the most usual among them surges—without even having to close one's eyes—a remarkable *riddle-image* which embodies and presents us, with no possible error, with the sole *real* actual object of our *desire*. It goes without saying that what is true of the complementary graphic image in question is not less true of a certain verbal image to which any poetry worthy of the name never ceases to appeal. Such images, of which the most beautiful specimens are met in Lautréamont, are endowed with a persuasive force strictly in proportion to the violence of the initial shock they have produced. Thus it is that at a feeble distance they are called upon to take on the character of revelation. Again the acts themselves, the acts to accomplish, will be imperatively detached from the block of acts accomplished from the day when one is put in the position of considering this block, like that of a wall or a cloud, *with indifference*. From the day when the means are found to free oneself voluntarily of all logical or moral preoccupations. (A. Breton, *Le Château étoilé*)

II. Setting under Whiskey-Marine

Before spoiling himself, Aragon wrote:

When and where did collage appear? I believe, despite the tentatives of several early Dadaists, that homage must be paid to Max Ernst, at least

for the two forms of collage most removed from the principle of the *papier collé*—the photographic collage and the illustration collage. At first, this discovery had a tendency to be generalized, and the German Dada publications, notably, contained collages signed by at least ten authors. But this procedural success arose more from amazement at the *system* than from the necessity to express something at all costs. Very soon the use of collage was limited to a few men, and it is certain that the whole atmosphere of collage at that time was found in the mind of Max Ernst, and Max Ernst alone. (L. Aragon, *La Peinture au défi;* [see above, pp. 46–50])

<p align="center">WHAT IS COLLAGE?</p>

Simple hallucination, in the words of Rimbaud, *Setting under Whiskey-Marine,* in those of Max Ernst. It is something like visual alchemy.

<p align="center">THE MIRACLE OF TOTAL TRANSFIGURATION OF BEINGS
AND OBJECTS WITH OR WITHOUT MODIFICATION OF
THEIR PHYSICAL OR ANATOMICAL ASPECTS.</p>

Poetry's obsolete ideas played a major part in my verbal alchemy.

I accustomed myself to simple hallucination: I saw very frankly a mosque in the place of a factory, a tambourine school taught by angels, carriages on heavenly highways, a parlor at the bottom of a lake; monsters, mysteries, a vaudeville poster raised horrors before my eyes.

Then I explained my magic sophisms with hallucinations of words!
(A. Rimbaud, *Une Saison en Enfer*)

<p align="center">WHAT IS THE MECHANISM OF COLLAGE?</p>

I am tempted to see it as the exploitation of *the fortuitous encounter of two distant realities on an unfamiliar plane* (to paraphrase and generalize Lautréamont's celebrated phrase: *"Beautiful, like the chance meeting of a sewing machine and an umbrella on a dissecting table"*) or, in short, the cultivation of the effects of a *systematic displacement,* according to André Breton's thesis: *Surreality will be, moreover, a function of our will to complete displacement of everything (and it is understood that one can go so far as to displace a hand by isolating it from an arm, that the hand gains as much qua hand and also that in speaking of displacement, we do not only think of the possibility of acting in space.)* (Note to the Reader, *La Femme 100 Têtes*)

A readymade reality, whose naïve purpose seems to have been set for once and for all (an umbrella), suddenly found in the presence of another very distant and no less absurd reality (a sewing machine), in a place where both must *feel out of place* (on a dissecting table), will be robbed of its naïve purpose and of its identity; its false absolute

will be transformed, by means of a relative, into a new absolute, poetic and true: umbrella and sewing machine will make love. This very simple example seems to me to reveal the mechanisms of the process. Complete transmutation, followed by an act as pure as that of love, will necessarily occur every time the given facts make conditions favorable: *The union of two apparently incompatible realities on an apparently unsuitable scale.* Speaking of the collage process in 1920, Breton told us:

> But the marvelous faculty, without leaving the field of our experience, of attaining two distant realities and drawing from their reconciliation a scale; of putting at the command of our senses abstract figures called up at the same intensity, the same relief as others; and, by depriving us of any system of reference, displacing us in our own memories; there is what, provisionally, retains it. (Preface to the exhibition of Max Ernst, May 1920[5])

And here he adds this prophetic note: "Who knows if we are not somehow preparing ourselves to escape from the principle of identity."

WHAT IS THE TECHNIQUE OF COLLAGE?

If it is plumes that make plumage, it is not glue [*colle*] that makes glueings [collage]?

One day in the year 1929, a painter acquaintance asked me: "What are you doing there? Are you working?" I replied, "Yes, I'm making collages. I am preparing a book which will be called "The 100 Headless Woman" (*La Femme 100 Têtes*). Then he whispered in my ear, "And what kind of glue do you use?" With that modest air so admired by my contemporaries, I had to admit that in most of my collages there was no use for glue. And that I am not responsible for the term "collage"; that in my "collage" exhibition in Paris, an exhibition described by Aragon (*Challenge to Painting*) as "perhaps the first manifestation to permit perception of the resources and thousands of entirely new artistic methods, in this city where Picasso could never exhibit his constructions of wire, cardboard, bits of cloth, etc."; only twelve justified the term *collage-découpage.* These are:

1) *The Hat Makes the Man*
2) *The Horse He's Sick*
3) *The Swan is Very Peaceful*
4) *The Undressed Ones*
5) *The Song of the Flesh*
6) *Aerography*
7) *Massacre of the Innocents*

[5] Editor's note: This exhibition, referred to throughout this essay as taking place in 1920, actually took place in May, 1921.

8) *Little Play for Eight Hands*
9) *The Chinese Nightingale*
10) *Gazometric Ingres*
11) *Switzerland, Birthplace of Dada*
12) *The Steam and the Fish.*

As for the forty-four others, Aragon was right to say that the place where Max Ernst's meaning can be captured is "where, with a little color, a pencil line, he tries to acclimate the phantom which he has just precipitated into a foreign landscape." For it is there that the explosive junction occurs, between the two processes which force inspiration: frottage and collage. The similarity between the two processes is such that I can, without changing anything important, use the same terms already employed for one to tell how I discovered the other. One day in 1919, finding myself in rainy weather in a town on the banks of the Rhine, I was struck by the obsession exercised upon my excited gaze by an illustrated catalogue containing objects for anthropological, microscopic, psychological, mineralogical and paleontological demonstrations. There I found such distant elements of figuration that the very absurdity of this assemblage provoked in me a sudden intensification of the visionary capacities and gave birth to a hallucinating succession of contradictory images, of double, triple, and multiple images which were superimposed on each other with the persistence and rapidity characteristic of amorous memories and of hypnagogical visions. These images called up new levels for their meetings in a new unknown (the unsuitable plane). Then it sufficed simply to add to these catalogue pages, by painting or drawing, and thus only docilely reproducing *what was visible within me*—a color, a pencil line, a landscape foreign to the represented objects, the desert, a sky, a geological cross-section, a floor, a single straight line for the horizon, to obtain a set and faithful image of my hallucination; to transform into dramas revealing my most secret desires that which had been nothing more than banal pages of advertising.

I collected and exhibited in Paris, in May [1921], under the title "Setting under Whiskey-Marine," the first results obtained by this procedure, from the *Phallustrade* to *Wet Nurse to the Stars*. (See André Breton's fine preface to this exhibition. . . .)

WHAT ARE THE COLLAGES BY MAX ERNST THE
NOMENCLATURE OF WHICH EVERY CHILD WORTHY
OF THE NAME SHOULD KNOW BY HEART?

The *Phallustrade*. The springlike robe of the muse. The shadow of a great dada.[6] Extraordinary menace coming from who knows where.

[6] Don't forget, this was 1919.

Bone-mill for peaceful hairdressers. All transverse and longitudinal cross-sections. Oozing relief taken from the lung of a forty-seven-year-old smoker. Bitterness of the Mattress. Preparation of Bone-glue. Hypertrophied trophy. Don't smile. Religious Dada. Ambiguous figure. The little tear gland that says tic-tac. The hat makes the man.

. . . *Half-grown, women are carefully poisoned/ they are bedded in bottles/ the little American girl we are launching this year amuses herself by suckling sea-dogs/ the human eye is embroidered with batavic tears of curdled air and salted snow.* (Knitted relief) The canalization of gas. The galactometric foreskin. The sand ascaride. The guardian angel. Dehumanized semen. Three sexless figures. Arp's stamens. Demi-monde of two worlds.

. . . *The transfiguration of the chameleon on mount Tabor takes place in an elegant limousine while angels and canaries fly from the houses of man and the very holy garb of Our Saviour exclaims De Profundis three times before lashing the flesh of exhibitionists.* Somnambulant elevator.

Opulant Mimi of love. A little sick, the horse. The little Venus of the Esquimoes. Massacre of the innocents.

Little play for eight hands. Gay awakening of the geiser. Young man burdened by a faggot. Guard corps' drums of the celestial army. Childhood learns dada. Charity and voluptuousness.

Max Ernst's bedroom.

The Chinese nightingale. Semen of the pyramids.

. . . *The dog that shits/ the well-coiffed dog despite difficulties of terrain caused by an abundant snow/ the woman with the beautiful throat/ song of the flesh.*

Dada Degas. Dada Gauguin. The volume of man, calculable by woman's accessories.

Wet nurse to the stars.

. . . *It is already the twenty-second time that Lohengrin has abandoned his fiancée (for the first time)/ it is there where the earth has stretched its rind over four violins/ we will never see each other again/ we will never combat the angels/ the swan is very peaceful/ he rows with all his might to reach Leda.*

The great orthochromatic wheel. Erectio sine qua non. Ask your doctor. Gazometric Ingres. The steam and the fish.

Small machine constructed by minimax dadamax in person, serving to salt without fear the female vents at the beginning of the critical age.

Above the clouds walks midnight. Above midnight soars the invisible bird of day. A little higher than the bird grows the ether, and walls and roofs float.

Landscape in scrap iron: error of those who prefer navigation to grass on the bust of a woman.

WHAT IS A PHALLUSTRADE?

It is an alchemical product composed of the following elements: an *autostrada*, a balustrade and a certain amount of phallus. A phallustrade is a verbal collage. Collage can be defined as an alchemical composition of two or more heterogeneous elements, resulting from their unexpected reconciliation owing either to a sensitive will—by means of a love of clairvoyance—towards systematic confusion and "disorder of all the senses" (Rimbaud), or to chance, or to a will favorable to chance.[7] Chance, in the sense that Hume defined it: "The equivalent of the ignorance in which we find ourselves in relation to the real causes of events," a definition increasingly confirmed by the development of the mathematics of probability, and by the importance of this discipline in modern science and practical life: microphysics, astrophysics, agronomy, demonography, etc.[8] Also—and this very difficult aspect of chance has been neglected by the seekers of "laws of chance"—chance is *master of humor,* and consequently, in a far from rosy era, the one we live in, where a good deed consists of losing both arms in battle, master of humor-which-is-not-rosy, of *black humor*. A phallustrade is a typical product of black humor. An oozing relief taken from the lung of a forty-seven-year-old smoker is another. It has been said that the predominant note in my collage from the Dada period is this humor; but it is not the only one, and in certain works there is no trace of it (*Somnambulant Elevator, Massacre of the*

[7] In the hope of augmenting the fortuity of the elements able to enter into the composition of a drawing and to render so much greater the suddenness of associations, the Surrealists have had recourse to a process called "Exquisite Corpse," which consists of having the different parts of a personage drawn on a folded paper by several different people, so that no one can know what the others' collaboration is.

The considerable role of chance here is no longer limited except by that which, for the first time, relates to mental contagion. To judge by the results obtained (see the reproductions in *La Révolution surréaliste,* nos. 9–10, and in *Variétés,* June, 1929) we can consider this process as particularly apt to produce pure and strong Surrealist images, according to the criteria given by Breton: "For me, the strongest [Surrealist image] is that which presents the highest degree of arbitrariness, I do not hide it; that which takes longest to translate into practical language, whether it conceals an enormous dose of apparent contradiction, whether one of its terms is curiously revealed, whether announcing itself as sensational it has the air of ending feebly (brusquely closing the angle of its compass), whether it draws a derisive, formal justification for itself, whether it is of an hallucinatory order, whether it very naturally lends to the abstract a concrete mask, or, inversely, whether it implies the negation of some physical, elementary property, whether it lets laughter loose." (*[The First] Surrealist Manifesto*)

[8] Arp, in certain works, allowed himself to be guided by "the laws of chance."

Innocents, Above the Clouds . . .) It seems to me that collage is a hypersensitive and rigorously just instrument, like a seismograph, capable of registering the exact quantity of possible human happiness in any period. The amount of black humor contained in each authentic collage is found in inverse proportion to the possibilities of happiness (objective and subjective).

This invalidates the opinion held by some people who want to see the essential difference between Surrealist painting and the Dada works as the supposed absence of all humor from the former: is our era any rosier than the years 1917–21?

WHAT IS THE NOBLEST CONQUEST OF COLLAGE?

The irrational. It is the magistral eruption of the irrational in all fields of art, poetry, science, fashion, the private life of individuals, the public life of nations.[9] He who says collage, says the irrational. Collage has slyly insinuated itself into our everyday objects. We have hailed its appearance in Surrealist films (I am thinking of *The Golden Age* by Buñuel and Dali: the cow in bed, the bishop and giraffe thrown out the window, the cart crossing the governor's drawing room, the Minister of the Interior stuck to the ceiling after his suicide, etc.). By placing one collage after another, at random, we were surprised by the clarity of the irrational action that resulted: "The 100 Headless Woman," "Dream of a Little Girl Who Wanted to Become a Carmelite," "One Week of Kindness." Let us not forget that other conquest of collage; Surrealist painting, at least in one of its multiple aspects, that which between 1921 and 1924 I was the only one to elaborate,[10]

[9] I recall this note, which appeared in the *"Oberbadisches Volksblatt,"* February 12, 1934:

ON POLITICAL SUPERZEALOUSNESS
Ailing Imagination

For some time now, the authorities have been receiving a certain quantity of postcards, paintings and posters in which camouflaged Communist propaganda can be detected. In the hairdo of one head, although it is a photograph, the figure of Lenin is discernible; in the ear of the same head, an obscene image. A shattered skull and the head of a Communist are found hidden in a poster. It is notable that, to enjoy this poster-riddle, glued and hung in the usual manner, the spectator would be obliged to stand on his head. Official quarters are opposed to such a political superzeal which could uselessly alarm the population and hinder legitimate interests. Official quarters have received the order to suppress with all their energy these senseless actions which could easily degenerate into dangerous psychosis.

[10] Chirico, to whom I ought to pay homage in passing, had already taken another route, we know which one.

Everyone knows this extremely important aspect of Surrealist painting, that of which the most authentic representatives are Arp, Miró, Man Ray, Picasso, and Giacometti, and whose origins go back to Braque's and Picasso's *papiers collés*.

and in which, later, while I was haltingly advancing alone into the still unexplored forests of frottage, others continued to experiment (Magritte, for example, whose paintings are collages entirely painted by hand, and Dali).

The systematic fusion of the thoughts of two or more authors in the same work (otherwise called "collaboration") can also be considered a relation of collage. I cite as examples two texts produced by collaboration between my great friend Paul Eluard and myself: the first extracted from *Les Malheurs des Immortels* (*The Misfortunes of the Immortals*), 1922, the second from a still incomplete book which proposes to find new techniques of amorous practice: *Et suivant votre cas* (*And Following Your Case*), 1923.

I. Broken Fans

Today crocodiles are no longer crocodiles. Where are the good old adventurers who hooked in your nostrils miniscule bicycles and pretty ice pendants? Following the finger's speed, the runners to the four cardinal points paid each other compliments. What pleasure it was then to lean with graceful abandon on those nice rivers salted by pigeons and pepper!

There are no more real birds. The cords stretched at night in the roads of return made no one trip, but at each false obstacle, smiles increasingly bordered the eyes of trapeze artists. The dust had the odor of lightning. In other days, the good old fish wore fine red shoes on their fins.

There are no more real water-cycles, nor microscopy, nor bacteriology. Believe me, today crocodiles are no longer crocodiles.

II. Series of Young Women

The woman lying on a flat surface, a table for example, covered by a cloth folded in two.

Give her the object, placing it above her head and in her line of vision. Lower the object progressively so that the woman follows it with her glance, first raising her head, then bending it, her chin contacting her breast.

Stay thus a moment and return gently to the starting position. It is preferable that the object be shiny and bright colored.

Seat the woman on the table, let her dispose her arms and legs as she wishes.

Attract her attention with the object placed over her head, move it, lower it to the right, continue the lowering movement, then take it back up to the left.

Always hold the object quite far away so that the woman can not seize it. Don't abandon it to her, except to reward her for her efforts.

III. Instant Identity

To believe the description of his person contained in his identity card, Max Ernst would be only 45 years old at the moment he wrote these lines. He would have an oval face, blue eyes and greying hair. His size would only slightly surpass the average. As for particular marks, the identity card accords him none; consequently, in case of police pursuit, he could easily plunge into the crowd and disappear there forever. Women, on the other hand, find his face young, framed by white silky hair which, to them, "looks distinguished." They see in him charm, much "reality" and seduction, a perfect physique and agreeable manners (the danger of pollution, at his own admission, has become such an old habit that he is proud of it as a "sign of urbanity"),[11] but also a difficult, inextricable, unruffled, character, and an impenetrable mind ("he is a nest of contradictions," they say), *at once transparent and full of enigmas,* a little like the pampas.

It is difficult for them to reconcile the gentleness and moderation of his expressions with the calm violence which is the essence of his thought. They voluntarily compare him to a very gentle earthquake which only displaces the furniture lightly without being pressed into the intention of putting everything in order. What is particularly disagreeable, unbearable, to them, is that they succeed only poorly in finding his IDENTITY in the flagrant (apparent) contradictions existing between his spontaneous behaviour and that dictated to him by conscious thought. For example, one can observe in him two apparently irreconcilable attitudes toward "nature": that of the god Pan and of the man Papou, who possess all its mysteries and enjoy their union with her ("he marries nature," "he chases the *nymph Echo,*" they say) and that of a conscious and organized Prometheus, thief of fire who, guided by thought, pursues her with an implacable hatred and does her great injuries. "This monster is only pleased by the *antipodes of the landscape,*" they say again. And one little tease adds: "He is at once cerebral and vegetable."

However, from these two attitudes (contradictory in appearance, but in reality only in a state of *conflict*) remarked in him in almost all areas, *one* results each time he is faced with facts, and this union happens the same way as that which happens when one combines the presence of two very distant realities on a plane which is apparently

[11] See "Danger de pollution" ("Danger of Pollution"), *Le Surréalisme au service de la révolution,* no. 3.

incompatible to them (what, in simple language, is called "collage"), in the form of an exchange of energy provoked by this very reconciliation. This exchange, (which might be like a calm and continuous current or, in one fell swoop, like thunder and lightning) I am tempted to consider the equivalent of that which, in classical philosophy, is called *identity*. I conclude, in transposing André Breton's thought, that IDENTITY WILL BE CONVULSIVE OR WILL NOT BE.

Paris, October 1936

What Is Surrealism?

Le mot délit n'a, en général, pas été compris
—Paul Eluard [1]

The fairy-tale of the artist's creativity is western culture's last superstition, the sad remains of the myth of creation. One of Surrealism's first revolutionary acts was to attack this myth with impartial means and in the severest form, and to destroy it, probably for once and for all, by insisting vigorously on the purely passive role of the "author" in the mechanism of poetic inspiration, and by unmasking as adverse to inspiration all "active" control through intellect, morality, or aesthetic considerations.

The author can be present as a spectator at the generation of a work, and can follow its stages of development impartially or passionately. Just as the poet listens to and takes note of his automatic thought-processes, the painter projects on paper or on canvas that to which his optical inspiration inspires him. Banished, of course, is the old notion of "talent"; also banished is hero-worship and the saga of the artist's "fertility," so gratifying to the voluptuaries of admiration, whereby he lays three eggs today, one tomorrow, and none Sunday. Since it is well known that every normal person (and not only the "artist") carries in his subconscious an inexhaustible supply of buried pictures, it is a matter of courage or of liberating methods (such as "automatic writing") to bring to light from expeditions into the unconscious unforged (uncolored by control) objects (pictures) whose union one can describe as irrational perception or poetic objectivity, after Paul Eluard's definition: "Poetic objectivity consists only in the union of all subjective elements whose slave—and not, so

"What Is Surrealism?" by Max Ernst. *Translated by Gabriele Bennett from the catalogue* of Austellung *(Zurich: Kunsthaus, October 11–November 4, 1934). Courtesy of Max Ernst.*
[1] Editor's note: "The word delinquency has not been generally understood." *Délit* also means the under-side of a stone embedded into the earth and a pun may well have been intended.

far, master—is the poet." Hence it follows that the "artist" is a forger. At first it did not seem easy for painters and sculptors to find methods of achieving poetic objectivity which were in accord with "automatic writing" and were adapted to their technical possibilities of expression, that is, to banish intellect, taste, and conscious will from the process of art-making. Theoretical research was no help, only practical experiments and their results. "The casual meeting of sewing machine and umbrella on a dissection-table" (Lautréamont) is today a well-known, almost classic example for the phenomenon discovered by the Surrealists, wherein the reconciliation of two (or more) seemingly incompatible elements within a scheme, incompatible to them, provokes the strongest poetic ignitions. Innumerable individual and collective experiments (for instance, those termed "cadavre exquis" [2]) have proved this method's usefulness. It became evident that the more arbitrarily elements were brought together, the greater was the certainty that a totally or partially new interpretation had to occur through the transcending spark. The joy accompanying every successful metamorphosis does not correspond to a miserable aesthetic propensity to distraction, but to the intellect's very ancient, vital need for liberation from the deceptive and boring paradise of fixed memories, and for exploration of a new, greater range of experience, in which the borders between the so-called internal world and external world (after the classic-philosophical concept) become more and more blurred, and one day (when methods more precise than "automatic writing" have been found) will probably disappear altogether. In this sense, I could apply the term "natural history" [3] to a sequence of panels on which I recorded a series of optic hallucinations with the greatest possible precision. The revolutionary meaning of this depiction of nature may seem absurd at first, but it may become more comprehensible with the presence of analogous results in modern microphysics. As the result of the measurement of a moving electron and the subsequent measurement of the transversed ambient space, P. Jordan states: "But this distinction (between external and internal world) is deprived of a main support with the experimental refutation of the concept that facts exist in the external world which have an objective existence, independent of the process of observation."

Thus, when it is said of the Surrealists that they paint constantly changeable dream-reality, this does not mean that they paint a copy of their dreams (that would be descriptive, naïve naturalism), or that

[2] Editor's note: "Exquisite Corpse": a Surrealist collaborative game of folded paper, in which each participant makes a different part of the drawing without seeing the others'. See p. 87.

[3] Editor's note: see above, p. 118.

each individual builds his own little world of dream elements, conducting himself amicably or maliciously within it (that would be a "flight from time" [Flucht aus der Zeit—title of Dadaist Hugo Ball's memoirs—ED.]) but that they freely, bravely, and self-confidently move about in the borderland between the internal and external worlds which are still unfamiliar though physically and psychologically quite real ("sur-real"), registering what they see and experience there, and intervening where their revolutionary instincts advise them to do so.[4] The fundamental difference between meditation and action (after the classic philosophical concept) falls namely within the fundamental distinction between the external and the internal worlds; the universal significance of Surrealism is that since this discovery, no area of life can remain closed to it. Thus sculpture, apparently inflexibly opposed to automatism of any kind, also found its way into the Surrealist movement. Besides the sculptures by Arp and Giacometti shown in this exhibition, one must also call attention to the Surrealistic objects "of symbolic function" [5] (for example, Giacometti's "Suspended Ball"), and to utopian projects whose poetic possibilities one can imagine by reading the following description: "Huge automobiles, three times as large as usual, will be reproduced in plaster or onyx (with a minutiae of detail surpassing that of the most exact casts), to be enveloped in women's lingerie, and enclosed in tombs, the sites of which will be recognizable only by the presence of a thin straw clock." (Salvador Dali)

Existing sculptural works can function, just like any other "reality," as poetic elements in Surrealistic experiments, a fact demonstrated by collective studies for the irrational beautification of Paris. "The most conventional sculptures will marvelously embellish the countryside. A few nude women in marble will look their best on a huge plowed field. Animals in the streams and councils of grave personages in black tie in the rivers will form a charming obstacle to the waves. Mountain tops will be ravishingly set off by petrifications of the dance. And to take part in the indispensable mutilation, why not heads on the ground, hands in the trees, feet in the fields?" (Paul Eluard)

What is surrealism? Whoever expects a definition in answer to this question will remain disappointed until the movement ends. My brief expositions were intended to combat to some extent the spreading confusion of ideas about the Surrealist movement which are, at

[4] In contrast to abstractionism, which deliberately restricts its possibilities to the purely aesthetic reciprocal actions of colors, planes, volumes, lines, space, etc., apparently to give a helping hand to the old "myth of creation," as shown in the group named "abstraction-création."

[5] Editor's note: Dali's phrase; see p. 94; and also Breton's "Crisis of the Object," p. 53.

the moment, very fashionable. For the rest, I can only refer to A. Breton's "Surrealist Manifestoes"[6] and *"Les vases communicants"* [communicating vessels]. Contradictions in the successive attitudes of the Surrealists can be detected and still appear continuously, which indicates that the movement is flowing freely. By subverting the interrelationship of realities, Surrealism could only contribute to the acceleration of the general crisis of conscience and consciousness.

The italicized phrases incorporated into "Beyond Painting" are titles of actual works, a device common to Ernst's writings, and one which serves to emphasize the very close relationship between the visual and verbal in his art; this was particularly apparent in the Dada collages mentioned by Aragon (pp. 39–50) in which the inscribed title and depicted image play off each other in a round of verbo-visual puns, or "sight-gags" as they are called in film. This was carried to an innovatory extreme in Ernst's "collage-novels." Although he had made entire collages of cut-up nineteenth-century wood engravings as early as 1921, the idea for a sustained suite or "novel" of them apparently occurred to him only when he was in the hospital in 1929 and someone brought him a mass of old illustrated magazines. The result was *La Femme 100 Têtes* (a pun fusing "The Hundred-Headed Woman" and "The Headless Woman"), 1929, *The Dream of a Little Girl Who Wanted to become a Carmelite,* 1930, and *One Week of Kindness,* 1934.

The Dream of a Little Girl . . . with its schizoid protagonist—Marceline/Marie, its blatant but wittily erotic anticlericalism, and potent sexual images, provides a synthesis not only of Ernst's own painted, sculpted and collaged imagery and obsessions (birds, flowers, forests, brides, moons, suns . . .), but also those of Surrealism as a whole. The collage-novels have a decidedly cinematic air and a specificity that, despite their non-photographic source, is analogous to Dali's and Buñuel's contemporary films (see pp. 101–7). The poetic captions below the full-page collage reproductions refer only glancingly to the pictures and it is the collages which outline the "plot." Such dislocation in action and sequence, juxtaposed against the ambiguous captions, suggest a silent movie with subtitles in an absolutely unknown language.

[6] Editor's note: see above pp. 9–35.

Dream of a Little Girl Who Wanted
to become a Carmelite: Preface

The night will come when the Academy of Sciences itself will not
disdain to plunge its gaze into the sewers of the world. The night
will come when, covered with all their jewels, the few secondary
skeletons called scholars will pose this problem:

What are the dreams of little girls who want to become Carmelites?

A violent storm will break out that night at the gates of the Academy
of Sciences, and water will roar in the pipes.

The water will remember the year of our shame 1930 when it would
have liked to see all the cathedrals in the universe parade in too
short dresses. It will especially remember one night. For . . .

The night of Good Friday of the year of our shame 1930 a little
girl barely sixteen years old soaked her hands in a sewer, pricked her-
self, and, with her blood, traced these lines:

To love the Good Lord well and soak our two hands in a sewer,
that is our good fortune, Children of Mary.

From the convent of the Visitation in Lyon, where she was raised,
she sent this sentence by carrier pigeon to her father, a Christian-
Socialist deputy in Paris, kissed him tenderly in spirit, went to bed,
and had the dream which we shall try to tell here by means of images.

In the sentence above, it is easy to trace the irresistible tendency
which led her to the practice of obstinate devotion and theatrical
sacrifice. It is easy to recognize the precocity of her fine intelligence,
her brilliant imagination, her ardent heart.

The same powerful sentiment which led her, in her eleventh year,
to enroll under the banner of Little Theresa of the Infant Jesus, had
been manifested since her extreme youth through her love for Latin
studies; she wrote, as though playing a game, sentences which some-
times revealed all the delicacy, sparkled with all the verve of a Latin
soul:

—Diligembimini gloriam inalliterabilem mundi fidelio.

—Benedictionem quasimodo feminam multipilem catafaltile astoriae.

At thirteen she called her body her dark prison:

—Hidden in the folds of my dark prison, multicolored groups repre-
sent the various peoples of the world.

It seems to me that these sentences already denote the spirit and
reveal the seeds of the extraordinary dream which follows.

"Dream of a Little Girl Who Wanted to Become a Carmelite: Preface" by Max
Ernst. Translated by the editor from Rêve d'une petite fille qui voulut entrer au
Carmel (Paris: Editions du Carrefour, 1930). Courtesy of Max Ernst.

For the comprehension of this dream it seems rather important to state here that at the age of seven she lost her virginity through the savagery of a base individual. This happened the very day that first communion had been refused her: she was too young, as her baby teeth testified. The individual, not content with having subjected her to his ignominies, took a large pebble and broke all her teeth with an incredible ferocity.

Then she returned to say to R. P. Denis Dulac Dessale, showing him her bloody mouth:—Now I can take communion, I have no more baby teeth.

Still a child, not mature enough to realize all her good fortune, she nevertheless sent her father the following message, again by carrier pigeon:—Oh, I am so happy! How right you were to say that the day of the first communion is the most beautiful day of one's life! Laudate dominum de coelibus catalinenia.

<div align="right">Spontanette.</div>

"Spontanette" was the pet name her father had given her because of her lively, alert and playful character, and also because of the red vapor she usually wore around her hips and ankles. Her real baptized name was Marceline-Marie. This double name was of primordial importance in the evolution of the following dream. For it is probably on account of the troubles provoked by the coupling of two names of such diverse significance that we will see her, from the beginning of the dream, split down the center of her back and assuming the continually changing appearances of two distinct but closely bound people, of "two sisters" as she says to herself in the dream, one of whom she calls "Marceline" and the other "Marie," or "me" and "my sister." It must also be noted that during the entire dream she succeeds only very rarely in identifying herself with either of them in a positive fashion, and that only in those happy moments does she see beyond her appearances to her real age, her real sex, dressed and hairdressed as usual, etc.

Note too that the "vocation" which she had invoked with all her heart since the tooth breaking—deflowering—first communion day, came to her at the age of eleven during the benediction ceremony of a cast-iron statue of the "Little Saint of Lisieux." She remained motionless during the procession of the relics of the martyrs and during the sermon, that is for two hours, arm outstretched, knife in hand to "incise the earth." Suddenly, at the very moment when the seminarians intoned the "Exaltation Chant of the Children of Mary," she rose above the floor, stayed suspended in space for several seconds, and cried out in an inspired voice, deliciously pure and surpassing in strength the choirs and organs:

"Enter dear knife, enter into the chamber of chambers.

"I sacrifice, I offer myself!"

The seminarians were silent, stupefied.

—Then, from the high altar, R. P. Denis Dulac Dessale replied, My child, glory to God and the Holy Church. You have, yes, you have a religious vocation. You must accept the part offered you, but you are only eleven years old! How much you owe to Mary, your beloved mother and patron! It is she, don't doubt it, who has done everything, before, during, and after.

—Before, during, and after, chimed the whole assembly.

That evening, perhaps from carelessness, she broke a porcelain vase which serves the intimate needs of little girls at night, and for this misdeed, was condemned to pay a penalty. She would pay it, this penalty, but after having improvised a scene which would ridicule the punishment inflicted by the Mother Superior. Until midnight she sang the "Wine of Consolations," a monotone chant of penitence repeated on one single note, got up afterwards and bit to the quick all the fingernails of her sleeping companions. In the morning she stood at the door when the bell rang for the students to leave the dormitory, held out to each one a fragment of the vase transformed into a begging bowl, and in a voice half sad, half mocking:

—I plead, she said, the cause of right and justice against the adversaries of religion. One penny, I beg of you, for the poor girl who has broken her vocation. It is she who has done everything, before, during, and after. The splendor of the stars is not reserved for those who have tickets.

Alberto Giacometti

Alberto Giacometti (1901–66) went to Paris from Switzerland in 1923 and had been studying sculpture with Bourdelle and others for six years when he met the Surrealists in 1929. He was involved with them only until 1935, when he rejected his Surrealist work, which he later called "nothing but masturbation," and returned to painting and working from the model, for which he was immediately expelled by the group. During those six years, however, he originated Surrealist sculpture (as distinct from the typically conglomerate Surrealist object). Somewhat influenced by Brancusi, he in turn had a strong effect on the only other two artists who can be said to have made Surrealist sculpture in the 30s—Arp and Ernst (Picasso's and Miró's sculptures being less easily categorized).

Giacometti also made one of the first mobiles (*The Hour of Traces*, 1930) and floor sculptures (*Woman with Her Throat Cut*, 1932). His *Palace at 4 A.M.* now in New York's Museum of Modern Art, variously referred to in the texts below, is both theatrical and fully sculptural. It is a key work for the history of modern sculpture as well as for Surrealism, especially as its premises were later adapted by the so-called "Abstract Expressionist sculptors" in America. Despite his disavowal of Surrealism, there are definite references, both formal and emotional, to the work of the early 30s in Giacometti's extraordinarily elongated "existentialist" figures, on which his reputation now rests, and especially in those lonely, needle-like nudes wandering in empty city squares. The childhood reminiscences and free associations in the texts reproduced here refer as often to images in his late as his early work.

Yesterday, Moving Sands

As a child (between four and seven years old), I saw in the outside world only those objects useful to my pleasure. These were above all rocks and trees, and rarely more than one object at a time. I remember that for at least two summers I saw nothing of my surroundings but one large rock which was located about 800 meters from the village, that rock and objects relating directly to it. It was a golden-

"Yesterday, Moving Sands" by Alberto Giacometti. Translated by the editor from "Hier, sables mouvants," Le Surréalisme au Service de la révolution, no. 5 (May 1933), pp. 44–45. Courtesy of Mme. Annette Giacometti.

colored monolith, its base opening into a cave: all the lower part was
hollow, the work of water. The entry was low and elongated, hardly
high enough for us at that age. In places, the interior was still more
recessed, seeming to form a second little cave at the very back. It was
my father who showed us this monolith one day. Enormous discovery;
immediately I considered this rock a friend, a creature animated by
the best intentions toward us; calling us, smiling to us, like some
beloved old friend, found again with infinite surprise and joy. Right
away it occupied us exclusively. From that day we spent all our
mornings and afternoons there. We were five or six children, always
the same ones, inseparable. Every morning when I awoke, I sought the
rock. From the house I saw it in its most minute details, as I did
the thread-like path which led to it; everything else was vague and
inconsistent, air attached to nothing. We followed that path without
ever leaving it and never left the area immediately surrounding the
cave. Our first concern, after the discovery of the rock, was to delimit
the entry to it. There had to be only one crevice, just large enough
to let us pass. But I was overcome with joy when I could crouch in
the little rear cave; I could barely contain myself; all my desires were
realized. One time, by some accident I don't remember, I got further
away than usual. Soon I found myself on a high place. Before me, a
little below, in the midst of the brambles, reared an enormous black
rock in the form of a narrow and pointed pyramid whose walls fell
almost vertically. I can not express the feeling of spite and defeat I
experienced at that moment. The rock struck me immediately as a
living creature, hostile, threatening. It threatened everything: us, our
games, and our cave. Its existence was intolerable to me and I sud-
denly felt—not being able to make it disappear—that it must be
ignored, forgotten, and never mentioned to anyone. Nevertheless I
did approach it, but with the feeling of delivering myself to some-
thing reprehensible, secret, suspicious. One hand barely touched it,
with repulsion and fright. I walked around it, trembling to discover
an entrance. No trace of a cave, which made the rock still more in-
tolerable, but I still felt some satisfaction: an opening in this rock
would have complicated everything and I already felt our cave's des-
olation if one were to be occupied with another at the same time.
I fled from this black rock, I did not mention it to the other children,
I ignored it and never returned to see it.

* * *

At the end of the same period, I impatiently awaited the snow. I
was not calm until the day when I estimated there had been enough
(and I estimated it time and again too early) for me to go, alone,
carrying a bag and a pointed stick, into a field at some distance from

the village (it was a secret matter). There, I tried to dig a hole just large enough to get into. On the surface only a round opening, as small as possible, was to be seen, nothing else. I proposed to spread the sack in the bottom of the hole and, once there, I imagined this place very hot and black; I thought I must experience a great joy . . . during the course of the preceding days, I often felt the illusion of this pleasure in advance; I spent my time going over the whole technique of this construction, mentally I accomplished all the work down to minute details; each gesture was lived in advance; I pictured the moment when I would have to take precautions to avoid its falling in. I was filled with the pleasure of seeing my hole completely set up and entering it. I would have liked to pass the whole winter there, alone, enclosed, and I thought with regret that I would have to return to the house to eat and sleep. I ought to mention that despite all my efforts, and also probably because exterior conditions were bad, my desire was never realized.

＊　　＊　　＊

When I first went to school, the first country which seemed marvelous to me was Siberia. There, I saw myself in the middle of an infinite plain, covered with grey snow: there was never any sun and it was always cold. The plain was bordered on one side, quite far from me, by a pine forest, a monotonous and black forest. I regarded this plain and this forest through the little window of an isab (this name was essential for me) in which I stayed, and where it was very hot. That was all. But very often I mentally transported myself to that place.

＊　　＊　　＊

In regard to a similar mental solicitation, repetition, I remember that at the same time, for months, I could not sleep at night without first imagining myself to have crossed at dusk a thick forest, and to have arrived at a grey castle which stood in the most hidden and unknown spot. There I killed, without their being able to defend themselves, two men, one of whom, around seventeen years old, always seemed pale and terrified, and the other of whom wore armor on the left side of which something shone like gold. I raped, after having torn off their dresses, two women, one thirty-two years old, all in black, with a face like alabaster, then her daughter, dressed in floating white veils. The whole forest resounded with their cries and whimpers. I killed them too, but very slowly (it got dark at that point) often beside a pond of stagnant green water in front of the castle. Each time with slight variations. Next I burned the castle and, content, fell asleep.

$1 + 1 = 3$...

I can only speak indirectly of my sculptures and hope at least to say in part what motivated them.

For many years I only executed sculptures that have presented themselves to my mind entirely accomplished, I limited myself to reproducing them in space without changing anything, without asking myself what they could mean (if I merely undertake to modify one part, or if I have to search for a dimension, I become entirely lost or the whole object gets destroyed). Nothing has ever appeared before me in the form of a picture, I rarely visualize in the form of drawing. The attempts at conscientious realization from a picture or even from a sculpture to which I have sometimes yielded have always failed.

Once the object has been constructed, I have a tendency to rediscover, transformed and displaced, images, impressions, realities which have moved me profoundly (often in my unconscious), forms to which I feel myself very close, although I may often be unable to identify them, and they become all the more troubling for me.

I take as an example the sculpture which represents a palace. This object took form little by little by the end of summer 1932; it clarified slowly for me, the various parts taking their exact form and their particular place in the ensemble. By the time autumn came it had attained such reality that its execution in space did not take me more than one day.

Without any doubt it relates to the epoch in my life which had come to a close one year previously, the period of six months passed hour by hour in the presence of a woman who, concentrating all life in herself, transported my every moment into a state of enchantment. We constructed a phantastical palace in the night (days and nights had the same color, as if everything had happened just before daybreak; I did not see the sunlight all this time), a very fragile palace of matches: at the least false movement a whole section of this diminutive construction would collapse; we always began it all over again. I do not know why it became populated with the spinal column in a cage—the spinal column which this woman sold me one of the very first nights I met her in the street—and with one of the skeletal birds which she saw the very night that preceded the morning our life together collapsed—the skeletal birds hovering very high over the basin of clear and green water, where the very delicate and very white skeletons of fishes were floating, in the great open hall amongst ex-

"*1 + 1 = 3*" by Alberto Giacometti. Translated by Ruth Vollmer and Don Gifford [*from untitled French text*, Minotaure, no. 3 (*1936*)] in trans/formation *1, no. 3* (*1952*): *165–66. Courtesy of Mme. Annette Giacometti.*

clamations of enchantment at four o'clock in the morning. In the middle rises the scaffolding of a tower, a tower possibly unfinished or whose upper part has collapsed, broken to pieces. On the other side came to be placed the statue of a woman, in which I discover my mother the way she impressed herself on my earliest memories. The long black dress that touched the ground disturbed me with its mystery; it seemed to be part of her body and this caused in me a feeling of fear and confusion; all the rest vanished, escaped my attention. This figure stands out against the thrice repeated curtain and it is upon this curtain that my eyes opened for the first time. Fallen prey to an infinite charm I stared at this brown curtain from beneath which a thin thread of light filtered along the parquet.

I cannot say anything about the object in the center, lying on a small board it is red; I identify myself with it.

A Letter

Here is the list of sculptures that I promised you, but I could not put it down without explaining a certain succession of facts, even though very brief, yet without which it would make no sense.

I made my first bust from nature in 1914, and continued working all the following years, during the period of my schooling.

I have a certain number of these busts and still look at the first with the feeling of longing and nostalgia.

At the same time and even years before I was doing a lot of drawings and paintings, besides drawing from nature and illustrating the books I read I often copied paintings and sculptures from reproductions. I say this because I have continued to do the same thing with only short interruptions up to the present.

In 1919 I went to the Ecole des Beaux Arts in Geneva for three days, and after, to the Ecole des Arts et Métiers to study sculpture. I painted water colors in the suburbs and by the shore of the lake, and did oil paintings at home.

In 1920 to 1922 I lived in Italy. In Venice first, where I spent my days looking especially at Tintoretto, not wanting one to escape me.

Tintoretto was a little dethroned, to my great regret, on the day I left Venice, by the Giottos in Padua, and the latter in turn some months later by the Cimabues at Assisi.

"A Letter" by Alberto Giacometti. Written to Pierre Matisse; anonymous translation first published in Alberto Giacometti: Exhibition of Sculptures, Paintings, Drawings *(New York: Pierre Matisse Gallery, January 19–February 14, 1948). Courtesy of Mme. Annette Giacometti and Pierre Matisse. Also published in* trans/formation *1, no. 3 (1952), and in* Alberto Giacometti *(New York: The Museum of Modern Art, 1965).*

I stayed nine months in Rome where I never had enough time
to do all I wanted. I wanted to see everything, and at the same time
I painted figures and landscapes in a somewhat pointillist way (I had
begun to feel that the sky is blue only by convention but that it is
really red) and compositions inspired by Sophocles and Aeschylus
that I was reading at this time (The Sacrifice of Iphigenia, The Death
of Cassandra, The Sack of Troy, etc.).

I had also begun two heads, a small one, and for the first time I
could not find my way out, I was lost, everything escaped me. The
head of the model before me became like a cloud, vague, unlimited.
I ended by destroying them before I left. I passed a lot of time in
museums, in churches, in ruins. I was particularly impressed by the
mosaics and the Baroque Period. I remember each sensation in front
of everything I saw.

I filled my notebook with copies (a marvelous sketch of Rubens
which comes to my mind this instant and the mosaic of Saint Cosme
and Damian and the latter is followed immediately by thousands of
other things, but I must hurry).

In 1922 my father sent me to Paris to attend the Academy. (I would
have preferred in a way to have gone to Vienna where money had
little value. At this period my desire for pleasure was stronger than
my interest in the Academy.)

From 1922 to 1925 and later I went to the Academy of the Grande
Chaumière to study in the studio of Bourdelle. In the morning I did
sculpture and the same difficulties began that I had experienced in
Rome. In the afternoon I drew, I could no longer bear sculpture
without color and I often tried to paint them after nature. I had
kept some of these for years, and then, mostly to make space, I had
them taken out and thrown away.

Impossible to grasp the whole of a head (we were much too near
the model, and if one started on a detail, a heel, or a nose, there was
no hope of arriving at the ensemble).

But if, on the other hand, one began by analyzing the detail, the
end of the nose, for example, one was lost. The form distorted itself,
it was little more than specks moving in a deep black emptiness. The
distance between one side of the nose and the other is like the Sahara.
There is no fixed point, no limitation of view, everything escapes.

As I wanted nevertheless, to realize the little that I understood and
saw, I began in desperation to work at home from memory. I tried
to save the little I could from this catastrophe. This brought, after
many sketches bordering on cubism, one necessarily had to touch on
it (it is too long to explain now) objects which were for me the nearest
I could get to my vision of reality.

This made me understand a certain part of the vision of reality but

was without what I felt I needed to realize the whole, a structure, a sharpness that I felt, a kind of skeleton in space.

Figures were never for me a compact mass but like a transparent construction.

After making once again all kinds of attempts I made cages, and inside them, a free construction executed in wood by a carpenter.

There was a third element in reality which struck me: movement.

Despite all my efforts, it was impossible for me to endure a sculpture which gave an illusion of movement, a leg advancing, a raised arm, a head looking sideways. Such movement I only wanted if real and effective. I also wanted to give the sensation of provoking it.

Several objects moving in relation to one another.

But all this took me little by little away from an exterior reality, I had a tendency to care only for the construction of the objects themselves.

There was in these objects an aspect too precious and too classical; and I was disturbed by reality which seemed different. Everything to do with this at that moment seemed a little grotesque, without value, to be thrown away. This is said summarily. Objects without foundation, without value, to be thrown away.

It was not anymore the exterior of beings that interested me but what I felt affected my life. During all the previous years (the period of the Academy) there had been a disagreeable contrast for me between life and work, one prevented the other; I found no solution. The fact of wanting to copy a body at a fixed hour and a body, by the way to which I was indifferent, seemed to me an activity that was false at its base, stupid, and which made me waste many hours of my life.

It was not important anymore to make a figure exteriorly life-like, but to live and to realize what moved me within, or what I desired. But all this changed, contradicted itself, and continued by contrast. A need also to find a solution between things that were full and calm, and clear and violent. Which led during those years (1932–1934 approximately) to objects moving in opposite directions, a kind of landscape-head, lying down, a woman strangled, her jugular vein cut, construction of a palace with a bird skeleton and a dorsal spine in a cage, and a woman at the other end. A layout for a large garden sculpture (I wanted one to be able to walk, sit, and lean, on the sculpture). A table for a hall, and very abstract objects brought me by contrariwise to figures and skull-heads.

I saw afresh the bodies that attracted me in life and the abstract forms which I felt were true in sculpture. But I wanted the one without losing the other (very briefly put).

A last figure, a woman called 1 + 1 = 3.

And then the desire to make compositions with figures, for this, I had to make (quickly I thought) one or two studies from nature, just enough to understand the construction of a head, of a whole figure, and in 1935 I took a model.

This study should take me (I thought) two weeks, and then I could realize my compositions.

I worked with the model all day from 1935 to 1940.

Nothing turned out as I had imagined. A head (I quickly left aside figures, it was too much) became for me a completely unknown object, one with no dimensions. Twice a year I began two heads, always the same without ever ending, I put my studies aside. (I still have the casts.)

Finally, in trying to accomplish a little, I began to work from memory. This mainly to know how much I retained of all this work. During all these years I drew and painted a little, most of the time from nature.

But wanting to create from memory what I had seen, to my terror the sculptures became smaller and smaller, they only had a likeness when very small, yet their dimensions revolted me, and tirelessly I began again and again, to end, several months later, at the same point.

A large figure seemed to me untrue and a small one intolerable, and then often they became so very small that with one touch from my knife they disappeared into dust. But head and figures only seemed to me true when small.

All this changed a little in 1945 through drawing.

This led me to want to make larger figures, then to my surprise, they achieved a resemblance only when long and slender.

And it is almost there where I am today, no, where I still was yesterday and I realize this instant that if I can draw easily all sculpture I could only with difficulty draw those I made during these last years; perhaps if I could draw them it would not be necessary to make them, but I am not sure about all this.

And now I stop, besides they are closing, I must pay.

Arshile Gorky

Arshile Gorky (1904–48) is considered by many the last genuine (or at least, important) convert to Surrealism as well as the first "Abstract Expressionist." An Armenian-born American, living in New York when the Surrealists arrived in exile from the war, a man of exotic and finally tragic temperament, Gorky had spent years absorbing Picasso's lessons. In the early 40s his work began to show the influence of Miró, probably in response to the latter's retrospective at the Museum of Modern Art in 1941, and of Matta, also in New York then. He met Breton in 1944, and though they spoke no language in common, they became good friends. Gorky's 1945 exhibition at the Julien Levy Gallery (home away from home for the exiled Surrealists) was accompanied by a Breton preface—"The Eye-Spring." While the erotic, biomorphic, yet very abstract forms of Gorky's painting were rougher and stronger than those of his European colleagues, the impact of Surrealism was obvious in them. In a 1941 interview, Gorky had said his art could be called "surrealistic" because "What man has not stopped at twilight and, on observing the distorted shape of his elongated shadow, conjured up strange and moving and often fantastic fantasies from it? Certainly we all dream and in this common denominator of everyone's experience, I have been able to find a language for all to understand."

The statement below was written on request about the Museum of Modern Art's oil, *The Garden in Sochi*, one of a series based on images associated with Gorky's childhood in Armenia. "The Garden of Wish Fulfillment" (in Lake Van, not Sochi) provides the central images of a tree hung with strips of colored cloth, bird, rock and breasts.

Garden in Sochi

I like the heat the tenderness the edible the lusciousness the song
of a single person the bathtub full of water to bathe myself beneath

"Garden in Sochi," June, 1942, by Arshile Gorky. From the Collection Archives (New York: The Museum of Modern Art). Courtesy of The Museum of Modern Art. Also published in Ethel Schwabacher, Arshile Gorky *(New York: The Macmillan Company, 1957) and* New York School *(Los Angeles County Museum, 1965).*

the water. I like Uccello Grünewald Ingres the drawings and sketches
for paintings of Seurat and that man Pablo Picasso.
I measure all things by weight.
I love my Mougouch. What about Papa Cézanne.
I hate things that are not like me and all the things I haven't got
are god to me.
Permit me—
I like the wheatfields the plough the apricots the shape of apricots
those flirts of the sun. And bread above all.
My liver is sick with the purple.

 About 194 feet away from our house on the road to
 the spring my father had a little garden with a
 few apple trees which had retired from giving fruit.
 There was a ground constantly in shade where grew
 incalculable amounts of wild carrots and porcupines
 had made their nests. There was a blue rock half
 buried in the black earth with a few patches of moss
 placed here and there like fallen clouds. But from
 where came all the shadows in constant battle like
 the lancers of Paolo Uccello's painting? This garden
 was identified as the Garden of Wish Fulfillment
 and often I had seen my mother and other
 village women opening their bosoms and taking their
 soft and dependable breasts in their hands to rub
 them on the rock. Above all this stood an enormous
 tree all bleached under the sun the rain the cold
 and deprived of leaves. This was the Holy Tree.
 I myself do not know why this tree was holy
 but I had witnessed many people whoever did pass
 by that would tear voluntarily a strip of their clothes
 and attach this to the tree. Thus through many
 years of the same act like a veritable parade
 of banners under the pressure of wind all these
 personal inscriptions of signatures very softly to my
 innocent ear used to give echo to the sh-h-h of
 silver leaves of the poplars.

Frederick Kiesler

Frederick Kiesler (1896–1965) was an Austrian, later American, architect, whose visionary projects were all too rarely executed. His "City in Space" at the Paris World's Fair of 1925 was already far ahead of its time, and his projects for an "Endless House," a series of egg-like concrete shells with no structural members, which provide an open, flowing, organic space with obvious parallels in Surrealist painting, occupied him until the end of his life. A sculptor as well as an architect, Kiesler was much concerned with a fusion of the arts, and to this end developed his own one-man "movement" called Co-Realism.

In Vienna, Kiesler had worked in the theatre and had designed moving scenery and a theatre in the round by 1924. His role in the Surrealist movement in New York in the 40s combined his theatrical and architectural talents. In 1942, he designed Peggy Guggenheim's gallery-museum, "Art of This Century," a long cylindrical space from which paintings projected on rods, with biomorphic furniture that could be turned around to serve as sculpture stands. The same year he participated in the "First Papers of Surrealism" exhibition; in 1947 he designed the "Bloodflames 1947" show at New York's Hugo Gallery, and, with Duchamp's cooperation, installed the last major Surrealist exhibition at the Galerie Maeght in Paris. The text below refers to that show, for which Kiesler made his first sculpture, *Totem of Religions*. Breton had planned a "mythical" theme, including a Labyrinth, a Rain Hall, an Initiation Place, etc. The Hall of Superstitions was an egg-shaped white grotto made of fabric over a curved stretcher. Tanguy made a "scaffolding" of blue-grey biomorphic shapes hanging from the ceiling, and other artists worked with Kiesler for a generally environmental effect.

The Magic Architecture of the Hall of Superstition

The nineteenth century was the twilight and the first quarter of the twentieth century saw the ruin of the unity of the architecture-

"The Magic Architecture of the Hall of Superstition" by Frederick Kiesler. Translated by the editor from H. P. Roche's French translation of lost English original,

painting-sculpture alliance. The Renaissance bloomed in this Unity. The people's faith in the happiness of the Beyond carried it there on wings.

* * *

In our times (1947) we are rediscovering social consciousness. The instinctive need for a new unity was reborn. This unity's hope is no longer placed in the beyond, but in the HERE AND NOW.

* * *

The new reality of the Plastic Arts is manifested as a correlation of data based not only on the perceptions of the five senses, but also in response to psychic needs.

* * *

"Modern functionalism" in architecture is dead. Inasmuch as "function" was vestigial, with not even an examination of the Body Kingdom on which it rested, it failed and was exhausted in the Hygiene and Estheticism mystique (The Bauhaus, Corbusier's system, etc.).

* * *

The Hall of Superstition presents an initial effort towards a Continuity of Architecture-Painting-Sculpture, with the means and expression of our times.

The problem is twofold: 1) to create a unity; 2) in which the painting-sculpture-architecture constituents can be transformed into each other.

* * *

I drew up the spatial configuration. I invited the painters Duchamp, Max Ernst, Matta, Miró, Tanguy, and the sculptors Hare and Maria[1] to execute my plan. They collaborated enthusiastically. I conceived each part of the whole, form and content, especially for each artist. There was no misunderstanding. If the ensemble did not work it was my fault alone, for they strictly followed my correlation plans. This collective work created not by artists of a single profession, but by the Architect-Painter-Sculptor alliance plus the Poet (author of the

"*L'Architecture magique de la Salle de Superstition,*" Le Surréalisme en 1947 (*Paris: Galerie Maeght, July–August 1947*), *pp. 131–34. Courtesy of Lillian O. Kiesler and Galerie Maeght.*

[1] The black lake (spring nourishing anguish), by MAX ERNST; the waterfall concealed by superstitions, by MIRÓ; Whist (Owl's luck, Crow's luck, Bat's luck, Woman's luck), by MATTA; the green ray, by MARCEL DUCHAMP; the totem of religions (drawing by KIESLER), executed by ETIENNE MARTIN; the anguishman sculpture by DAVID HARE (drawing by KIESLER); the vampire by DE DIEGO; the evil eye by DONATI; the anti-taboo fig, by KIESLER.

Theme), represents, even in case of failure, the most stimulating promise of development for our plastic arts.

I oppose the mysticism of Hygiene, which is the superstition of "Functional Architecture," the realities of a Magic Architecture that takes root in the totality of the human being, and not in the blessed or cursed parts of that creature.

René Magritte, E. L. T. Mesens, and Jean Scutenaire

René Magritte (1898–1967), influenced by de Chirico and by Max Ernst's collages, began around 1925 to paint curiously disturbing subject matter in a dry manner that became the cornerstone of the *"peinture-poésie,"* or literary-precisionist branch of Surrealist painting. Unlike those of Dali and other illusionists of the 1930s, Magritte's subjects were generally as understated as his technique, and all of his work, no matter what it depicts, is essentially still life. Where Ernst fused word and image, Magritte sought to separate their implications in an almost academic manner. One of his most famous paintings is the picture of a pipe and an inscription: "this is not a pipe"; in other words, it is not a pipe but the picture of a pipe. (The *title* of this painting is "The Wind and The Song.") Similarly, Magritte's "picture within-a-picture" motifs endlessly vary the relationship between a painted reality (a picture of a painted canvas on an easel) and "real" reality (the landscape in which it stands).

Although he lived in Paris for a few years, Magritte spent most of his life in his native Brussels, where he was a co-founder of the Belgian Surrealist movement, with E. L. T. Mesens—a poet, critic and collagist, Paul Nougé, and Scutenaire, who used the name "Jean" as a lawyer and "Louis" as a poet. "The Five Commandments" from *Oesophage,* a one-shot review published by this group in 1925, are, strictly speaking, more Dada than Surrealist in tone. The two later texts are more typical of Surrealism; Bourgeois Art" reflects the concern of many artists (even those so notably apolitical as Magritte), with the state of the world in the late thirties; "Lifeline" reflects the preoccupation with childhood memories, second only to dreams in the Surrealist litany; and "Ariadne's Thread" restates the optimistic hopes of the movement to change the consciousness of the world.

The 5 Commandments

1. In politics we will practice auto-destruction with all our might, and trust in human virtues.

"The 5 Commandments" by *René Magritte and E. L. T. Mesens. Translated by Margaret I. Lippard from "Les 5 Commandemants,"* Oesophage, no. *1* (*March 1925*). Courtesy of Mme. René Magritte.

2. All our collaborators must be handsome so we can publish their portraits.

3. We will energetically protest all erudite decadence, *The Charterhouse of Parma,* dadaism and its substitutes, morality, union of north and south, syphilis in its various stages, cocaine, scratchy hairs, compulsory education, polyrhythm, polytone, polynesia, carnal vices, and particularly homosexuality in all forms.

4. Our freshness will submit neither to second-hand tubes nor to our friends' wives.

5. Under all circumstances we will refuse to explain precisely what will not be understood.

Our enterprise is as mad as our hopes. Having taken the greatest precautions with things of the least importance, we will claim nothing; love of the most superior girls is more important. "Hop-la, Hop-la," that is our motto.

Ariadne's Thread

The most authentic manifestations of the mind seem vulnerable, thanks to some defect: one gets rid of them too easily; if the slightest sentimental grievance intervenes, they are denied with scorn or indifference.

As for the poetic effect, most of the time its scant effectiveness does not so much arise from the poverty of its mechanisms as from its real weakness. Given a bit of experimentation, this weakness and the constantly repeated deception accompanying it becomes evident. It is still more aggravated by the extent to which the poetic effect approaches the esthetic plane. There are rare exceptions to stage settings giving the illusion of contact with reality, but encountering only the void.

But *assuming as real* the poetic fact, if we try to discover its *meaning,* we find a new orientation which immediately removes us from that barren region that the mind has ceased to fecundate. The object of poetry would become a knowledge of the secrets of the universe which would allow us to act on the elements. Magical transactions would become possible. They would truly satisfy that profoundly human desire for the marvellous, which has been deceived by miracles and to which, still very recently, we owe the success of sordid apparitions.

In order to consider this desire seriously, one must renounce, for once and for all, the idea of being satisfied with subterfuges. And the discovery of so beautiful a secret should never be used for the

"Ariadne's Thread" by René Magritte. Translated by Margaret I. Lippard from "Le fil d'Ariane," Documents 34, *n.s., no. 1 (June 1934), p. 15. Courtesy of Mme. René Magritte.*

facile transformation of everything into astonishing objects—for the sole and immediate pleasure of a poetic effect henceforth without quality.

The reality of the element which confides its secret to us is surely the place from which one should not stray at any price; it is a landmark.

Bourgeois Art

Middle-class order is only disorder. Disorder to the point of paroxysm, deprived of all contact with the world of necessity.

The profiteers of capitalist disorder defend it by a stack of sophisms and lies whose credit they attempt to maintain in all realms of human activity.

Thus they do not hesitate to affirm that the bourgeois social order has permitted an extraordinary cultural development and that art, among other things, has conquered unexplored regions until then apparently inaccessible to the mind.

Doubt is no longer possible. We must denounce this imposture. Our criticism is based not on the desire for combat but on precise and strictly objective observations alone.

The very special value accorded to art by the bourgeoisie brutally unmasks the vanity of its esthetic concepts erected under the pressure of class interests totally foreign to cultural preoccupations.

The ruse consists essentially of warping the normal relationship between man and the world so that it is no longer possible to use the object for itself but always for motives perfectly foreign to it. A diamond is desired not for its intrinsic properties—its only authentic qualities— but because, being very expensive, it confers on its possessor a kind of superiority over his fellow men and constitutes a concrete expression of social inequality. Moreover, things take a ridiculous turn when a false diamond is bought unknowingly, since the satisfaction would be the same as it would be if the prize had been won.

Things are no different in art. Capitalist hypocrisy, always refusing to take a thing for what it is, lends to art the characteristics of a superior activity, although it lacks any resemblance to man's general activity. While usually man MAKES something, accomplishes some task within an ordinary range, the middle-class artist claims TO EXPRESS elevated sentiments relevant only to himself. Here bourgeois individualism is pushed to the extreme, that individualism which isolates men and permits each one to consider himself superior to his fellow men with whom he has no real contact.

"Bourgeois Art" by René Magritte and Jean Scutenaire. Translated by the editor from "L'Art Bourgeois," London Bulletin, no. 12 (March 15, 1939), pp. 13–14. Courtesy of Mme. René Magritte.

One need not imagine, however, that no worthwhile opinion on art has been formulated during the course of capitalist domination. Here it is sufficient to evoke the ideas of Hegel, Nietzsche and Freud. Hegel, who saw clearly that art permits all men to express the very depths of the spirit in a durable manner. Nietzsche, who remarked that one could not envision the impressive number of virgins painted by Raphael without attributing to him an exacerbated sexual prowess. Freud, finally, whose psychological works are of prime importance, who tried to demonstrate that artistic activity is none other than an activity substituted for sexual activity, at times also a preparation for the latter and often even a disguised exhibitionism.

In the light of similar propositions, all the critical literature prowling around the realm of art ought to acknowledge its essential ridiculousness; it recalls a cloud of awkward flies buzzing around a cadaver in an advanced state of decay. It suffices to recall Clemenceau's delirious opinion:

"I have won the world war. But I rely on my incursions into the realm of art to give my name the only renown that will not be exhausted by posterity."

It must be realized that the revolutionary artist is heir to a complex of habits and troubled feelings. He is exposed to scorn and to a certain extent is submitted to the demoralizing effect of obscure and contradictory advice in the midst of which he is lost. His essential freedom is thus threatened. But he rebels against these execrable conditions of life and, with limited means, confronts the suspect ideas of morality, religion, patriotism, esthetics, imposed on him by the capitalist world.

This is why he happens to resort to scandal (Rimbaud wrote on church walls: Shit on God!) which, by overthrowing conformism, can open certain minds to doubt. This is why he tries to realize certain objects (books, paintings, etc.) which he hopes will ruin the prestige of bourgeois myths.

The real value of art is a function of its power of liberating revelation. And nothing confers on the artist any superiority whatsoever in the order of human labor. The artist does not practice the priesthood that bourgeois duplicity tries to attribute to him. Let him not, however, lose sight of the fact that his effort, like that of every worker, is necessary to the dialectic development of the world.

Lifeline

In my childhood I used to play with a little girl in the old crumbling cemetery of an out-of-the-way provincial town, where I always spent

"Lifeline" by René Magritte. Translated by Felix Giovanelli from "La ligne de

my vacations. We would lift the iron grates and descend to the underground passageways. Climbing back up to the light one day I happened upon a painter from the Capital, who amidst those scattered dead leaves and broken stone columns seemed to me to be up to something magical.

When, about 1915, I myself began to paint, the memory of that enchanting encounter with the painter bent my first steps in a direction having little to do with common sense. A singular fate willed that someone, probably to have some fun at my expense, should send me the illustrated catalogue of an exposition of Futurist paintings. As a result of that joke I came to know of a new way of painting. In a state of intoxication I set about creating busy scenes of stations, festivities, or cities, in which the little girl bound up with my discovery of the world of painting lived out an exceptional adventure. I cannot doubt that a pure and powerful sentiment, namely, eroticism, saved me from slipping into the traditional chase after formal perfection. My interest lay entirely in provoking an emotional shock.

This painting as search for pleasure was followed next by a curious experience. Thinking it possible to possess the world I loved at my own good pleasure, once I should succeed in fixing its essence upon canvas, I undertook to find out what its plastic equivalents were.

The result was a series of highly evocative but abstract and inert images that were, in the last analysis, interesting only to the intelligence of the eye. This experience made it possible for me to view the world of the real in the same abstract manner. Despite the shifting richness of natural detail and shade, I grew able to look at a landscape as though it were but a curtain hanging in front of me. I had become sceptical of the dimension in depth of a countryside scene, of the remoteness of the line of the horizon.

In 1925 I made up my mind to break with so passive an attitude. This decision was the outcome of an intolerable interval of contemplation I went through in a working-class Brussels beerhall: I found the door moldings endowed with a mysterious life and I remained a long time in contact with their reality. A feeling bordering upon terror was the point of departure for a will to action upon the real, for a transformation of life itself.

When, moreover, I found that same will allied to a superior method and doctrine in the works of Karl Marx and Frederick Engels, and became acquainted about that time with the Surrealists, who were then violently demonstrating their loathing for all the bourgeois

vie" [manuscript of lecture given by Magritte at the Musée des Beaux-Arts (Antwerp: November 20, 1938)], and published in View 7, no. 2 (December 1946): 21–23. Courtesy of Mme. René Magritte.

values, social and ideological, that have kept the world in its present ignoble state—it was then that I became convinced that I must thenceforward live with danger, that life and the world might thereby come up in some measure to the level of thought and the affections.

* * *

I painted pictures in which objects were represented with the appearance they have in reality, in a style objective enough to ensure that their upsetting effect—which they would reveal themselves capable of provoking owing to certain means utilized—would be experienced in the real world whence the objects had been borrowed. This by a perfectly natural transposition.

In my pictures I showed objects situated where we never find them. *They represented the realization of the real if unconscious desire existing in most people.*

The lizards we usually see in our houses and on our faces, I found more eloquent in a sky habitat. Turned wood table legs lost the innocent existence ordinarily lent to them, when they appeared to dominate a forest. A woman's body floating above a city was an initiation for me into some of love's secrets. I found it very instructive to show the Virgin Mary as an undressed lover. The iron bells hanging from the necks of our splendid horses I caused to sprout like dangerous plants from the edge of a chasm.

The creation of new objects, the transformation of known objects, the change of matter for certain other objects, the association of words with images, the putting to work of ideas suggested by friends, the utilization of certain scenes from half-waking or dream states, were other means employed with a view to establishing contact between consciousness and the external world. The titles of the pictures were chosen in such a way as to inspire a justifiable mistrust of any tendency the spectator might have to over-ready self-assurance.

* * *

One night in 1936, I awoke in a room where a cage and the bird sleeping in it had been placed. A magnificent visual aberration caused me to see an egg, instead of the bird, in the cage. I had just fastened upon a new and astonishing poetic secret, for the shock experienced had been provoked by the affinity of two objects: cage and egg, *whereas before, I had provoked this shock by bringing together two unrelated objects.* From the moment of that revelation I sought to find out whether other objects besides the cage might not likewise show—by bringing to light some element that was characteristic and to which they had been rigorously predestined—the same evident poetry as the egg and cage had produced by their coming together. In the course of my investigations I came to a conviction that I had always

known beforehand that element to be discovered, that certain thing above all others attached obscurely to each object; only, this knowledge had always lain as though hidden in the more inaccessible zones of my mind. Since this research could yield only one exact "tag" for each object, my investigations came to be a search *for the solution of a problem for which I had three data: the object, the thing attached to it in the shadow of my consciousness, and the light under which that thing would become apparent.*

The problem of the door called for an opening through which one could pass. I showed, in my *Réponse Imprévue,* a closed door in a room; in the door an irregular shaped opening reveals the night.

Woman was responsible for *Le Viol (The Rape).* In that picture a woman's face is made up of the essential details of her body. Her breasts have become eyes, her nose is represented by her navel, and the mouth is replaced by the sexual zone.

The problem of the window led to *La Condition humaine.* In front of a window, as seen from the interior of a room, I placed a picture that represented precisely the portion of landscape blotted out by the picture. For instance, the tree represented in the picture displaced the tree situated behind it, outside the room. For the spectator it was simultaneously inside the room; in the picture, and outside, in the real landscape, in thought. Which is how we see the world, namely, outside of us, though having only one representation of it within us. Similarly, we sometimes situate in the past something going on in the present. Time and space then lose that unrefined meaning in which daily experience alone takes stock.

A problem to the solution of which I applied myself, over a long period, was that of the horse. In the course of my research I again had occasion to find that my unconscious knew beforehand the thing that had to be brought to light. In fact, the first glimmer of an idea was that of the final solution, however vaguely adumbrated. It was the idea of a horse carrying three shapeless masses. Their significance became clear only after a long series of trials and experiments. First I painted an object consisting of a jar and a label bearing the image of a horse, with the following printed letters: HORSE PRESERVE (CONFITURE DE CHEVAL). I next thought of a horse whose head was replaced by a hand, with its index finger pointing the direction: "Forward." But I realized that this was merely the equivalent of a unicorn.

I lingered long over an intriguing combination. In a black room, I placed a horsewoman seated near a table; with her head resting on her hand, she was dreamily gazing at a landscape whose limits were the silhouette of a horse. The animal's lower body and forelegs were earthen-colored, while upward from a horizontal line at the level of the horsewoman's eyes, the horse's coat was painted in different sky and cloud hues. What finally put me on the right track was a horse-

man in the position assumed while riding a galloping horse. From the sleeve of the arm thrust forward emerged the head of a noble charger, and the other arm, thrown back, held a riding whip. Beside this horseman I placed an American Indian in an identical posture, and I suddenly divined the meaning of the three shapeless masses I had placed on the horse at the beginning of my experiment.

I knew that they were horsemen and I then put the finishing touches to *La Chaîne sans fin*. In a setting of desert land and dark sky, a plunging horse is mounted by a modern horseman, a knight of the dying Middle Ages, and a horseman of antiquity.

* * *

Nietzsche is of the opinion that without a burning sexual system Raphael could not have painted such a throng of Madonnas. This is at striking variance with motives usually attributed to that venerated painter: priestly influences, ardent Christian piety, esthetic ideals, search for pure beauty, etc., etc. . . . But Nietzsche's view of the matter makes possible a more sane interpretation of pictorial phenomena and the violence with which that opinion is expressed is directly proportionate to the clarity of the thought underlying it.

Only the same mental freedom can make possible a salutary renewal in all the domains of human activity.

This disorderly world which is our world, swarming with contradictions, still hangs more or less together through explanations, by turns complex and ingenious, but apparently justifying it and excusing those who meanly take advantage of it. Such explanations are based on a certain experience, true.

But it is to be remarked that what is invoked is "ready-made" experience, and that if it does give rise to brilliant analysis, such experience is not itself an outcome of an analysis of its own real conditions.

Future society will develop an experience which will be the fruit of a profound analysis whose perspectives are being outlined under our very eyes. And it is under the favor of such a rigorous preliminary analysis that pictorial experience such as I understand it may be instituted.

That pictorial experience which puts the real world on trial inspired in me belief in an infinity of possibilities now unknown to life. I know I am not alone in affirming that their conquest is the only valid end and reason for the existence of man.

André Masson

André Masson (born 1896) came to Paris in 1922. In 1923 he met Breton and began to make automatic drawings, and the next year he joined the new Surrealist movement. He broke with Breton in 1929 and, after living in Spain for three years, rejoined the group in 1937, only to be re-ex-communicated in 1947. At first Masson's work was largely Cubist, but freer elements began to appear and in 1927 he made a major series of Surrealist sand paintings and collages. During the 30s, his work became quite dry and illustrative, but the four years (1941–45) he spent in America and in the Caribbean were fertile ones, and his return to automatic techniques and erotic near-abstractions produced a few important canvases that made a strong impression on the young Jackson Pollock.

Masson is also a printmaker and has illustrated many books and designed sets for ballet and opera. He has called himself a follower of Cézanne and Matisse; his theoretical writings, with their frequent citations of philosophers and old masters, eschew the Surrealists' extravagance in both content and expression, although his fundamental romanticism allies him more generally with their goals. He continues to consider himself "a dissident Surrealist."

Excerpt from *James Johnson Sweeney's Interview with André Masson*

Yes, I was associated with surrealism. With me surrealism has been a cyclic affair. I was one of the first group of surrealists. Then in a manner of speaking I became separated from them.

But I am actually more a surrealist in my illustrations than in my painting. Perhaps it is really that my romanticism appears surrealist.

Fundamentally I am more a sympathiser with surrealism, than a surrealist or a non-surrealist. In the beginning I tried to satisfy myself with the automatist approach. It was I who became the severest critic of automatism. I still cannot agree with the unconscious approach. I do not believe you can arrive by this means at the intensity essential for

Excerpt from "James Johnson Sweeney's Interview with André Masson." From James Johnson Sweeney, ed., Bulletin of The Museum of Modern Art *13, nos. 4–5,* Eleven Europeans in America *(1946). Copyright 1946 by The Museum of Modern Art, New York. Courtesy of André Masson and The Museum of Modern Art.*

a picture. I recognize that there are intense expressions to be obtained through the subconscious, but not without selection. And in that I am not orthodox.

Only so much as can be reabsorbed esthetically from that which the automatic approach provides should be utilized. For art has an authentic value of its own which is not replaced by psychiatric interest.

It is perhaps more difficult for a Frenchman to be an orthodox surrealist than for artists of other races. I like Chardin too much ever to be a surrealist. In Chardin we find no association with things outside the representation itself, or at any rate, a minimum of them. Plastic rigour cannot be replaced by even the richest literary imagination. A painting or sculpture does not have a survival value if it lacks this plastic rigour. The literary imagination in such work is never anything but a pretext or excuse for it and must be absorbed into the plastic form. If it is not, the literary imaginative element soon becomes dated.

As a consequence I am solitary: I am too surrealist for those who do not like surrealism, and not surrealist enough for those who do. I accept the ambiguous situation much as Delacroix did—I do not compare myself with Delacroix, but I believe I understand Delacroix. If he had not the strength of plastic rigour Delacroix would have been a Redon.

The surrealist movement is essentially a literary movement. Its leaders are exacting in literary matters. The surrealist theoreticians are writers; there are no painters among them such as those theoreticians of impressionism as Seurat and Cézanne. In literature the surrealists are as insistent on the exact word as Boileau; but when it comes to painting they are very liberal in matters of structure. The spiritual directors of surrealist painting are not of the profession. They are writers, very brilliant poets who thoroughly recognize the demands of their own profession, but in the case of the plastic arts are not consistently as strict in their requirements. What makes such a complaisance possible is an elasticity of judgment which can lead to deplorable aberrations. . . .

A Crisis of the Imaginary

To look for the unusual at all cost or to shun its appeal, to refer to the *natural*[1] or to protest against it, is not the question. A picture

"A Crisis of the Imaginary" by *André Masson. Anonymous translation from* Fontaine, *no. 35, published in* Horizon *12, no. 67 (July 1945): 42–44. Courtesy of André Masson.*

[1] *"La grande odalisque,"* by Ingres, is no more *natural* than a still life by Georges Braque.

always relates to the Imaginary. Jean-Paul Sartre proves this irrefutably in an important work of this name.

The reality of a picture is only the sum of the elements which compose it: canvas, coloured paints, varnish. . . . But what it expresses is necessarily something *unreal*. And we might add that the artist, whatever pretext he may have for his work, always makes his appeal to the imagination of other people.

Once this is understood, all discussion about the pre-eminence of the super-real over the real (or the contrary) falls flat. Since a picture is in essence something *unreal,* what is the point of giving the advantage to the dream over reality? A victory for the ambiguous.

For instance the surrealist painters implicitly recognise the supremacy of the pictorial imagination over *the imitation of poetry* since they admire Georges Seurat more than Gustave Moreau or Redon. The former, entirely preoccupied by problems relating to his profession, has used only scenes of everyday life for subject-matter: Sunday walks (from which neither the nursemaid nor the soldier is omitted), circuses, fair scenes, the pleasures of the most ordinary citizen—a model undressing, a woman powdering herself. Each picture was preceded by numerous studies "from nature." And let us not forget the method: the dot, the most deliberate and considered of techniques: automatic to the least possible degree. But the "subject" is a secondary affair and what does it matter if the artist lets himself be carried away by dreams. The dreams of Goya are the equal of his observations.

The childish mistake has been to believe "that to choose a certain number of precious stones and to write down their names on paper was the same, even if well done, as *making* precious stones. Certainly not. As poetry consists of creating, we must take from the human soul moods and lights of such absolute purity that well hung, and well displayed, they really constitute the jewels of man . . ." This remark of Mallarmé condemning one kind of literature can be applied very well to a certain kind of painting.

In fact, the mistake is to believe that there is anything except the intrinsic value of a work: the personal flavour it gives out, the new emotion it displays and the pleasure it gives.

A work of art is not written information. Read again in the inexhaustible *Curiosités esthétiques* the passage summing up the failure of Grandville: "He has touched on several important questions but finished by falling between two stools, being neither absolutely a philosopher nor an artist . . . By means of his drawings he took down the succession of dreams and nightmares with the precision of a stenographer who is writing out the speech of a public speaker . . ." but "as he was an artist by profession and a man of letters by his head" he has not known how to give all that a sufficiently plastic form.

In fact, once the raw materials offered by chance or by experience, by the known or by the unknown are collected together, the only thing left is . . . to begin.

It is far from my aim to present favourable arguments to those who accuse some contemporary artists of representing monsters on their canvases. For these people are most unwelcome who, spurred on by the basest interest or by the blindest grievance, helped to drive the day out of our sky and made it possible for funereal hallucinations and the chilling dreams of a Kafka to become daily reality. Reactionary critics will do this in vain: disturbed periods have their beast-fighters and their apocalypses. Nevertheless, should we not realise that he who is neither a poet, nor a visionary, nor an artist and who sets to work to fabricate the "fantastic" *is dishonouring the profession?* The meeting of the umbrella and the sewing-machine on the operating table happened only *once*. Traced, repeated over and over again, mechanized, the unusual vulgarizes itself. A painful "fantasy" can be seen in the street shop-windows.

* * *

People talk a lot about abstraction with reference to contemporary painting. I do not know at what point in a work of art the critics decide that it begins or ends. Perhaps a painter will be allowed to suggest that this term abstract should be reserved for metaphysical discussions: a domain in which this notion—it is at home there—has provoked brilliant controversies from Aristotle to Husserl and Whitehead.

The absence of subject—the picture itself considered as an object—this aesthetic is perfectly defensible.

However, the fear of painters who lay claim to it: the fear of making reference to the outer world forms a curious parallel to the fear of those who will not compromise with the irrational: that of not being surprising enough.

Now, it is not enough to draw or to paint a few cylinders or rectangles in a certain assembled order to be out of the world. The demon of analogy, in a sly mood that day, may whisper to us that there is an involuntary allusion here to ordinary, commonplace, recognizable objects.

In the same way it is not enough to introduce a rapturous passage into a mediocre form nor to descend into the frontiers of the invertebrate to escape conformism, nor again to convince oneself that to achieve originality it is sufficient to bow to the Hegelian contradiction.[1]

[1] "We must not take the word contradiction in the mistaken sense in which Hegel used it and which he made others and contradiction itself believe that it had a creative power." (Kierkegaard)

Extremes cannot enslave genius; on the contrary genius contains and masters them. To place oneself on one end of the map of art waving a laughable working drawing, or on the other end offering a soliciting anecdote—mistakenly rivalling the engineer or parodying the psychiatrist—only results in installing oneself comfortably on the lower slopes of the mind.

The columns of the storm, the pure pediment and the peaks hold sway far above this.

Matta

Matta (Sebastian Antonio Matta Echaurren, born 1912 in Chile) studied architecture with Le Corbusier in Paris from 1934–35. In 1937 he began to make abstract Surrealizing drawings and later in the year met Breton and joined the movement. In 1939 he went to New York, where his style matured into what has been called "the futurism of the organic"— hazy, luridly lit, abstract-biomorphic landscapes of the inner mind or other worlds, a series of which were titled *Psychological Morphology*. These probably derived initially from Dominguez' "cosmic" paintings and current Surrealist interests in science and mathematics with which Matta, as an architect, was already familiar. His forms and indeterminate space in turn influenced Arshile Gorky (see p. 149). In color and atmosphere they also anticipate more recent developments in light and "intermedia." In a 1942 statement, Matta predicted that "Soon, very soon, there will be no more painting. . . . In its place there will be a hard and morphological conception of light. No more painting, but instead the canvas will be replaced by a round planetarium, a planetarium of imagery or of the spirit, or a kaleidoscope of daily life, until a new animal will succeed in dominating this planet."

"Sensitive Mathematics" was illustrated by a "project for an apartment" which offered "a space suitable to provide an awareness of the human vertical, different levels, a stairway without banisters to master the void, a psychological ionic column, supple armchairs, inflated materials" all of which would cybernetically adapt themselves to the occupant. The walls were curved and pliable, somewhat resembling Kiesler's works of sculpture/architecture (see p. 151). The text on Max Ernst is an homage from a second-generation Surrealist to a first-generation master. In 1948, Ernst painted a "portrait" of Matta inscribed "Mattamathics."

Sensitive Mathematics—Architecture of Time

It is a matter of discovering how to pass between the rages which displace each other in tender parallels, in soft and thick angles, or

"Sensitive Mathematics—Architecture of Time" by Matta. *Adapted by Georges Hugnet and translated by the editor from "Mathématique sensible: Architecture du tempts,"* Minotaure, *no. 11 (Spring 1938), p. 43. Courtesy of Matta.*

how to pass under the shaggy undulations through which terrors are well retained. Man yearns for the obscure thrusts of his beginning, which enclosed him in humid walls where the blood beat near the eye with the sound of the mother.

Let man be caught, incrusted, until he possesses a geometry where the rhythms of crumpled marble paper, a crust of bread, smoke's desolation, are to him as the pupil of an eye between lips.

Let us put aside the techniques which consist of setting up ordinary materials and brutally push him who inhabits them into the midst of a final theatre where he is everything, argument and actor, scenery and that silo inside of which he can live in silence among his fripperies. Let us reverse all the stages of history with their styles and their elegant wafers so that the rays of dust, whose pyrotechnics must create space, will flee. And let us stay motionless among revolving walls to rid ourselves with fingernails of the crust fetched from the street and from work.

We need walls like damp sheets which lose their shapes and wed our psychological fears; arms hanging among the interrupters which throw a light barking at forms and to their susceptibly colored shadows to awake the gums themselves as sculptures for lips.

Leaning on his elbows, our protagonist feels himself deformed down to the spasm in the corridor, reeling, and caught between the vertigo of equal sides and the panic of suction, giddy when he finally realizes the efforts of the clock which is taxing its ingenuity to impose an hour on the infinity of time of those objects describing in wood or in verve their existence, which he knows is perpetually threatened. And he wants to have at his disposal surfaces which he could fasten to himself exactly, and which, carrying our organs in well-being or sorrow to their supreme degree of consciousness, would awake the mind on command. For that, one insinuates the body as in a cast, as in a matrix based on our movements, where it will find such a freedom that the liquid jostling of life which gives in here or resists there will not touch it, without its always having an interest for us.

Objects for the teeth, whose bony point is a lightning-conductor, ought to breathe our fatigue, deliver us from the angels in an air which will no longer be angel-blue but with which it will be lawful for us to struggle.

And again, other objects, opened into, comporting sexes of unusual conformation whose discovery provokes to ecstasy desires more stirring than those of man for woman. As far as knowledge of the very nervous irresolutions which can compensate for the full opening of trees and clouds from this window onto always identical daylight, plated from the outside.

In a corner where we can hide our acid pleats and bewail our

timidity when a lace, a brush, or any other object confronts us with our incomprehension; and ever since then, in reaction, consciously, with a hand gloved several times, rub one's intestines with victims. That will succeed in creating in one charm and gentleness.

Very appetizing and with well-shaped profiles is furniture which rolls out from unexpected spaces, receding, folding up, filling out like a walk in the water, down to a book which, from mirror to mirror, reflects its images in an unformulizable course designing a new architectural, liveable space.

This furniture would relieve the substance of its whole past from the right angle of the armchair; abandoning the origin of its predecessors' style, it would open itself to the elbow, to the nape of the neck, wedding infinite movements according to the consciousness-rendering medium and the intensity of life.

To find for each person those umbilical cords that put us in communication with other suns, objects of total freedom that would be like plastic psychoanalytical mirrors. And certain hours of rest as if, among other things, masked firemen, crouching so as to smash no shadow, brought to Madame a card full of pigeons and a package of tirra-lirras. We need a cry against the digestions of right angles in the midst of which one allows oneself to be brutalized while contemplating numbers like prize tickets and considering things only under the aspect of one single time among so many others.

By mixtures of fingers similar to the clenched hands of a woman whose breasts are slashed, the hardenings and softnesses of space would be felt.

And we will start to waste it, that filthy ragged time offered us by the sun. And we will ask our mothers to go to bed in furniture with lukewarm lips.

Hellucinations

The fact that man thinks he grasps phenomena is a hallucination. The notion that "man *is*" is in itself a hallucination; manness is nothing but a sickness of apes. Once hallucinations are sufficiently rooted, they become what we call myths, and cease to have outside limits. I mean that the native African who believes in certain kinds of, let us say, supernatural voices actually hears such voices; his myth, his hallucination is perhaps no more "unreasonable" than the present

"Hellucinations" by Matta. From Max Ernst, Beyond Painting *(New York: George Wittenborn, Inc., 1948), 193–94. Courtesy of George Wittenborn, Inc.*

day one that every house ought to have electric refrigeration so that pop can be served chilled.

History is the story of man's various hallucinations; once we think about some of the influential personages in the story—the devil, venus, christ for example—it is plain that they in part owe their existence as historical personages to having been *pictured* by men with a gift for graphic hallucination. The devil, for instance, is the image of a creature, unhuman, still part animal; the devil could not wholly exist before being pictured; and Max Ernst in this sense has given certain images a historical existence.

The myths Max Ernst has made exist only in notebook form, so to speak; though he has invented many things, he has never bothered to exploit any of them. He has the temperament of a philosopher.

The risk in the power to create hallucinations is that they could be exploited by established authority for its own purposes, the way the Church, for instance, uses images to enslave its members. But the power to create hallucinations should not be checked because it is sometimes criminally abused. However, it is true that in the last century religious hallucinations had to be killed by positivism; history had reached the point where it was necessary to retest all our beliefs. But nowadays science knows very well how to test everything, it is once again permissible to create hallucinations, science can always prevent them from becoming tyrannical—except the scientific hallucination.

At the same time science has castrated emotional experience.

We have been reduced to the fact that white is white, black is black, and that all that we can feel is a punch on the nose. This resolves nothing; the teeth of the dragon remain everywhere. All the same I am violently against St. George. The power to create hallucinations is the power to exalt existence. It can be argued this constitutes a form of madness but I think that Max Ernst accepts this as part of the task of the artist. The artist is the man who has survived the labyrinth. It is hard to imagine man ever finding happiness without employing his hallucinatory powers. I believe that this is the essential justification of Max Ernst's direction. *To use hallucinations creatively, not to be enslaved by other men's hallucinations, as usually happens.*

The validity of Max Ernst's procedures is supported by the fact that the mind works the same way in dreams. Certainly the mind works this way in primitive cultures. I am sure that a man could die in fire without *feeling* burnt. From the viewpoint of rational history this is unintelligible; to men in primitive societies it is self-evident. In this sense Max Ernst is a primitive man, even if he doesn't live in a primitive society. But what an affinity he feels, for instance, with the Katchina images from Arizona! He insists throughout his work on the

right to create his own hallucinations, and to ridicule other hallucinations. His doves constantly remind us how ridiculous it is to suppose that doves regard the world as a place without conflicts.

Max Ernst has lived two Odysseys: the Odyssey of the erotic and the Iliad of the mind.

Joan Miró

Joan Miró (born 1893) is, from a formal point of view, the major Surrealist painter. In fact, his influence on later abstraction entirely transcends the Surrealist program, to which he actively adhered only from 1924–29, though he never actually broke with Breton as so many others did. In 1940, Miró settled in Palma de Majorca and has lived there ever since. The direct and childlike quality of his nevertheless highly sophisticated painting is reflected in his writing, but a note of perversity, as well as a haunting primitivist aura, often belies the optimistic Matissean color and gaily floating forms. Miró has insisted that his work is "never abstract," that a form is "always a sign of something," though his method is hardly that of an illustrator: "Rather than setting out to paint something, I begin painting, and as I paint, the picture begins to assert itself, or suggest itself under my brush."

In the mid-to-late 20s, the qualitative peak of Surrealist painting, Miró made a series of masterpieces, among which was *Harlequin's Carnival* of 1924–25. The ball of yarn, cats, guitar music, ball, spider-sex, ladder, stem-flame and other images mentioned in the artist's poetic commentary appear in the painting itself. The same year he painted this swarming, sharply detailed canvas, he also experimented in automatism, producing such spontaneous works as the partially drip-painted *Birth of the World*.

In the late 30s, the catastrophic civil war in his native Spain and the hovering war-clouds in Europe provoked from Miró a series of darkly ominous paintings like the 1938 *Nocturne*, the mood of which corresponds to Statement II below.

Two Statements

I (1933)

It is difficult for me to talk about my painting, for it is always born in a state of hallucination provoked by some shock, objective or subjective, for which I am entirely irresponsible.

"Two Statements" by Joan Miró. Both statements translated by the editor: the first from *Minotaure*, nos. 3–4 (1933), p. 18; the second from George Duthuit's transcription in *Cahiers d'Art*, nos. 1–4 (1939), p. 73. Courtesy of Joan Miró and Christian Zervos.

As for my means of expression, I increasingly force myself to attain a maximum of clarity, power, and plastic aggressiveness, that is, to provoke first of all a physical sensation, and then to arrive at the soul.

II (1939)

The outside world, contemporary events, never cease to influence the painter, that goes without saying. The play of lines and colors, if it does not strip naked the creator's drama, is nothing more than bourgeois entertainment. Forms expressed by the individual attached to society must reveal the movement of a soul that wants to avoid present reality (of a particularly ignoble character today), then approach new realities, finally offer the possibility of greatness to other men. What rottenness must be swept away to discover a liveable world!

If we do not try to discover the religious essence, the magic sense of things, we will only add new sources of brutalization to those innumerable ones offered today.

The horrible tragedy we are going through can rouse some isolated geniuses and give them increased vigor. Allow the powers of known regression under the name of fascism to expand further, however, allow them to plunge us a little further into the impasse of cruelty and incomprehension, and it is the end of all human dignity.

On the other hand, a revolution tending toward comfort alone will end up in the same disgrace into which the bourgeoisie has plunged us. Proposing only material satisfactions to the masses would annihilate our last hope, our last chance of health.

There are no more ivory towers. Retreat and detachment are no longer allowed. But what counts, in a work, is not what too many intellectuals want to discover there, but that which in its ascendant movement carries with it experienced facts, human truth, for plastic finds have no kind of importance *per se*. Thus the promises offered the artist by professional politicians and other specialists in agitation must not be confused with the profound necessity that makes him take part in social convulsions, attaches him, him and his work, to the flesh and the heart of the future, and makes everyone's need for freedom his own need.

Harlequin's Carnival

The ball of yarn unraveled by the cats dressed up as Harlequins of smoke twisting about my entrails and stabbing them during the period of famine which gave birth to the hallucinations enregistered

"Harlequins Carnival" by Joan Miró. From Verve *1, no. 4 (January–March 1939): 85. Courtesy of Joan Miró.*

in this picture beautiful flowering of fish in a poppy field noted on the snow of a paper throbbing like the throat of a bird at the contact of a woman's sex in the form of a spider with aluminum legs returning in the evening to my home at 45 Rue Blomet a figure which as far as I know has nothing to do with the figure 13 which has always exerted an enormous influence on my life by the light of an oil lamp fine haunches of a woman between the tuft of the guts and the stem with a flame which throws new images on the whitewashed wall at this period I plucked a knob from a safety passage which I put in my eye like a monocle gentleman whose foodless ears are fascinated by the flutter of butterflies musical rainbow eyes falling like a rain of lyres ladder to escape the disgust of life ball thumping against a board loathsome drama of reality guitar music falling stars crossing the blue space to pin themselves on the body of my mist which dives into the phosphorescent Ocean after describing a luminous circle.

I Dream of a Large Studio

On my arrival in Paris in March 1919, I stopped at the Hôtel de la Victoire, rue Notre Dame des Victoires. I stayed in Paris all the winter. That summer I went back to Spain, to the country. The next winter I am back again in Paris. I stopped at another hotel, number 32 Boulevard Pasteur. It is there that I had a visit from Paul Rosenberg. Picasso and Maurice Raynal had spoken to him about me. Sometime later Pablo Gargallo, who was spending the winter in Barcelona teaching sculpture at the Beaux Arts School, turned his studio over to me. It was at 45 rue Blomet, next door to the Bal Nègre, still unknown to Parisians at that time as it had not yet been discovered by Robert Desnos. André Masson had the studio alongside. Only a partition separated us. In the rue Blomet I began to work. I painted the "Tête d'une Danseuse Espagnole" which now belongs to Picasso, the "Table au Gant," etc. Those were pretty hard times: the panes of the window were broken, my heater that cost me forty-five francs in the flea market would not work. However, the studio was very clean. I used to tidy it up myself. Since I was very poor I could not afford more than one lunch a week: the other days I had to be contented with dried figs and I chewed gum.

The next year it is not possible to get Gargallo's studio. I go first to a small hotel on the Boulevard Raspail where I finish the "Fer-

"I Dream of a Large Studio" by Joan Miró. Translated by James Johnson Sweeney from "Je rêve d'un grand atelier," XXe siècle 1, no. 2 (May–June 1938): 25–28, and published in Joan Miró (New York: Pierre Matisse Gallery, March 1940). Courtesy of Joan Miró and Pierre Matisse.

mière," "l'Epi de Blé" and some other pictures. I give up the hotel for a boarding house on the rue Berthollet. *"La Lampe à Carbure."* Summer in the country. Return to Paris to the studio in the rue Blomet. I finish *"La Ferme"* which I began in Montroig and carried on in Barcelona. Léonce Rosenberg, Kahnweiler, Jacques Doucet, all the Surrealists, Pierre Loeb, Viot, the American writer Hemingway, dropped in to see me. Hemingway buys *"La Ferme."* In rue Blomet I paint the *"Carnaval d'Arlequin"* and the *"Danseuse Espagnole"* now in the Gaffé collection. In spite of these first sales times were still hard enough. For the *"Carnaval d'Arlequin"* I made many drawings into which I put the hallucinations provoked by my hunger. In the evening I would come home without having eaten and put down my sensations on paper. I went about quite a bit that year with poets because I felt that it was necessary to go a step beyond the strictly plastic and bring some poetry into painting.

A few months later Jacques Viot arranged my first exhibition at the Galerie Pierre. After that I had a contract with Jacques Viot which helped me to stick it out. I rented a studio, rue Tourlac, Villa des Fusains, where Toulouse-Lautrec and André Derain had lived and where Pierre Bonnard still has his studio. At that time Paul Eluard, Max Ernst, a Belgian dealer from the rue de Seine, Goemans, René Magritte, Arp were also living there. On my door I put up a sign I had found in a junk shop: *TRAIN PASSANT SANS ARRÊT.* Things were now going better but it was still hard enough. One day with Arp, I lunched on radishes and butter. As soon as it was possible I took a larger studio in the same house, on the ground floor, but I did not keep it long.

Back to Spain. Am married. Return to Paris with my wife and leave the Villa des Fusains where I had painted my whole series of the blue canvases for an apartment on the rue François Mouthon. Worked a great deal. Spent most of the year in Spain where I could concentrate better on my work. In Barcelona I used to paint in the room where I was born.

In Spain, where I went very often, I never had a real studio. In the beginning I used to work in such tiny cubby-holes I could hardly squeeze in. When I was dissatisfied with my work I used to bang my head against the wall. My dream, when I am able to settle down somewhere, is to have a very large studio, not for the light—north light, etc.—that does not matter to me—but to have room and lots of canvases, for the more I work the more I want to work. I would like to try sculpture, pottery, engraving, and have a printing press. To try to go further than easel painting which in my opinion, sets itself a narrow aim—to try to go as far as possible and through painting, to get closer to the people who are never out of my mind.

Now I am on Boulevard Blanqui in the house of the architect Nelson. It was in this house that Mrs. Hemingway kept *"La Ferme"* before taking it away to America.

Once I felt like taking another look at the studio of the rue Blomet. In the court there was a very beautiful lilac bush. The house was being pulled down. A big dog jumped at me.

Gordon Onslow-Ford

Gordon Onslow-Ford (born 1912) was about to become a British naval officer when he met Matta in September, 1937. He was so taken by the latter's drawings that he decided to become a painter, and in 1938 joined the Surrealists. The next year he invented a technique he called *coulage,* a brushless pouring of paint to produce swirls of color over which he superimposed rectangles and focal lines. The results suggest a kind of interplanetary space or mathematical design with affinities to Matta's, Dominguez', Paalen's, and Esteban Frances' work of the late 30s and early 40s. The text below was written primarily to introduce the theory of "psychological morphology" (see Matta, p. 167), and is based on a still unpublished manifesto by Matta.

The Painter Looks Within Himself

In times of crisis it is only natural that those who have confidence in man's power to create a better world should consult the artist, as he is one of the most sensitive members of society who tends to live in advance of his time.

In this search for knowledge we must discard the school whose aim is reproduction of the rational world, and the school whose aim is æsthetical. The former has only sentimental or historical value, and the latter has come to a dead end in abstract harmonies of lines and colours. The work of both these schools reacts on the senses in much the same way as music and is equally incapable of adding to the knowledge of man.

If we look back about 30 years to the beginning of fauvism and cubism we find a clear prediction of the coming change in man's outlook. Painters, in their struggle to find a new and satisfying reality, proclaimed in their various ways their dissatisfaction with all that the eye saw. Distortion and destruction of the rational world were perpetuated until little remained on the tangled heap of smoking flesh and stone.

A clear example of this common feeling is given in the paintings by Victor Brauner who was so insistent that the eye (a female symbol) had to be destroyed and replaced by a horn (a male symbol) that this obsession actually led to the loss of his left eye as is told in the analy-

"The Painter Looks Within Himself" by Gordon Onslow-Ford. From London Bulletin *(June 1940), pp. 30–31. Courtesy of Gordon Onslow-Ford.*

sis of the accident and its causes by Dr. Pierre Mabille in Minotaure No. 13.

The first glimmering of the new world is given by Georgio de Chirico between the years 1911 and 1917. Instead of looking at his immediate surroundings for inspiration he looked deep into his unconscious. By abandoning all moral and æsthetical control he was able to dream onto the canvas, and so give us a record of his unconscious thoughts. He painted simple objects mostly remembered from his childhood and was able to tell us of his troubles and desires. We now know from an analysis of his works that he made broadly speaking the same discoveries as those of Freud.

The researches of Max Ernst, Joan Miró, André Masson, René Magritte, Salvador Dali and others have already been told, though not sufficiently studied. By an automatic arrangement, directed by the desires of the unconscious, of objects in the rational world, dialectical materialism, paranoia, obsessions and complexes were explored. Our minds were enriched and we were brought nearer to the true human being. At last painters, poets and doctors were walking hand in hand. This work continues today, but the vital ground has already been covered. Surrealism was also discovering the need to destroy completely the rational world.

The next big step towards the new world was given by Yves Tanguy who had the courage through the inspiration of Georgio de Chirico and his friendship with André Breton to plunge once again into the void. He created a world of his own—a simple world of objects, shadows, lines of force all bathed in an ever-varying atmosphere. These landscapes could be compared to the original cell that will one day develop into a complicated organism.

Tanguy has always trusted his first impulse and has never altered or discarded a canvas. His work is pure creation taking inspiration from looking within himself. His internal vision at first sight appears to have no relation to the rational world, yet the two worlds are connected psychologically and morphologically. He has surmounted all the moral, æsthetical and visual prejudices that bias our conscious mind, and I hail him as the first truly automatic painter. Miró, Dali and many other painters were influenced by Tanguy's work, but it was not until 1937 that Matta Echaurren began to develop the enormous possibilities of what he calls psychological morphology. He was soon joined by Esteban Frances and myself.

The world of psychological morphology gives form to our unbridled thoughts. It is a Hell-Paradise where all is possible. The magical achievement of our most deeply buried desire can be realised. There are objects which correspond to "personnages," stars, trees and architecture free to obey the laws of the common desire, and bound into one unity by auras and lines of force. The panic created by cubism in

time and space is here developed. The details of the furthest star can be as apparent as those of your hand. Objects can be extended in time so that the metamorphosis from caterpillar to butterfly can be observed at a glance. Objects that can only be seen under the microscope are revealed. Objects containing new mathematical formulæ appear. Chirico spoke of women in terms of arcades, railway engines, boats, boxes, clocks, etc., now all these symbols can be bound into one stronger whole. The secrets contained in the universe of the human mind are being laid bare for study.

In this realm of scientific poetry there lies a philosophy, and we hope to start a bureau of analytical research to study the most important creations of the century in co-ordination with all branches of science. Painters who join our research will be able to play their part in the formation of a new world.

Wolfgang Paalen

Wolfgang Paalen (1905–59), originally Austrian, joined the Surrealists in Paris in 1935–36. In 1937 he invented "fumage" (the burns and scorch marks left by a candle flame pictorially interpreted), a technique continued in the 50s and 60s by Yves Klein and Otto Piene. In 1939, Paalen settled in Mexico, where, with Breton and César Moro, he organized an "International Surrealist Exhibition" in 1940. While there he also befriended the young American painter Robert Motherwell. From 1942–44 he published *Dyn*, a review emphasizing studies of primitive art, the influence of which appeared in his own work. In its first issue he wrote that Surrealism was no longer capable "either of determining the artist's position in the world today, or of formulating objectively art's reason for existence," an assumption in which history has shown him to be justified. Paalen's work during his Surrealist period was based on a totemic illusionism, also shared at the time (though more abstractly), by the Cuban Surrealist, Wifredo Lam. In the 40s, as in *Space Unbound* (1941), his painting became freer and more determinedly "cosmic" in spirit.

Excerpts from *Surprise and Inspiration*

If Scholastic disputes were unable to decide in what language the suggestions of the Serpent of Paradise were spoken, at least there will be no doubt for the historian that, in the genesis of modern art, inspiration spoke French by preference. For it was Rimbaud who uttered the Open-Sesame of modern expression, when he said that the artist must become a seer (*"être voyant, se faire voyant"*).

Before the great clefts appeared in Occidental civilization, art in general contented itself with perfecting, with enriching its procedures of *showing*. Thus painting, like literature, found ever more subtle and exclusive means to show what was judged worthy of being seen. So long as theology made it its business to take the bearings of man in the universe, art did not have much more to do than to show what was given once and for all. Nevertheless, even in the shadow of the church there were always a few outsiders—visionaries, inspired men —often of admirable courage in their exploration of the dangerous

Excerpts from "Surprise and Inspiration" by Wolfgang Paalen. From Form and Sense *(New York: George Wittenborn, Inc., 1945). Courtesy of George Wittenborn, Inc.*

no-man's-land which lay between the stake and the halo of sainthood. It is among them that significant poets of our days justly recognize their ancestors. For today authentic artists must strive above all to *see*. They are outcasts from a strictly utilitarian scale of values, in which they are no longer solicited to show except by their own desire for communion with mankind. No longer to refine unto infinity their means of showing generally admitted subjects, to rehash sham mythologies, but within the precise needs of their own aptitudes to see, to discover new universal horizons!

Within the field of artistic creation it has been assumed for a very long time that a certain disposition named inspiration is the one above all others that gives access to the source of vision. There is no lack of subtle appreciations of the functioning of inspiration. But there has never been any definition as to just what this inspiration really is, which until our days has been considered a kind of state of grace. Perhaps one should first ask oneself what it is that releases this unusual state: which, in the midst of an apparent calm, suddenly raises a mysterious breeze which pushes this tiny ship of the *me*, whether it likes it or not, into the wide ocean of vision. In other words, what are the stimuli, both exterior and interior, that produce this phenomenon, this interruption of conscious behavior—this phenomenon so difficult to grasp, but so consistent in its manifestations that for two thousand years one has found no other name for it than that of inspiration? . . .

The remembrance of an almost imperceptible *click* which made the first spark leap forth, has often associated inspiration with fire. "All that we can do is to prepare the pile of wood and dry it well; and then it catches fire in its own hour, and we ourselves are surprised," said Goethe. "To be set on fire by a thought or scene is to be inspired," declared John Dewey. It seems to me that instead of trying to *circumscribe the fire,* it would be better to try to explain the functioning of the activity of inspiration by taking surprise into account. Freud in his work on *wit* (*"Der Witz und seine Beziehung zum Unbewussten"*) speaks of the role of surprise. "Our attention was taken by surprise," he says, and speaks later of a "deviation of attention." But it still remains to be known what it is that brings about this deviation of attention—what is the invisible magnet that turns aside the magnetic needle of the mind, so that it loses the direction of its consciousness. In short, what in this case is surprise? Commonly one says that it stupefies, that it glues you to the spot; for obviously it provokes a moment of stopping short, a suspension of the conscious activity of our intelligence, which has the effect of a *shock*. But in order to be felt as a sudden stopping short, as a shock, this suspension had to be preceded by a phenomenon of *rapidity*. Thus the German word for surprise is significant. *"Ueberraschung"* comes from the words *"über"*

and *"rasch,"* of which the first means "over," and the second "quickly."
The exact translation of the term would be "overcome by rapidity"
(a meaning confirmed by the etymology of the word). In French as
well, rather than *"pris,"* which means "taken" one is *"surpris"* which
is "over-taken." Of course I speak only of the phenomenon of percep-
tion and not of the unexpected event that modifies our behavior by its
simple physical shock.

Certain interruptions in the course of our habitual associations as-
sume the character of enigmas because of their lack of apparent rea-
sonableness. Thus too in the analysis of dreams we are at times stopped
short by enigmatic words. It is well known that the absurd quality of
the dream comes from the fact that it organizes its materials neither
according to the objectivity of the facts, nor according to the pos-
sibilities admitted by reason, but according to the affective value which
they possess for the dreamer. "The first peculiarity of the dream is its
process of *condensation* . . . there are condensations of places: one is
in Paris and at the same time walks in the streets of London; con-
densations of words: an invention which is *originale* and *loufoque*
(meaning crack-brained) in the dream became *originouloque,* etc. One
must think of this process of condensation every time one is in the
presence of an incomprehensible word." Which allows us to suppose
that much that appears among the innumerable sensations of our life
as disturbingly enigmatic is a condensation of this type. A condensa-
tion that troubles us through the affective value which it conceals from
us. Thus the Sphinx asks her questions not as an abstract voice but as
the redoubtable condensation of woman and beast. To sum up: the
enigmatic character of an event which surprises us seems enigmatic to
us through its content of condensed elements of affective value of which
we are unaware. Thus what strikes us without our knowing why, is an
unconscious discovery. I say unconscious, for we can react emotionally
to a situation without consciously taking cognizance of the situation;
to discover is not necessarily to identify. That which surprises us par-
ticularly about the appearance of any object, blot, word or whatsoever
—things that reasonably considered would not seem more unusual
than any other—that which gives them the features of the Sphinx at
the cross-roads of our thought, what is it if not the marvelling before a
suggestion of something secretly corresponding to a preoccupation
which we are as yet unable to make conscious? What is it if not the
unconscious and involuntary discovery of an affective value? This un-
derstood, the shock of surprise must be the echo of an unconscious dis-
covery secretly knocking at the door of consciousness. And the rapidity
which had surprised us, *über-rascht,* is the lightning rapidity of uncon-
scious imaginative association.

The arbitrary dualism between the psychic and the physical led to
the over-mechanistic schematization of the mind as a system of flood-

gates separating the various states of consciousness. Thus thinking and imagining have always been confounded. To speak of "unconscious thought" is epistemologically inconvenient. But the presumed activity of this unconscious thought (the part of mental activity that takes place outside the focal points of consciousness) becomes perfectly comprehensible when one distinguishes between thinking and imagining.

Thus the incredible rapidity of association in dreams (and of certain associations in the waking state) can be explained by the fact that it is purely an association of images which, so to speak, fly where logical thought has to climb one by one up the causal steps of reason. And *unconscious discovery*, which causes surprise, acts with the rapidity of the dream. That is why at a single bound it reaches the deepest strata of the unconscious, and raises the floodgates. And thus inspiration leaps forth; thus is illuminated the mirror which no longer reflects the Narcissus-me, but the wealth of forms that belong to all. For the poetic gift is not what a vain virtuosity would wish it to be: a deliberate discovery of the self—but it is the capacity to lose the self, the audacity to smash the vain reflection, to immerse oneself headlong in the well of egocentricity.

Inspiration is the liberation of the torrent of imaginative association through the shock of surprise.

Of course, certain high-frequency brains need only minimum impulsions in order to set them off like seismographs. What is vaguely called genius is probably nothing more than a superior responsiveness. But be that as it may, inspiration, alas, does not preside over the practice of our days, and social conditions do not allow the majority inspiration, except in their dreams. According to Kant: "Dreaming is an involuntary poetic art." But the dream, egoistically preoccupied with satisfying individual desire, usually remains without collective importance even when using universal symbols—while artistic creation, using symbols personally, attains collective importance when it succeeds in formulating what inspiration reveals in the depths of the ego—there where "I is another" (*"je est un autre"*). . . .

Francis Picabia

Francis Picabia (1879–1953) was above all a highly influential founder of Dadaism, whose "object portraits" (Alfred Stieglitz as a camera, the "American Girl" as a spark plug) extended Duchamp's ready-mades toward collage. Though he broke with Dada in 1921 and never officially joined the Surrealists, Picabia's work and writings (antibourgeois and pro-freedom at any cost) continued in a Dada vein, and he has been called a "para-Surrealist." In 1922, Breton listed Picabia, Duchamp and Picasso as the pillars on which the still prenatal Surrealist movement would rest. In the last issue of his own review, *391*, in 1924, Picabia signed himself "Francis Picabia, Stage Manager for André Breton's Surrealism." The spasmodic friendship continued through the years, however, and at Picabia's funeral Breton delivered the oration, praising "an *oeuvre* based on the supremacy of caprice, on a refusal to follow, entirely directed towards freedom—even a freedom to displease." In the artist's own words: "One must be a nomad, pass through ideas as one passes through countries and cities." No matter how often his painting style changed, from the seminal machine period through heavy-handed figuration, Picabia's style remained parodic and sarcastic above all.

Cerebral Undulations

The other day Jacques Doucet told me "You walk at 150 kilometers an hour: How do you expect to be followed?" I do not claim to walk faster than others, but I do like ceaselessly to manufacture new vehicles for my outings!

There are artists whose canvases collectors are happy to possess, because these artists invariably do the same thing, and have done so for a number of years; if they changed their style the art-lover would hesitate to acquire their work, for in the back of his mind he has always, or almost always, the possibility of speculation, even if only from the point of view of vanity: "See," he says, "I was right, these paintings I bought twenty years ago for between thirty and forty francs are

"Cerebral Undulations," by Francis Picabia. Translated by the editor from "Ondulations Cérébrales," L'Ere Nouvelle (July 12, 1922), pp. 1–2. Courtesy of Mme. Olga Picabia.

worth twenty to thirty thousand francs today: is there any better proof that this artist is a genius?"

One must not forget, however, that Meissonier sold works when he was alive for sixty per cent more than they cost today. I think it takes a lot more than a few years to test the solidity of an *oeuvre*, and it amuses me to see a Derain drawing sell for more than a Delacroix or a Corot. Master Derain's fantasies are, it is true, as amusing as these that emerge from his friend Poiret, and share the same spirit, an international spirit if one considers that they are alternately inspired by Spanish, Japanese, Italian or Negro styles! I like still better Jean Cocteau, who is content to be a good little Parisian.

When, then, will men made of a material that permits them to move and act, know how to use the completely independent activity that they receive? Each human being possesses quite a strong will to refuse to submit to the least outside influence, but most refuse to use this willpower or do not even suspect it in themselves!

Many consider themselves animals incapable of evolving, like rabbits who never modify their terrain and birds who are inspired only to build their nests by swallows' methods. In animal fashion again, how many men only use their hands? They forget to use their brains, which aspire only to repose; they accept what they are told; action is the same to them, and the little intellectual activity that they retain serves them to combine a commercial speculation more abject than theft and murder. The lack of knowledge is often at the bottom of those people's condition; they live in the shadows and are happy with what some salaried individuals whisper to them behind a door.

Some go to the theatre a little, on the advice of their newspaper or a friend: others buy pictures, not very often by taste, but to be fashionable, and I have heard intelligent men, out of laziness, listening to imbeciles . . . This laziness that happens to make one lose consciousness of all real existence, I fear it will get worse from day to day and, with it, that absence of light, that descent into nothingness, that comatose state of indifference that makes human beings resemble closed bottles thrown in a river, dragged by the current or lying caught on a bank because of the wake of a small boat.—Be thus assured that each of our brains can become a globe, a center of personal activity, that it can react and hinder us from accepting all the idiocies and ineptitudes that so many of you swallow with such welcome, like that with which believers receive the host, symbol of a god created by men. Artists, politicians, snobs, etc. make us take communion; we accept and it is only a bad "chewing gum" that certain people ingest conscientiously, that others chew for years, until the day when, disgusted, they finally understand and get rid of that product, sticking it under their neighbor's chair!

Because of this daily inertia, mediocre people take on more and more importance: though others let them do it, saying that there is room for everyone; they do not perceive that under these conditions, the atmosphere becomes unbreathable.

Dear friends, space is not a receptacle, space is in us, and I want to warn you against the agitations of people who have an interest in maintaining the diseased air that gently intoxicates us.

I have had enough of that spirit that invades the world: "it seems that the intelligent man is not Lenin, but Trotsky! Trotsky weighed Lenin as Einstein did light!" You guess why? It is as though they said [the art dealer] Bernheim had more talent than Claude Monet!

You see, I would like a man who was influenced by no one, who was preoccupied neither with modernism nor cubism nor dadaism; who would be neither Socialist nor Communist nor the opposite; a man who would quite simply be himself; a man who wouldn't give a damn for the Chinese or Russians, a man who would exteriorize somewhat his own life. A man who would succeed in communicating to us the desire of life in full breadth and activity, without arriviste ambitions and without that false ideal of sacrifice which never ends in anything but the most absolute materialism. A man who would teach us not to hypnotize ourselves to sleep before a mirror. A man, finally, who would drag us toward the new world of discovery, the world of love which mediocre people don't want to enter and which horrifies "intellectuals" afraid of ridicule.

Jesus Christ invented this way of life a long time ago; I would prefer it to the present dilution.

Picabia described *Entr'acte* as just that, "an intermission in all the conventions—glory, money, good and bad, or the absurd 'legion of honor.' " A film conceived by Picabia and realized by René Clair, it was shown between the acts of Picabia's Dada Ballet, *Relâche,* in Paris, December, 1924. Its score, by Eric Satie, who also did the ballet, was the first ever made for a film. *Entr'acte* is an anarchistic and often outrageously funny preview of Buñuel's and Dali's great Surrealist films (see pp. 101–7), particularly in its use of non-linear time and juxtaposition of ludicrously frenzied speed and slow motion, notable in the famous runaway hearse passage. The other best-known sequence is that in which a graceful ballet dancer, first seen from below through a sheet of glass, is revealed to be a heavily bearded actor.

Entr'acte

"Entr'acte" is a film I made the scenario for, which doesn't count for much! Its realization was complicated, my collaborator René Clair busied himself with it in a prestigious fashion and I experienced the liveliest pleasure in seeing my conception realized.

"Entr'acte" is an interlude in the cinema, a suggestive intermission, an intermission to the idea of commercialism. The cinema to which we are accustomed, like the Theatre, makes me think of a most typical story: One of my friends bought a magnificent monkey "Which resembled him like a brother," that is to say, he had a great personality; when he got home, he locked him in a room so as to find out what this quadrumane would do when he was alone; he waited a minute, then put his eye to the keyhole and he saw . . . he saw, from the other side of the keyhole, the monkey's eye watching him! No comment; you have all understood.

All our fine scenarists are monkeys looking through the keyhole. "Entr'acte" is the keyhole where the actors' gestures, actions, freely evolve.

There is a hearse made to serve as an advertisement for pharmaceutical products: "He is dead because he did not take Nader Serum—or Boding-Didi." The hearse is drawn by a camel. Why? I don't know, the assistants eat the crowns because they are made of bread and they are hungry. Why are they hungry? There is a dancer one sees from below. Why? I would always like to see dancers from below! The hearse passes through Magic City; before stopping at the cemetery the corpse moves into the Russian mountains. Why? I still have no idea, but that seems very natural to me, as does the following.

At the end the hearse falls, Life hurried its march too fast, only a legless cripple could have saved the mortuary convoy! When it falls the coffin opens, out of it comes a prestidigitator in the most marvelous costume, covered with medals; he makes the legless cripple and all who have rejoined him disappear, he makes himself disappear, perhaps finding it too fatiguing to be dead. . . . And the public leaves the theatre saying that Francis Picabia must not give a damn about the world.

"Entr'acte" by Francis Picabia. Translated by the editor from This Quarter, *no. 3 (1927), pp. 301–2. Courtesy of Mme. Olga Picabia.*

Pablo Picasso

The case for Pablo Picasso (born 1881) as a Surrealist has never been a strong one, and it is in his infrequent writings that he came closest to a Surrealist esthetic, particularly in the poem reproduced below and a play, *Desire Caught by the Tail*, of 1941. Nevertheless, it is true that, as Robert Rosenblum has observed, Picasso's eroticism, primitivism, and metaphorical use of the double image and form (see Dali on "paranoiac criticism," p. 96) provide points of comparison. Picasso was a good friend of Breton, whom he met in 1923, as well as of many other Surrealist poets and artists, and he shared their distrust of pure abstraction. For the most part, his own robust art departs from the *seen*. The closest he has come to sheer fantasy is a series of drawings from around 1933, in which hybrid figures are constructed of bits of wood, furniture, human limbs, and other objects. The "bone" paintings from 1929–30 and other isolated works have been called Surrealist in their grotesquerie, biomorphism, distortion, and punning use of form. It must also be remembered that Picasso was a great influence on Dada and Surrealism despite their break from Cubism, and the range of his work is such that he can be fitted into almost any movement, while remaining in solitary splendor.

The statement from which the excerpt below has been taken was set down by Christian Zervos after a conversation with Picasso at Boisgeloup in 1935; the artist approved his notes, originally published as "Conversation avec Picasso." In it, the abyss between Picasso's ideas and those of the Surrealists should become clear, although he shares their dislike of conventional responses to and treatment of art.

From *Statement: 1935*

. . . It would be very interesting to preserve photographically, not the stages, but the metamorphoses of a picture. Possibly one might then discover the path followed by the brain in materializing a dream.

"*Statement: 1935*" by Pablo Picasso. From Alfred H. Barr, Jr., Picasso: Fifty Years of His Art (*New York: The Museum of Modern Art, 1946*). *Copyright 1946 by The Museum of Modern Art, New York; first published under the title "Conversation avec Picasso" in* Cahiers d'Art *10, no. 10 (1935) 173–78. The above translation is based on one by Myfanwy Evans. Courtesy of The Modern Museum of Art.*

But there is one very odd thing—to notice that basically a picture doesn't change, that the first "vision" remains almost intact, in spite of appearances. I often ponder on a light and a dark when I have put them into a picture; I try hard to break them up by interpolating a color that will create a different effect. When the work is photographed, I note that what I put in to correct my first vision has disappeared, and that, after all, the photographic image corresponds with my first vision before the transformation I insisted on.

A picture is not thought out and settled beforehand. While it is being done it changes as one's thoughts change. And when it is finished, it still goes on changing, according to the state of mind of whoever is looking at it. A picture lives a life like a living creature, undergoing the changes imposed on us by our life from day to day. This is natural enough, as the picture lives only through the man who is looking at it.

At the actual time that I am painting a picture I may think of white and put down white. But I can't go on working all the time thinking of white and painting it. Colors, like features, follow the changes of the emotions. You've seen the sketch I did for a picture with all the colors indicated on it. What is left of them? Certainly the white I thought of and the green I thought of are there in the picture, but not in the places I intended, nor in the same quantities. Of course, you can paint pictures by matching up different parts of them so that they go quite nicely together, but they'll lack any kind of drama.

I want to get to the stage where nobody can tell how a picture of mine is done. What's the point of that? Simply that I want nothing but emotion to be given off by it.

Work is a necessity for man.

A horse does not go between the shafts of its own accord.

Man invented the alarm clock.

When I begin a picture, there is somebody who works with me. Toward the end, I get the impression that I have been working alone —without a collaborator.

When you begin a picture, you often make some pretty discoveries. You must be on guard against these. Destroy the thing, do it over several times. In each destroying of a beautiful discovery, the artist does not really suppress it, but rather transforms it, condenses it, makes it more substantial. What comes out in the end is the result of discarded finds. Otherwise, you become your own connoisseur. I sell myself nothing.

Actually, you work with few colors. But they seem like a lot more when each one is in the right place.

Abstract art is only painting. What about drama?

There is no abstract art. You must always start with something. Afterward you can remove all traces of reality. There's no danger

then, anyway, because the idea of the object will have left an indelible mark. It is what started the artist off, excited his ideas, and stirred up his emotions. Ideas and emotions will in the end be prisoners in his work. Whatever they do, they can't escape from the picture. They form an integral part of it, even when their presence is no longer discernible. Whether he likes it or not, man is the instrument of nature. It forces on him its character and appearance. In my Dinard pictures and in my Pourville pictures I expressed very much the same vision. However, you yourself have noticed how different the atmosphere of those painted in Brittany is from those painted in Normandy, because you recognized the light of the Dieppe cliffs. I didn't *copy* this light nor did I pay it any special attention. I was simply soaked in it. My eyes saw it and my subconscious registered what they saw: my hand fixed the impression. One cannot go against nature. It is stronger than the strongest man. It is pretty much to our interest to be on good terms with it. We may allow ourselves certain liberties, but only in details.

Nor is there any "figurative" and "non-figurative" art. Everything appears to us in the guise of a "figure." Even in metaphysics ideas are expressed by means of symbolic "figures." See how ridiculous it is then to think of painting without "figuration." A person, an object, a circle are all "figures"; they react on us more or less intensely. Some are nearer our sensations and produce emotions that touch our affective faculties; others appeal more directly to the intellect. They all should be allowed a place because I find my spirit has quite as much need of emotion as my senses. Do you think it concerns me that a particular picture of mine represents two people? Though these two people once existed for me, they exist no longer. The "vision" of them gave me a preliminary emotion; then little by little their actual presences became blurred; they developed into a fiction and then disappeared altogether, or rather they were transformed into all kinds of problems. They are no longer two people, you see, but forms and colors: forms and colors that have taken on, meanwhile, the *idea* of two people and preserve the vibration of their life. . . .

Academic training in beauty is a sham. We have been deceived, but so well deceived that we can scarcely get back even a shadow of the truth. The beauties of the Parthenon, Venuses, Nymphs, Narcissuses, are so many lies. Art is not the application of a canon of beauty but what the instinct and the brain can conceive beyond any canon. When we love a woman we don't start measuring her limbs. We love with our desires—although everything has been done to try and apply a canon even to love. The Parthenon is really only a farmyard over which someone put a roof; colonnades and sculptures were added because there were people in Athens who happened to be working, and wanted to express themselves. It's not what the artist *does* that

counts, but what he *is*. Cézanne would never have interested me a bit if he had lived and thought like Jacques Emile Blanche, even if the apple he painted had been ten times as beautiful. What forces our interest is Cézanne's anxiety—that's Cézanne's lesson; the torments of van Gogh—that is the actual drama of the man. The rest is a sham.

Everyone wants to understand art. Why not try to understand the songs of a bird? Why does one love the night, flowers, everything around one, without trying to understand them? But in the case of a painting people have to *understand*. If only they would realize above all that an artist works of necessity, that he himself is only a trifling bit of the world, and that no more importance should be attached to him than to plenty of other things which please us in the world, though we can't explain them. People who try to explain pictures are usually barking up the wrong tree. Gertrude Stein joyfully announced to me the other day that she had at last understood what my picture of the three musicians was meant to be. It was a still life!

How can you expect an onlooker to live a picture of mine as I lived it? A picture comes to me from miles away: who is to say from how far away I sensed it, saw it, painted it; and yet the next day I can't see what I've done myself. How can anyone enter into my dreams, my instincts, my desires, my thoughts, which have taken a long time to mature and to come out into the daylight, and above all grasp from them what I have been about—perhaps against my own will?

With the exception of a few painters who are opening new horizons to painting, young painters today don't know which way to go. Instead of taking up our researches in order to react clearly against us, they are absorbed with bringing the past back to life—when truly the whole world is open before us, everything waiting to be done, not just re-done. Why cling desperately to everything that has already fulfilled its promise? There are miles of painting "in the manner of"; but it is rare to find a young man working in his own way.

Does he wish to believe that man can't repeat himself? To repeat is to run counter to spiritual laws; essentially escapism.

I'm no pessimist, I don't loathe art, because I couldn't live without devoting all my time to it. I love it as the only end of my life. Everything I do connected with it gives me intense pleasure. But still, I don't see why the whole world should be taken up with art, demand its credentials, and on that subject give free rein to its own stupidity. Museums are just a lot of lies, and the people who make art their business are mostly imposters. I can't understand why revolutionary countries should have more prejudices about art than out-of-date countries! We have infected the pictures in museums with all our stupidities, all our mistakes, all our poverty of spirit. We have turned them into petty and ridiculous things. We have been tied up to a fiction,

instead of trying to sense what inner life there was in the men who painted them. There ought to be an absolute dictatorship . . . a dictatorship of painters . . . a dictatorship of one painter . . . to suppress all those who have betrayed us, to suppress the cheaters, to suppress the tricks, to suppress mannerisms, to suppress charms, to suppress history, to suppress a heap of other things. But common sense always gets away with it. Above all, let's have a revolution against that! The true dictator will always be conquered by the dictatorship of common sense . . . and maybe not!

Poem

> give tear out twist and kill I cross light and
> burn caress and lick embrace and look I ring
> full peals from the bells until they bleed
> frighten the pigeons and make them fly all
> around the dovecot until they fall to the
> ground already exhausted I will stop up all
> the windows and the doors with earth and
> with your hair I will hang all the birds that
> sing and cut all the flowers I will cradle the
> lamb in my arms and give it my breast to
> be devoured I will wash it with my tears of
> pleasure and of pain and send it to sleep
> with the song of my loneliness by *Soleares*
> and engrave with acid the fields of wheat
> and oats and watch them die lying face up
> in the sun I will wrap the flowers in news-
> paper and I will throw them through the
> window into the stream which repents with
> all its sins on its back goes away content
> and laughing in spite of all to make its nest
> in the cesspool I will break the music of
> wood against the rocks of the waves of the
> sea I will bite the lion's cheek will make the
> wolf weep with tenderness before a portrait of
> water that lets its arm drop into the bath tub

"Poem" by Pablo Picasso. Translated by Sir Roland Penrose in London Bulletin, *nos. 15–16 (May 15, 1939). Courtesy of Sir Roland Penrose.*

Man Ray

Man Ray (born 1890) met Marcel Duchamp at an artists' colony in New Jersey in 1915, and Francis Picabia in New York a year later. His early Cubist-oriented painting was much influenced by them, though he also experimented with colored paper collages (*Revolving Doors*, 1916–17, published 1926) and invented the "aerograph" or spray-gun painting. In 1921 he went to Paris, where he was automatically absorbed in the Dada and then the Surrealist movement. His major contribution to the two movements, aside from some effective objects, was his innovation in the field of photography. In 1921 he invented the Rayograph, a cameraless photograph made by placing objects directly on sensitized paper. His fashionable photographic portraits reflected Surrealism in their bizarre props and unexpected poses and angles. Three of his films, *Anemic Cinema* (1926, with Duchamp), *Emak Bakia* (1927), and *Etoile de Mer* (1928) were important additions to the growing Surrealist interest in motion pictures. In 1931, Man Ray applied Surrealist chance techniques to an exploitation of accidental "solarizations," or the pale gray auras changing the contours of subjects on photographic negative.

Photography Is Not Art

I wish I could change my sex as I change my shirt.
—André Breton

Ask me, if you like, to choose what I consider the ten best photographs I have produced until now, and here is my reply:

1. An accidental snap-shot of a shadow between two other carefully posed pictures of a girl in a bathing suit.
2. A close-up of an ant colony transported to the laboratory, and illuminated by a flash.
3. A twilight picture of the Empire State building completely emptied of its tenants.
4. A girl in negligee attire, calling for help or merely attracting attention.
5. A black and white print obtained by placing a funnel into the tray of developing liquid, and turning the light onto the submerged paper.

"Photography Is Not Art" by Man Ray. From View, *ser. 3, no. 1 (April–October 1943). Courtesy of Man Ray.*

6. A dying leaf, its curled ends desperately clawing the air.

7. Close-up of an eye with the lashes well made up, a glass tear resting on the cheek.

8. Frozen fireworks on the night of a 14th of July in Paris.

9. Photograph of a painting called, "The rope dancer accompanies herself with her shadows. Man Ray 1916."

10. Photograph of a broken chair carried home from Griffith Park, Hollywood, at one of its broken legs the slippers of Anna Pavlova.

Do you doubt my sincerity? Really, if you imagine that I value your opinion enough to waste two minutes of my precious time trying to convince you, you are entirely mistaken.

Let me digress for a moment. Some time ago, in the course of a conversation, Paul Eluard proclaimed very simply "I detest the horse." And yet the horse in Art . . . from Uccello to Chirico, the horse reappears again and again as a dream motive and as a symbol of woman. Its popularity is universal, from the most vulgar chromo of the racing fan to the painting full of implications by the psychologist. One of the reasons we have to thank abstract art is that it has freed us from this obsession. One would have thought that a single picture of the horse would have been sufficient once and for all to dispose of this preoccupation, and that never again would an Artist have resorted to the same motive. Noble animal! The horse a noble animal? Then are we by comparison nothing but dogs, good or bad, as the case may be. The dog's attachment to man is not the result of any similarity that may exist in physiognomy between him and man, nor even of odor. What attaches the dog is his own capacity for loving. The dog is such a complete lover. The horse, however, like the cat, is content with *being* loved. But *we* are not such good lovers, we humor the horse for his hoofs as we cater to the cat for her guts, and our affection and caresses are calculated to exploit their attributes. And so we kid the dog along for his doggedness. So agree; the dog is the only animal that knows what real love is. With his set expression, but unlike that of his determined master, he has no hope, no ambition, he has only the desire for the regular caress and the bone. Take the following example. It is a one-sided but true story of man's perfidy:

For fifteen years this woman has been raising dogs. Now she is twenty-four years old, and wishes to retire. She wants to sell her dogs, fifty-seven of them, all pedigreed, sell them so that she may retire and devote the rest of her life to writing poetry. She speaks,

> Yesterday was a cocoon
> Tomorrow will be a butterfly

Tonight as I sit and gaze at the moon
I wonder and mutter "WHY?"

Photography as Consolation

Smile, for your teeth are not just made to eat or bite with.

If the threat of hard little birds, whose dung is so destructive, paralyses your gums, even so, make a grimace to please the photographer—and your very optimistic family.

Smile too, photographer, but if your hand trembles too much, leave your camera there and take up a brush. The trembling of your hand will pass for an excess of sensitivity. But whether you photograph the most beautiful woman in the world or a potato, you will make the same gesture, and you will succeed infallibly if you hold your camera without trembling.

Fear and anger, like love, have accomplished miracles in painting. Miraculous cures.

The complicated engines manufactured by men demand, if one really wants to use them, much calm. Ever since our love for machines replaced the love we used to have for our fellow men, catastrophes proceed to increase.

Consolation: "The pen is mightier than the sword, ink more indelible than blood," and the blackening of a silver plate by light currently serves to confirm these proverbs.

The Biography below is of Man Ray's old friend Marcel Duchamp, and was published in a special Duchamp issue of the Surrealist magazine, *View*, in New York, where both artists lived during the war. Perhaps in recognition of the fact that Duchamp, the Frenchman, lived mainly in New York and Man Ray, the American, in Paris, and their friendship was thus a bi-lingual one, he wrote the text partly in French. The italicized sections are those which have been translated here. For further information on their friendship, see Robert Lebel, *Marcel Duchamp* (New York: Grove Press, 1959).

"Photography as Consolation" by Man Ray. Translated by the editor from "La Photographie qui console," XXe siècle, no. 2 (1938). Courtesy of Man Ray.

Bilingual Biography

"RROSE SELAVY AND I AVOID THE ECCHYMOSES OF ES-
QUIMOES WITH EXQUISITE WORDS." [1]

and *NOTICE TO EXHIBITIONISTS*: If you cannot show us your
anatomy, it is of no avail to show us that you know your anatomy.

1915, Yes and Love; Our first meeting at tennis (no net), in two
words, we speak poorly but keep the ball from oculist witnesses.[2]

West 67th Street; *The Bride stripped bare by her bachelors, even.*[3]
While the bride lay on her face, decked out in her bridal finery of
dust and debris, I exposed her to my sixteen-candle camera. Within
one patient hour was fixed once for all the Domaine de Duchamp.
Dust Breeding;[4] didn't we raise the dust, though, old boy!

West 71st Street; *Rotating Glass Plaques,*[5] *the only happy crime in*
my life; as I loved danger and as we love glass, and as you break them,
like the Russians. Yes, and chess.

Grand Central; The very independent Richard Mutt[6] robbed the
vestals of their vespasienne in broad daylight and called it another
day. Yes, and chess.

West 8th Street; Stereoscopic streptococci in pretechnicolor, prelude
to *Anemic Cinema.*[7] Yes, and chess.

"*Bilingual Biography*" by *Man Ray. From* View [*special Duchamp issue*] (*1945*),
pp. 32, 51. Courtesy of Man Ray.

[1] Editor's note: one of Duchamp's punning aphorisms, written under the name
of his female alter-ego Rrose Selavy, in the 20s.

[2] Editor's note: probably a reference to Ray's and Duchamp's meeting at Ridge-
field, New Jersey; they did not speak each other's languages.

[3] Editor's note: the Bride is Duchamp's "Large Glass" (see p. 111), now at the
Philadelphia Museum of Art. In 1916, Duchamp lived at 33 West 67th Street in New
York.

[4] Editor's note: *Dust-Breeding:* a Duchamp work consisting of the dust naturally
accruing to the surface of the "Large Glass" as it lay flat in his studio over a period
of time: photographed by Man Ray in 1920.

[5] Editor's note: *Rotating Glass Plaques:* a series of mechanized optical spheres by
Duchamp and Ray, 1920.

[6] Editor's note: Richard Mutt was the name under which Duchamp exhibited his
Fountain (a urinal) in 1917 at the Independents' Exhibition, New York.

[7] Editor's note: *Anemic Cinema:* a film made with rotating plaques by Duchamp
and Ray in 1926.

Dada New York; *Beautiful old Helen sits in mourning for our youth.*[8]

Société Anonyme Incorporated; Fair, cold but warmer, as indicated by my special device, Catherine Barometer, very reliable.[9] Now you have almost unfinished the only authentic portrait of Lautréamont's god, jumping hair of cones in a bordel.

They treated us like finished men. Because we are never finishing? Then say unfinished (infinite) men.

Appointment in rue la Condamine, and then, I receive at the Hotel Meuble all those critics well disposed toward me. I thank you, old friend, I owe much to you. Only I didn't know how to profit from it. As our dear André says, "I have always been drawn only to what is not a sure bet." [10]

Puteaux; in the gardens of Jacques Villon[11] (I am still not speaking French), you return to your spiral monocle embellished with delicious pornographic anagrams. Final vindication and prototype of the ideal obscenema. Yes, and chess.

31 rue Campagne-Première; the *semi-spheres with exquisite words* continue to rotate. But you never told me about the *Chocolate Grinder.*[12] I had to find out for myself. It was a pleasure, a much greater pleasure to find out by myself. Would it be an indiscretion on my part to relate that, walking down the streets of Rouen with my back to the lopsided steeples of the cathedral, I was overcome by a most delicious odor of chocolate which grew stronger as I advanced? And then, there they were, in a window, those beautifully polished steel drums churning around in the soft brown yielding mass of exquisite aroma? Later when questioned, you admitted your pure school-boy love. Your amour-propre. I translate freely.

[8] Editor's note: *Belle Haleine, Eau de Violette* (Beautiful Breath, Veil Water): a perfume bottle label picturing Duchamp in the female guise of Rrose Selavy; photo by Man Ray, published in *New York Dada*, 1921.

[9] Editor's note: "Catherine Barometer": Katherine Dreier, founder of the Société Anonyme (see Duchamp, pp. 111 and 114–17).

[10] Editor's note: Duchamp was living with Jean Crottis in the *rue de la Condamine,* Paris, in Spring, 1921, when Man Ray arrived there; "dear André" must be Breton.

[11] Editor's note: the painter Jacques Villon was Duchamp's brother and lived in Puteaux, outside Paris.

[12] Editor's note: the Chocolate Grinder *(Broyeuse de Chocolat):* early machine painting by Duchamp, 1913.

Monte Carlo; *While I was caught between the auto races and the bull fights, you ran after the number wheel.*[13]

> "*Words made of numbers*
> *Call of numbers, clamour of gold,*" *Paul said.*
> Yes, and chess.

At the Belles Japonaises; I lost my hat, but you never had time nor money to lose.

Arcachon; you write, "*I hope you have not tried to go back to Paris.*" We both came back, at different times, and we both left at different times without seeing each other.

Hollywood; thanks, old friend, I received your valise.[14] Those who say you do not work any more are crazy. I know you do not like to repeat yourself, but only a real cheater can repeat himself with impunity. The most insignificant thing you do is a thousand times more interesting and fruitful than the best that can be said or done by your detractors. Strange how those most suspicious of your pulling their legs haven't any to stand on.

1945, New York; yes, and chess. *Goodbye!*

[13] Editor's note: In 1924 Duchamp made a "Monte Carlo Bond" with his own portrait and a roulette wheel on it.

[14] Editor's note: The valise: Duchamp's "suitcase," a cardboard box made in 1938 containing miniature reproductions of sixty-eight of his works.

Kurt Seligmann

Kurt Seligmann (1900–1962) was a Swiss painter who joined the Surrealists in Paris in 1937; in 1938 he and ten other Surrealist artists illustrated the complete works of Lautréamont. During the war he went to New York, providing, in 1941, one link between Surrealism and New York painting via Robert Motherwell, who studied engraving with him. Seligmann later became an American citizen. His illusionist paintings resemble curiously animated swathes of cloth, blowing into empty space or forming figures with a medieval cast that was not accidental, given the fact that Seligmann, in 1934, had published a series of heraldic engravings, and that he contributed several scholarly articles on the history of magic, like the one below, to Surrealist magazines. These culminated in a book, *The Mirror of Magic* (New York: Pantheon, 1948). The subject was particularly attractive to the Surrealists in the 30s, when they became very involved with alchemy, magic, and the myths of transformation.

Magic and the Arts

Magic sprang from desire. Its roots lay in man's psyche. But with the growth of civilization a hundred-branched tree evolved from these roots, hiding in its foliage a wealth of mysteries. What was their true meaning? The wise men of antiquity were faced with the difficult task of discovering a higher significance in the apparent absurdities inherited from the past. The more such tradition seemed absurd to them, the greater was their mental effort when spinning around it a philosophy or a glistening cocoon of esotericism. Magic was spiritualized, ready to merge into religion. It was from the last magicians, the Neo-Platonists, that the Church inherited contempt for earthly matters, and both Pagans and Christians, despairing of ever being able to understand the universe, relied upon *revelation* as the sole contact with divinity, in whom resided all wisdom. The primitive desire for power here on earth was succeeded by a longing for felicity in the beyond. This must have been a sad epoch for investigators of nature and for artists, whose works were still bearing witness to the proud world-systems of old. Now the world was split, disunited through Lucifer's rebellion. The world-clock's pendulum did not swing be-

"Magic and the Arts" by Kurt Seligmann. From View *(Fall 1946), pp. 15–17. Courtesy of Mrs. Arlette Seligmann.*

cause it was moved by an admirable mechanism which comprised everything high and low, good and bad: now all happenings were caused by the Incomprehensible. Wisdom was taken from man to be restored in the heavens.

The magical man had placed himself in a circle formed by the chain of happenings. He did not resent as a servitude this implacable succession of events; rather, he welcomed it as liberation from tyrannical hazard.

When John was writing his Gospel, an anonymous magus composed the books of Hermes Trismegistus, which sum up the great ideas of dying Paganism. Many passages resemble those of John's Gospel, betraying the period in which they were written and the intellectual crucible in which they were formed. Others illuminate doctrines of magic which through centuries have influenced the investigators of nature and the artists of the Christian Occident.

How much they are alive we may gather from the following inquiry among modern writers, artists, composers, and architects. Their spontaneous answers to "what about magic" reflect magical ideas which may have been expressed by Gnostics or Neo-Platonists at the beginning of our era.

FERNAND LÉGER: it is an astounding power, trespassing the average understanding and the *creative imagination* of the individual.

ANDRÉ MASSON: its aim is to discover, to retain, relations invisible in nature, with the purpose of exerting by this *knowledge* power upon the invisible world.

JACQUES LIPCHITZ: if the art work did not *magically act* upon the spectator, I would not waste my time with sculpting.

AMÉDÉE OZENFANT: . . . an ensemble of procedures (some functioning, some not) whose aim it is to attain by short cuts what science and knowledge permit at times to be obtained.

PAVEL TCHELITCHEW: . . . a *revelation,* whether spontaneous or forced, of universal incomprehensible laws.

MARCEL DUCHAMP: Anti-reality!

MAX ERNST: . . . the means of *approaching the unknown* by other ways than those of science or religion.

CHARLES HENRI FORD: *Magic pervades everything.* Its highest form today is poetry. Poetry when really inspired is inexplicable, supernatural, magical.

CHARLES DUITS: Magic controls nature and the supernatural by the *verb.*

PARKER TYLER: Magic is present but never known; it is the source behind the source and the effect in front of the effect. Man is its child more intimately than he is the son of his parents. Man may

disobey everything else, but magic he must obey. In the furor of creation he believes that *nature obeys him,* and so he became the magician. But magic is the magician behind the magician, the one to whom "I love" is a command, "Love me" a plea. It is the opposite with a passion for itself.

IVAN GOLL: it fulfills a task, similar to that of poetry or music, in opening to man unknown realms beyond his reason and enabling him to *subdue obscure forces.*

NICOLAS CALAS: Halfway between religion and freedom, compulsion and inquiry, lies magic: it appeals to the sons in their struggle against the father, and favors the mother's favorite child. With all the weight of an abandoned stone gong it awaits the hour when the silenced will discover it. It is the dreaded shadow in the Pyrrhic, it is the dreaded sacrifice, the *tangible proof demanded* by nocturnal convictions. . . .

FREDERICK KIESLER: the art of power . . .

EDGAR VARESE: Corporealisation of the intelligence that is in sound. (cit. Hoene Wronski)

According to the Judeo-Christian doctrines, God had created the universe out of nothing. He and the world are two distinct things. To the magician, All is contained in All—and All is *One.* God and the Universe are o n e. They obey that same magical law that causes every happening. Moreover: *what is above, is also below,* the visible and the invisible world reflect one another. And the two worlds are connected through a hierarchy which rises from the stone to the star, from the star to the supreme. Good and bad are encircled by this system. They combat one another, but they cannot exist without each other. In such a unified world man could find peace and felicity. He and the stars are made of the same dust, as Paracelsus recalls to us; all things are inter-related. They form a unity within their endless diversity. "O Sun, O Air," writes Hölderlin, "with you alone lives my heart, as with brothers."

In Scipio's Dream, the only fragment of Cicero's Republic that has come to us, we learn of the secrets of the world's harmony: the younger Scipio is dreaming that his grandfather leads him to the stars which vibrate with a wonderful symphony. "You hear," Scipio the Elder says, "*the* Harmony." It is formed by unequal intervals, calculated according to perfect proportions, and reproduced by the movement of the spheres . . . And men who know how to imitate this celestial music with their lyre, have traced their way back to this sublime realm, in the same way as others who have by their genius raised themselves to the knowledge of the divine."

The proportions of which the world is built are those of the musical

intervals; the whole universe, Robert Fludd says, together with the heavens is like an instrument. In his beautiful treatise on the "Music of the Soul" he offers an image of man, built according to similar proportions, tuned to the harmony of the stars.

Fludd had formed these poetic images after conceptions uttered before by Agrippa von Nettesheim, who says: "Musical harmony is a most powerful conceiver. It allures the celestial influences and changes affections, intentions, gestures, notions, actions and dispositions . . . Fish in the lake of Alexandria are delighted with harmonious sound, music has caused friendship between dolphin and man . . . melodious voices tame the Indian elephant. *And the elements themselves delight in music!* The Hulesian fountain, otherwise calm—rises—rejoicing—at the trumpet's sound and overflows its banks. And in Lydia, the Nymph's Islands leaves the shore when music is played and travel to the midst of the sea where they dance . . ."

This is a truly magical world of *earthly* felicity, delight and peace, as man identifies himself with the All.

Dance, like music, may express the world's harmony. "The world being built in human proportions," Agrippa explains, "man moving in harmonious gestures means that he is in support with the All. Such movements cause the gods to rejoice, and echoes the haunts of the planets."

And similarly is literature connected with the universe, as the Cabala teaches. In the Book Zohar we read:

> Throughout the expansion of the sky which circles the world, there are figures, signs by which we may know the secrets and the most profound mysteries . . . He who travels early in the morning shall look to the East. He will see there something like letters marching in the sky, some rising, some descending. These brilliant characters are the letters with which God has formed heaven and earth . . .

Georges Gaffarel, the learned librarian of Richelieu, adds to this: "Since time immemorial, people in the East read the prophetic words of the wandering stars . . . We Europeans have utterly neglected this marvelous art. Reuchlin was the first who called our attention to it, and he was followed by Pico della Mirandola." Speaking about the plastic arts, Gaffarel believes that not only metal plates and other talismen be endowed with magical power, but also sculptures and paintings. For how could we explain, he says, that people are moved by art works, if there were not a magical link between the world, painted or hewn, and the macrocosm which acts upon man's emotions?

What is above is also below. The universe is harmony, and its multiplicity brought into One by a mysterious law. These principles, can they not be applied to every good work of art? Is it not the

painter's task to express the marvelous manifoldness of nature through the variety of forms he depicts? And does he not, following the law which he sees in the universe, strive to bring all these forms into one organic whole?

Yves Tanguy

Yves Tanguy (1900–1955) was born in Brittany, and his paintings of bleak, graying plains peopled by biomorphic stonelike forms have been compared to the menhirs and dolmens found there. In 1925, so the story goes, a painting by de Chirico, seen from a passing bus, impressed him so much that he decided to be a painter. He joined the Surrealists that same year and had evolved his mature style, which changed very little from then on, by 1927. It is very possible that Tanguy's illusionist depictions of what are basically sculptural forms had some influence on the development of an abstract biomorphic sculpture like that of Arp or Henry Moore. Although sculpture seemed the logical outcome of such concerns, Tanguy himself made only a few objects during his Surrealist career. Those discussed below (illustrated by drawings above each description in the original publication) were never executed, but the obsession with materials is prophetic of much recent sculpture; two-dimensional counterparts appear constantly in his canvases.

Weights and Colors

The object above, which is the size of a hand and looks as if it were kneaded by one, is made of pink plush. The five ends at the bottom, which fold back into the object, are of transparent and pearlescent celluloid. The four holes in the body of the object permit the four large fingers of the hand to pass through there.

* * *

In the ensemble above, the object at left is in plaster painted a reddish violet color, and the nail is pink. It is weighted in the lower part by a lead ball which permits oscillations but always returns to the same position.

The very small object in the middle, full of mercury, is recovered with woven straw, bright red, so as to appear extremely light. The fat object at the right is of molded cotton, pale green, the nails in pink celluloid. The last object on the right is of plaster covered with black ink; the nail is pink.

"Weights and Colors" by Yves Tanguy. Translated by the editor from "Poids et couleurs," Le Surréalisme au service de la révolution, *no. 3 (December 1931), p. 27. Courtesy of Pierre Matisse.*

* * *

The object at left is in soft wax, imitation flesh. The appendage above is floating and a browner color. The three rounded forms in the center are in a hard material, matte white.

The object at the right is in sky-blue chalk. At the top, hairs. This object ought to be used to write on a blackboard. It should be used from the base, so that at the end it consists of the tuft of hairs at the top.

Unlike many Surrealists, Tanguy wrote little (he drew instead) and made few public statements. "I expect nothing of my reflexions, but I am sure of my reflexes," he once said. The text below, dating from 1954, after the demise of Surrealism, would be irrelevant in the case of most other artists, but Tanguy's stylistic consistency and singleness of purpose renders it of genuine interest in regard to his art.

Contribution to a Symposium on
The Creative Process

La surprise doit être recherchée pour elle-même inconditionnellement.[1]

—André Breton, *"L'Amour fou."*

The element of *surprise* in the creation of a work of art is, to me, the most important factor—surprise to the artist himself as well as to others.

The painting develops before my eyes, unfolding its surprises as it progresses. It is this which gives me the sense of complete liberty, and for this reason I am incapable of forming a plan of making a sketch beforehand.

I believe there is little to gain by exchanging opinions with other artists concerning either the ideology of art or technical methods. Very much alone in my work, I am in fact almost jealous of it. Geography has no bearing on it, nor have the interests of the community in which I paint. I work very irregularly and by "crises"—sometimes for weeks at a stretch, but never on more than one painting at a

Contribution to a symposium on "The Creative Process" by Yves Tanguy. From Art Digest 28, no. 8 (January 15, 1954): 14. Courtesy of Pierre Matisse and Arts Magazine.

[1] Editor's note: "Surprise should be sought unconditionally for its own sake."

time, nor in more than one medium. Regular hours for work would be abhorrent, as anything resembling a duty is to me the negation of all fantasy in creative work.

Certain of my paintings are finished very quickly; others take two months or more. This does not depend on the size of the canvas.

I am, naturally, interested in the paintings of others. To cite a few of my favorites: Hieronymus Bosch, Cranach and Paolo Uccello among the old masters, and De Chirico (metaphysical period) of the contemporaries.

And, to finish, should I seek the reasons for my painting, I would feel that it would be a self-imprisonment.

The Abridged Dictionary of Surrealism

The "definitions" below were selected from *The Abridged Dictionary of Surrealism*, which was published in connection with the International Surrealist Exhibition at the Galerie Beaux-Arts, Paris, in January–February 1938. They have been re-alphabetized in translation. The initials following the entries refer to: Louis Aragon, Hans Arp, Hans Bellmer, André Breton, René Crevel, Salvador Dali, Marcel Duchamp, Paul Eluard, Max Ernst, Wolfgang Paalen, Pablo Picasso, Man Ray. The book itself was richly illustrated with decorated capital letters, drawings, and other devices. Some of the definitions were arrived at by game techniques; others are quotations from randomly chosen sources. The artists themselves were "defined" as well as their favorite words. Thus Arp was "the dune-eel"; Dali, "the prince of Catalan intelligence, colosally rich"; Dominguez, "the dragon-tree of the Canaries"; Ernst, "the Bird Superior"; Magritte, "the cuckoo's egg"; Masson, "Feather [pen] man"; Miró, "the sardine tree"; Tanguy, "the guide from the age of mistletoe druids"; Brauner, "the white rose top-boot"; and Seligmann, "the sheaf of wings."

Selected Definitions

ANACHRONISM. "Sentimental cataclysm sparkling with *arrière-pensées* of *new skin*." (SD)

APHRODISIAC TELEPHONE. "telephonic apparatuses will be replaced by lobsters, whose advanced state will be rendered visible by phosphorescent plaques, vertible *flytrap truffle-grounds*." (SD)

ASSASSINATION. "The tranquillity of past and future assassinations." (ME).

BREAST. "The breast is the chest elevated to the state of mystery—the chest moralized." (Novalis)

BREAST-PLATE. "The breast-plate is a sort of child who grows between the sex of a hat and the sex of shoes. If you embrace your own image in the mirror, the breast-plate makes a foot of your nose and a hand of your nose." (HA)

Selected "definitions" from The Abridged Dictionary of Surrealism. *Translated by the editor from* Le Dictionnaire abrégé du Surréalisme, *catalogue of the Exposition Internationale du Surréalisme (Paris: Galerie Beaux-Arts, January–February, 1938).*

CHANCE. "pickled chance." (MD) "Chance would be the form of manifestation of exterior necessity that prepares the way into human unconsciousness." (AB) "Chance is the master of humor." (ME)

CHIRICO. (Giorgio de) born in 1888, in Greece, of Italian parents. Pre-surrealist painter. "The most amazing painter of this time." (Apollinaire, 1914) "If this man had some courage he would have tired long ago of that game of making fun of his lost genius." (AB, 1928) "Heir of Böcklin and of imaginative painting in general, Chirico sensationally revolutionizes anecdote and also the subject in the manner of and in circumstances proper to the surrealist revolution in the realm of imagination." (SD) The pictorial work of Chirico claimed by Surrealism came to a halt in 1918. Since then one owes him for nothing but the publication of an admirable prose work: *Hebdomeros* (1929).

COLLAGE. "If it is plumes that make plumage, it is not the glue that makes a glueing." (ME) "It is something like the alchemy of the visual image. The miracle of total transfiguration of beings and objects with or without modification of their physical or anatomical appearance." (ME)

DELAY. "Use 'delay' instead of picture or painting. . . . A delay in glass as one would say a poem in prose or a spittoon in silver." (MD)

DOLL. "Would it not be in the doll which, despite its accomodating and limitless docility, would surround itself with a desperate reserve, would it not be in the doll's very reality that the imagination would find the joy, exaltation and fear it sought? Would it not be the final triumph over those adolescents with wide eyes turning away if, beneath the conscious stare that plunders their charms, the aggressive fingers were to assail their plastic form and construct slowly, limb by limb all that had seen appropriated by the senses and the brain?" (HB)

FILM. Principal Surrealist films: *Emak Bakia* (1926), *The Starfish* (1928) by Man Ray; *Anemic Cinema* (1925) by Marcel Duchamp; *The Pearl* (1929) by Georges Hugnet; *The Andalusian Dog* (1929), *The Golden Age* (1931) by Luis Buñuel and Salvador Dali. "What can be expected of Surrealism and what could be expected of a certain cinema called *comic*, is all that deserves to be considered." (SD)

FROTTAGE. Process discovered by Max Ernst, August 19, 1925. "The process of collage resting only on the intensification of the irritability of the spiritual faculties by appropriate and technical means, excluding all conscious mental conduction, reducing to an extreme the active part of what has up till now been called the 'author,' this process is revealed as the veritable equivalent of *automatic writing*." (ME)

GLOVE. "The glove [*gant*] is worn by a *gantleman*. The glove is the cast of a head pierced, through which the index finger passes to tickle new nature." (HA)

LOVE. "Everything leads us to believe that love would be only a sort of incarnation of dreams corroborating the usual expression which wishes the loved woman to be a dream made flesh." (SD)

OBJECT. *Ready-mades* and *assisted ready-mades,* objects chosen or composed, beginning in 1914, by Marcel Duchamp, constituting the first Surrealist objects. In 1924, in the *Introduction to the Discourse on the Slightness of Reality,* André Breton proposed to fabricate and put in circulation "certain of those objects one perceives only in dreams" (oneiric object). In 1930, Salvador Dali constructs and defines an *object with symbolic functionings* (object which lends itself to a minimum of mechanical functioning and which is based on the phantasms and representations susceptible to being provoked by the realization of unconscious acts). Objects with symbolic functionings were envisaged following the mobile and silent objects: Giacometti's suspended ball which reunited all the essential principles of the preceding definition, but still retained the methods proper to sculpture. On the passage of Surrealism, a fundamental crisis of the object was produced. Only the very attentive examination of numerous speculations which this object has publicly occasioned can permit the grasp, in all its import, of the actual temptation of Surrealism (*real and virtual object, mobile and silent object, phantom object, interpreted object, incorporated object, being object, etc.*). Similarly, Surrealism has attracted attention to diverse categories of objects existing outside of it: *natural object, perturbed object, found object, mathematical object, involuntary object, etc.*

PAINTING. "The only exploitable realm for the painter today is that of the pure mental representation, such as extends *beyond* true perception, without becoming one with the hallucinatory realm. The appeal to mental representation (outside of the physical presence of the object) furnishes, as Freud has said, "sensations resembling the processes unfolding in the most diverse, indeed the most profound, deliveries of the psychic apparatus." In art, the more and more systematic research for these sensations works toward the abolition of the *I* in *oneself,* forces accordingly the predominance of the principle of pleasure over the principle of reality. . . . The painter is offered a world of possibilities which ranges from pure and simple abandon to graphic impulsion through the fixation of dream images, in *trompe l'oeil* passing through all the means of "paranoiac-critical" interpretation. . . . Surrealist painting and constructions have permitted the organization of perceptions around subjective elements with an objective tendency. These perceptions

present an unsettling character, revolutionary in the sense that they call imperiously, in exterior reality, to something which responds to them. This something *will be.*" (AB)

PARANOIA. "Delirium of interpretation comporting a systematic structure.—*Paranoiac critical activity:* Spontaneous method of *irrational knowledge* based on critical and systematic objectivation of delirious associations and interpretations." (SD)

PERTURBATION. "Perturbation, my sister, the hundred-headless woman." (ME)

PHALLUSTRADE. "It is an alchemical product, composed of the following elements: autostrada, balustrade, and a certain amount of phallus. A phallustrade is a verbal collage." (ME)

PHANTOM. "Semblance of volume.—Obese stability.—Suspect mobility or immobility.—Affective contours.—Metaphysical perimeter.—Exhibitionist collapse.—Phenomenal silhouette.—Architectonic anguish. Examples of phantoms: Freud, Chirico, Greta Garbo, the Mona Lisa, sponge, etc." (SD)

RAYOGRAMME. "Photograph obtained by simple interposition of the object between sensitive paper and the light source.—Seized from moments of visual detachment, during periods of emotional contact, these images are the oxidations of residues, fixed by light and chemistry, of living organisms." (MR)

READY-MADE. Ordinary object promoted to the dignity of an art object by the simple choice of the artist. "Reciprocal ready-made: to use a Rembrandt as an ironing board." (MD)

REPOPULATION. "Stay then, that one who speculates on the vanity of the dead, the phantom of repopulation." (ME)

SPONTANEITY (adage of). "The bachelor grinds his chocolate himself." (MD)

SUPERCONSCIOUSNESS. "Poetry, no longer revealing esthetic or metaphysical preoccupations, appears more and more as the supreme degree of comprehension of the *I* and the *oneself,* become accessible by the bridge which binds our nights to days. The bridge thrown between the unconscious and the conscious by Surrealism.

"The superconscious is, beyond the unconscious and the conscious, the third term of the scale of intellectual comportment. It consists of the sublime identification in which what is called the *state of grace,* the ecstasy of love, all *convulsive beauty* participates, which, having already transformed the image of the universe through seismographs of the intelligence of our times, will contribute beyond all conjecture to transforming the world." (WP)

SURREALISM. "Everything leads us to believe that there exists a certain point of mind at which life and death, real and imaginary, past

and future, communicable and incommunicable, high and low, cease to be perceived contradictorily. One would search surrealist activity in vain for another motive than the hope of determining this point." (AB) "The vice called *surrealism* is the unruly and passionate usage of the stupefying *image*." (LA) "Surrealism, which is an instrument of knowledge and as such even an instrument of conquest, as well as defense, works to bring to light the profound consciousness of man, to reduce the differences which exist between men." (PE) "Surrealism gratifies with a pretty little rain of fiery coals, the bazaar of Reality, which has as much right to conflagration as that of Charity, its twin in hypocrisy." (RC)

TEETH. "No one knows the dramatic origin of teeth." (PE and ME)

WINDOW. "I will stop up all the windows and doors with earth." (PP)

VVV

The advent of a large group of Surrealists in New York in the late 30s and early 40s was particularly important for the then maturing group of American artists later vaguely bulked together as "Abstract Expressionists." Formal influence was for the most part limited to abstract adoption of the Surrealist "personnage" motif, biomorphism, and a more generalized interest in primitivism, but collage and the techniques of automatism (by then abandoned by most of the Surrealists) were important for Pollock, Motherwell and others. The most significant result of the Surrealist presence in New York, however, was probably the chance for the young Americans, then trying to fight their way out of a suffocating provincialism epitomized by a social realist style, to be in contact with work of international significance and with the authors of that work. Reviews like *VVV* and *View*, which surmounted the language barrier, provided a forum, if not always a satisfactory meeting ground, for such contacts. Abstract Expressionism was the last movement in which Surrealism actively or directly participated. Since then, its ideas and techniques have expanded and been absorbed so thoroughly that traces of its original esthetic and anti-esthetic can be found in the most unlikely places.

The first issue of *VVV* appeared in New York in October 1942; a second issue for the same month was announced but never appeared, and the next, double, number came out as *Almanac for 1943* in March of that year. The third and last appeared in February, 1944. Officially edited by the young American sculptor, David Hare, its editorial advisors were André Breton, Marcel Duchamp and Max Ernst, and it was very much an organ of the exiled Surrealist movement. The text below was a kind of editorial credo published in a box on the title page of each issue.

Editorial Statement from *VVV*

vvv

that is, V + V + V. We say . . . — . . . — . . . — that is, not only

 V as a vow—and energy—to return to a habitable and conceivable
world, Victory over the forces of regression and of death un-
loosed at present on the earth, but also V beyond this first
Victory, for this world can no more, and ought no more, be
the same, V over that which tends to perpetuate the enslavement
of man by man,

<div align="center">and beyond this</div>

VV of that double Victory, V again over all that is opposed to the
emancipation of the spirit, of which the first indispensable con-
dition is the liberation of man,

<div align="center">whence</div>

VVV towards the emancipation of the spirit, through these necessary
stages: it is only in this that our activity can recognize its end

<div align="center">Or again:</div>
<div align="center">one knows that to</div>

 V which signifies the View around us, the eye turned towards the
external world, the conscious surface,

<div align="center">some of us have not ceased to oppose</div>

VV the View inside us, the eye turned toward the interior world and
the depths of the unconscious,

<div align="center">whence</div>

VVV towards a synthesis, in a third term, of these two Views, the
first V with its axis on the EGO and the reality principle, the
second VV on the SELF and the pleasure principle—the resolu-
tion of their contradiction tending only to the continual, sys-
tematic enlargement of the field of consciousness

<div align="center">towards a total view,</div>

<div align="center">VVV</div>

which translates all the reactions of the eternal upon the actual,
of the psychic upon the physical, and takes account of the myth
in process of formation beneath the VEIL of happenings.

Editorial Statement from VVV *(New York, 1942–44). Courtesy of David Hare,
editor,* VVV.